Inside the Dancer's Art

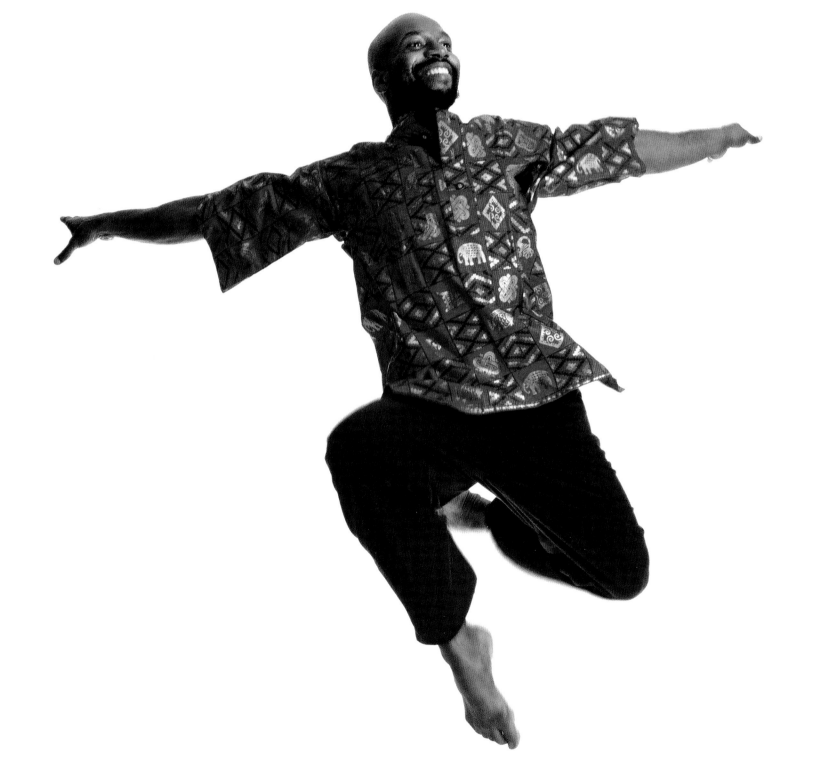

Inside the Dancer's Art

ROSE EICHENBAUM

Foreword by LAR LUBOVITCH

Edited by ARON HIRT-MANHEIMER

WESLEYAN UNIVERSITY PRESS Middletown, Connecticut

Wesleyan University Press
Middletown CT 06459
www.wesleyan.edu/wespress
Manufactured in China
Typeset in Utopia and Aller by Tseng Information Systems, Inc.

Library of Congress Cataloging-in-Publication Data
Names: Eichenbaum, Rose, photographer. | Hirt-Manheimer, Aron, 1948– editor.
Title: Inside the dancer's art / Rose Eichenbaum ; foreword by Lar Lubovitch ; edited by Aron Hirt-Manheimer.
Description: Middletown, Conn. : Wesleyan University Press, 2017.
Identifiers: LCCN 2016038497 (print) | LCCN 2016058292 (ebook) | ISBN 9780819577009 (pbk. : alk. paper) | ISBN 9780819577016 (ebook)
Subjects: LCSH: Dancers—United States—Portraits. | Dancers—United States—Quotations.
Classification: LCC GV1785.A1 E525 2017 (print) | LCC GV1785.A1 (ebook) | DDC 792.80922 [B]—dc23
LC record available at https://lccn.loc.gov/2016038497

5 4 3 2 1

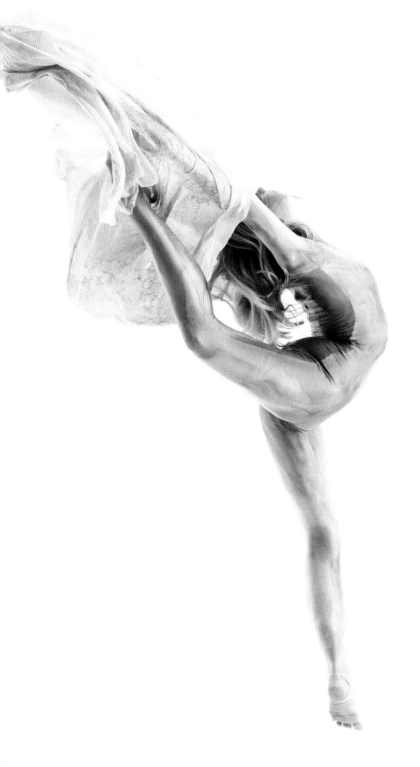

Contents

Foreword

Pictures, like dancers, do not speak in words. They call upon one's intuition rather than one's intellect, enriching our ability to see and to understand through seeing. Martha Graham used to tell a story of her father's admonition to her as a child that words can lie, but he would know the truth by her movements. Whether apocryphal or not, the point is clear: there is a higher knowing than words can provide. All visual artists know this; in fact they can't help it.

Rose's pictures of dancers reveal the most touching thing there is to know about them—their humanity. Her keen view takes us past the pretty lines and the illusions of ease and beauty (though that is there as well) as her photos guide our eyes to intuit a more intimate knowledge of the subject, a view of something more vulnerable than hard bodies and perfect arabesques. If you are her subject, as I have been several times, steady your nerves, relax, and give up the pretense. You will be revealed. Her psychologically inclined eye through her camera seeks to show who you are, like it or not.

Lar Lubovitch

Introduction

The legendary choreographer Martha Graham described those who possess an irrepressible inner force to move, stretch, run, and jump as being "doomed to dance." I have met many dancers who fit that description.

After a thirty-year performance career, Nancy Colahan told me, "I am, and always will be a dancer. Every cell in my body is primed to be so." Michele Simmons, an Alvin Ailey dancer who was later sidelined by multiple sclerosis and confined to a wheelchair, insisted to the end of her life, "My identity as a dancer will never, ever, ever, ever be taken from me. It's who I am."

In the words of Desmond Richardson, one of the greatest dancers of his generation, "I define dance as life—using your life experience to express yourself through your art." Top-rated national competitive break-dancer, Trinity (Nicole Whitaker) put it simply, "Dance means everything. I'd die without it."

Performance is how these individuals express who they are at the core. Tap dancer Jason Samuels Smith told me, "I am my most honest when I'm dancing. No one can own my thoughts, or my actions, or tell me how to feel."

Spanish dancer Carmela Greco, daughter of the late flamenco star, José Greco, described dance as therapeutic: "Before every performance I feel a huge emotional weight—the weight of my life. But once I begin to move, the weight lightens and lifts away."

The dancer's art requires dedication, discipline, and sacrifice. Russian-trained ballerina Natalia Makarova explained how she had to tame her body in her quest to reach the top. "One must work the body like a racehorse. Rein her in and bring her under control. When she rebels, you must conquer her, become her master to bring body and mind into harmony."

I asked former Broadway dancer and ballet choreographer Eliot Feld, "What is the payoff for all the sacrifices you've made for your

art?" He replied, "I've learned that it's unreasonable to expect rewards simply because you have given everything to make your dances. It's a one-way street. The dances that you make owe you nothing. You owe them everything!"

Film star Shirley MacLaine, who performed on Broadway in Bob Fosse's *The Pajama Game*, described dancers as "artistic soldiers" who "will do anything they're asked." The dancer's job is to entertain, engage, and uplift an audience—and with that comes the responsibility to deliver one's best performance.

Carmen de Lavallade, who for decades has mesmerized audiences with her beauty and talent, confessed, "You spend your entire life trying to elevate an audience to another level. You also spend your entire life afraid you might not." As Tony Award winner Chita Rivera put it, "All I've ever wanted was to touch that one person out there in the dark."

And yet, for all the training, long hours and, in most cases, low pay, dancers rarely know how much their performances truly affect an audience. Alvin Ailey American Dance Theater star Matthew Rushing explained, "Even though you receive applause, you usually don't know how your dancing affects people. But when someone comes up to you after a performance with tears in their eyes and says, 'You touched my spirit, you touched my soul,' that's when you know you've made a difference."

New York City Ballet's principal dancer Tiler Peck pondered, "What do I look like when I'm dancing? I really don't know. I know what I feel like when my arms are doing this or when I'm in the air. But if I were someone sitting in the audience looking at me—what would they be seeing? Would they be able to read my thoughts and feel my emotions?"

Yuriko, the legendary Martha Graham dancer, asserted that the dancer's art should be used as a tool for political awareness and as a force for social good. "Look at what's happening in our world, in our century. Use your imagination and the human body to demonstrate life and the human condition." Tap dancer Mark Mendonca agreed: "Dance is how I connect with the power we all have to change the world."

Dance also operates on a spiritual realm, connecting us to a higher power. Choreographer Cleo Parker Robinson described dance as "a spiritual language we can use to feed our souls, communicate with each other, and show respect for all peoples." For choreographer Judith Jamison, "The dancer is someone who makes you feel part of the universe." Former Bella Lewitzky dancer, John Pennington, views dance as a way for artists to express what they know about their own spirituality.

As personally fulfilling as dancers' lives can be, the duration of their stage careers are relatively short when compared to those of artists in other fields. Choreographer David Parsons spoke from personal experience when he lamented, "There comes a time when the body betrays you."

So what does the dancer do when her body betrays her? Retired ballerina Martine van Hamel responded. "She must simply learn to live with her own demise. I don't feel anymore like I'm a dancer, and yet, I'm nothing but." When I asked the same question of veteran Martha Graham dancer Mary Hinkson, she said, "If you can't do it, don't do it. Why get on the stage and just hobble around?"

Many told me about the challenges of finding a balance between their personal and professional lives. They shared deeply personal stories and, in some cases, their darkest and most frightening moments. They recalled with pride their signature roles, reminisced about the invaluable relationships they had developed with other dancers and choreographers. They spoke eloquently and lovingly of their appreciation for the dance—how it had given their lives

meaning and enriched it beyond their wildest expectations. Others confessed hurt and betrayal by an art form that can be fiercely unforgiving.

Whether starting out, at the height of their career, or looking back, dancers know that they have the ability to inspire, stimulate the imagination, communicate ideas and emotions, and offer commentary about ourselves and our world. Many feel compelled not only to uplift audiences, but humanity as a whole.

I know all this because long before I picked up a camera and tape recorder, I was a dancer. I too had dreamed of a career on the stage, but ultimately found my true calling as a dance photographer, author, and teacher.

My earliest influence as a photographer was Barbara Morgan, whose extraordinary skill at capturing moving bodies in time and space, artfully lit and composed, had a profound effect on my visual aesthetic. She practiced "previsioning," an intuitive approach that prepared her to establish an empathetic relationship with her subjects as she searched for "meaning within form."

It is through this method that Morgan captured so poignantly the personas and artistic expressions of Martha Graham, Erick Hawkins, José Limón, Anna Sokolow, Merce Cunningham, Doris Humphrey, and others. Her desire to take pictures that contained "the essential emotion of the dance and arrest time to capture the dance at its visual peak" made her images of the late 1930s and 1940s among the first to reveal the dancer's spirit and artistry. When I studied her photos, I saw intimate portraits that conveyed what lies beneath technique, costumes, and character. She captured the dancers' relationship to their art and of the art itself. Could I do the same? I vowed to try. The year was 1985.

For more than three decades, I've photographed hundreds of dancers of every style—from ballet, tap, jazz, and break-dancing to ballroom, postmodern, world dance, butoh, and the avant-garde—in dance studios, photo rental houses, and site-specific locations, in rehearsals and in performances. Regardless of the assignment, whether marketing a dance company or performance, shooting a magazine cover, publishing a book, or pursuing a personal project, it's always been my intention, in the spirit of Barbara Morgan, to search for meaning within the form.

My thirty years as a photographer and chronicler of dance brought me in close contact with some of the most celebrated names in dance, as well as many talented emerging artists. Every such encounter contributed in some way to my understanding of the dancer's life and art. This work is a record of my journey into the world of dance, and is dedicated to the dancers who I have had the honor to photograph and interview during the course of my exploration of one of humanity's oldest and most impassioned forms of artistic expression.

Rose Eichenbaum

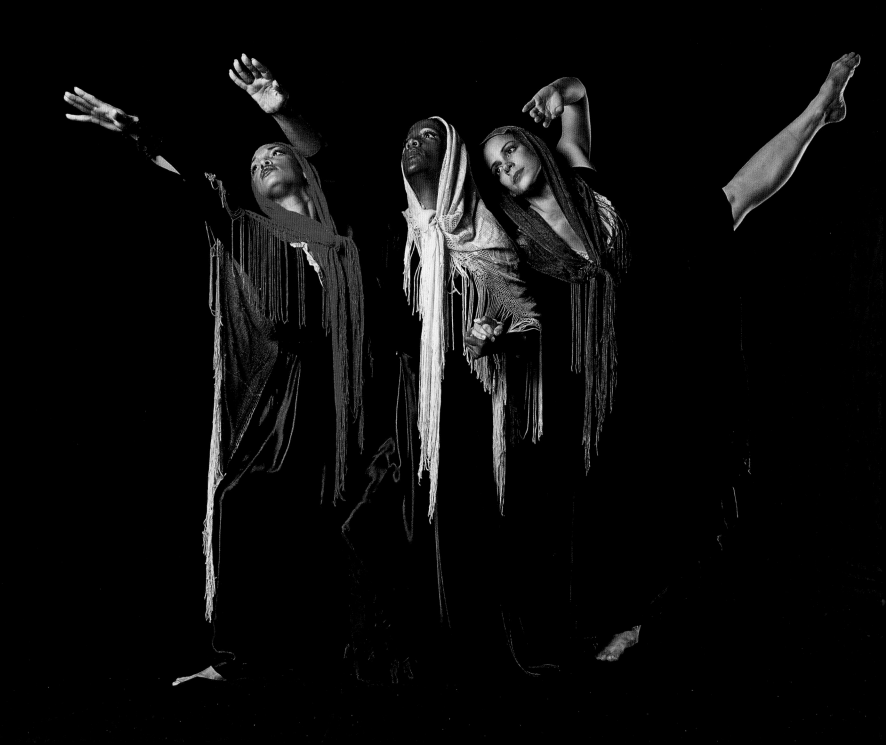

Inside the Dancer's Art

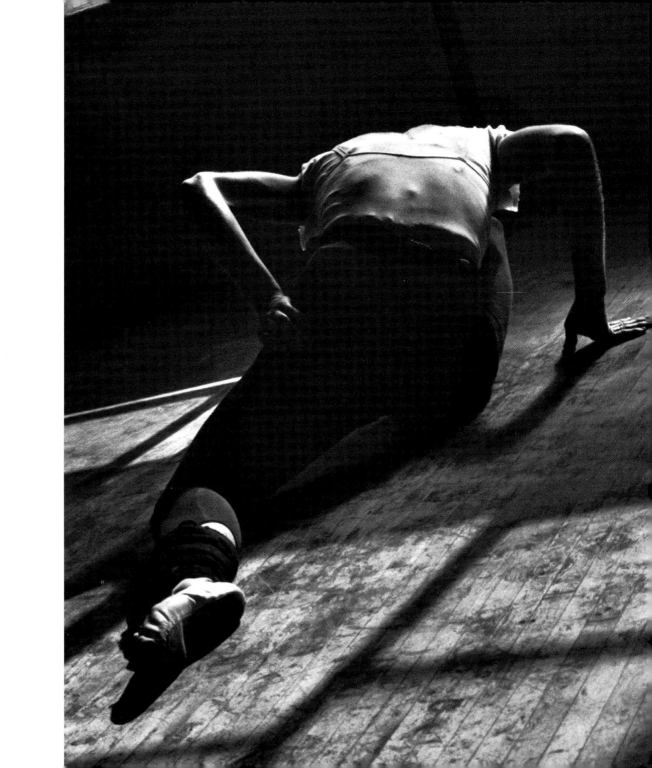

This image of a dancer stretching is among my very first dance photographs and my most personally meaningful. Taken in 1985 at the dance studio where I trained, it reminds me of my yearning for the stage, the drive to perform, and the physical challenges I faced. Most of all, it informs me that I will always be, first and last, a dancer.

Rose Eichenbaum

Dancer's identity unknown

Dance changes you.
You can never go back to being
the person you were before.
Joaquin Escamilla

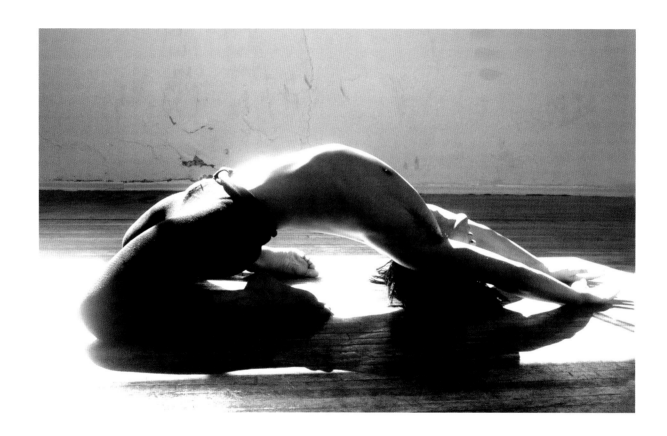

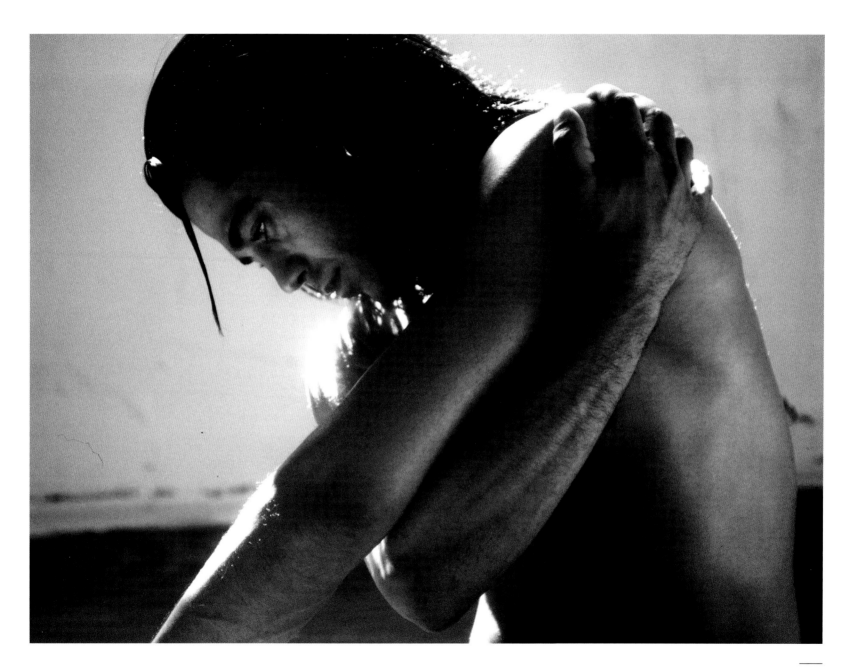

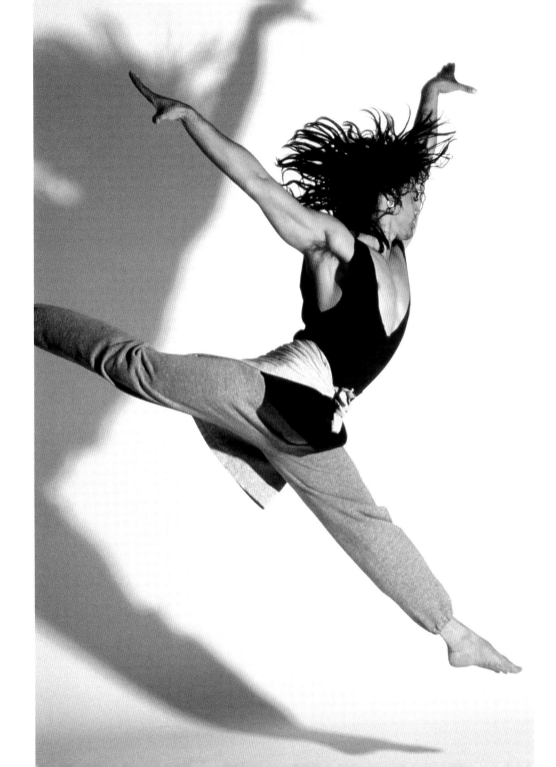

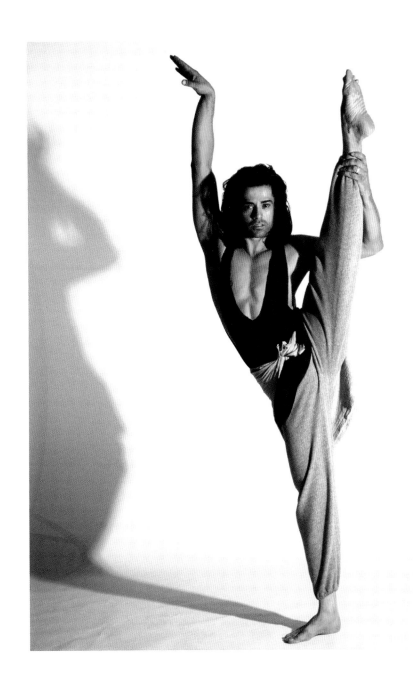
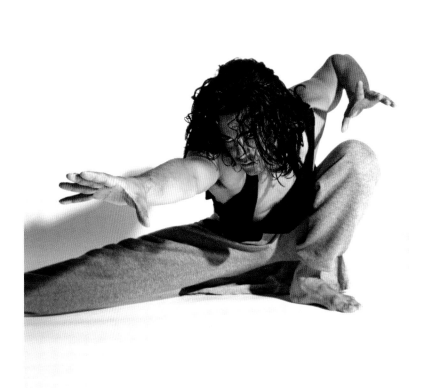

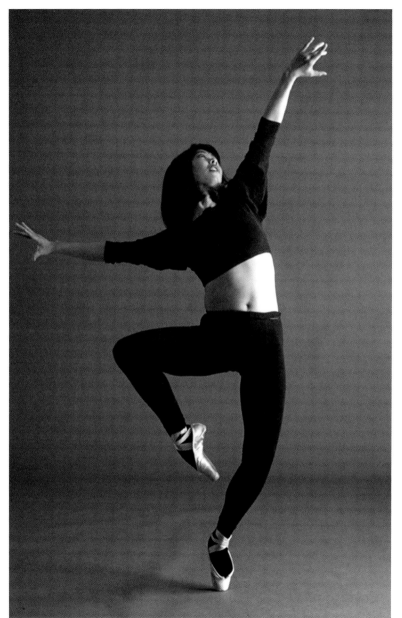

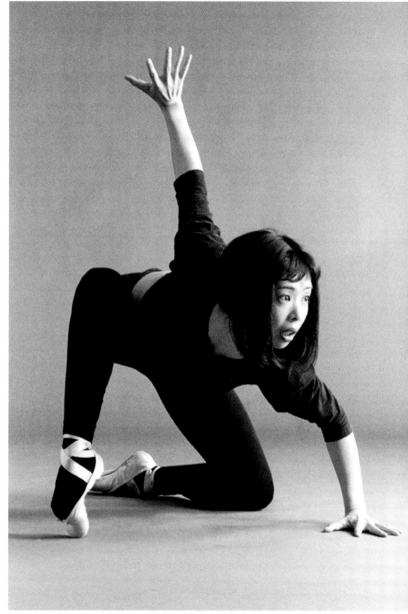

Dancing is how I connect
with the power we all have to
change the world.
Mark Mendonca

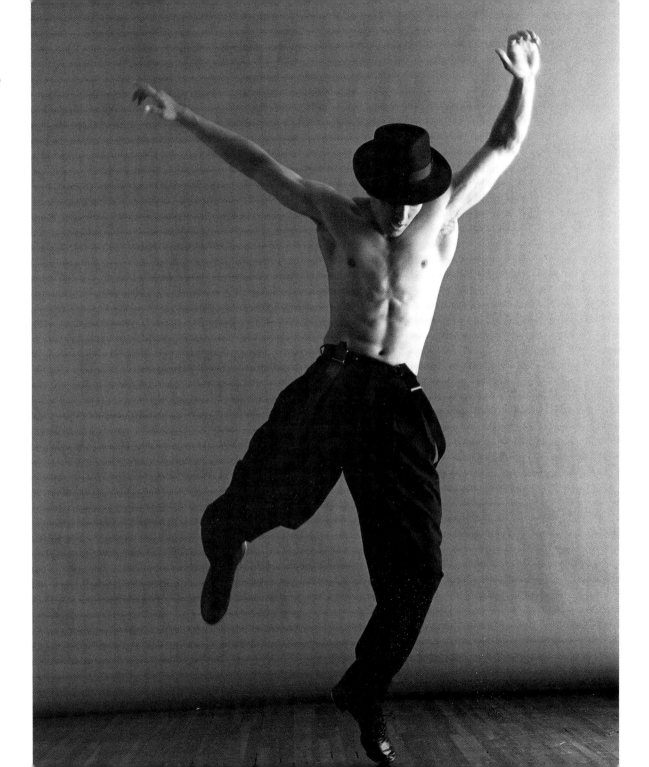

I can always remember the
dances, even from the shows
I did forty years ago.
Gwen Verdon

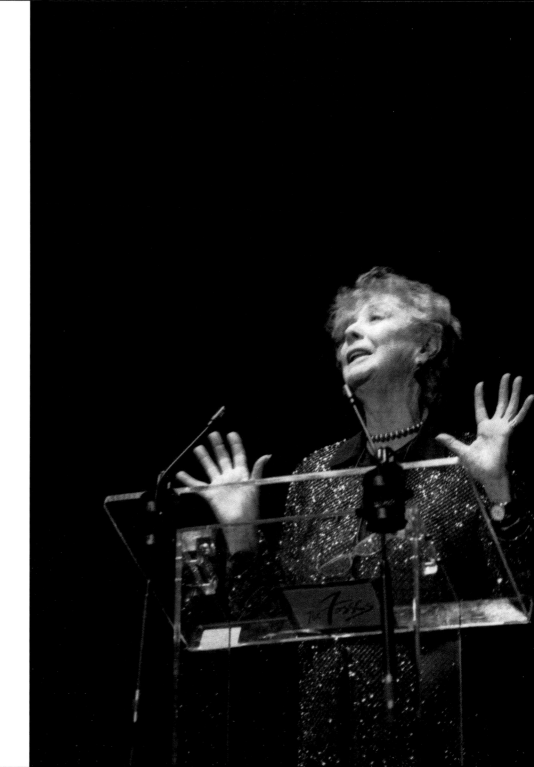

Intertwining moves,
caressing ever so lyrically—
adagio-ing with God—
a romance with my creator.
Natalie Willes

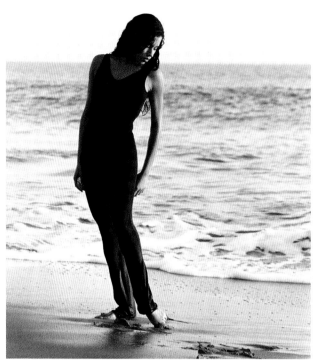

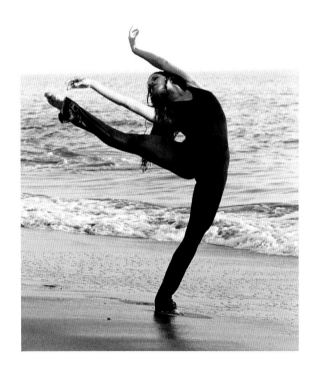

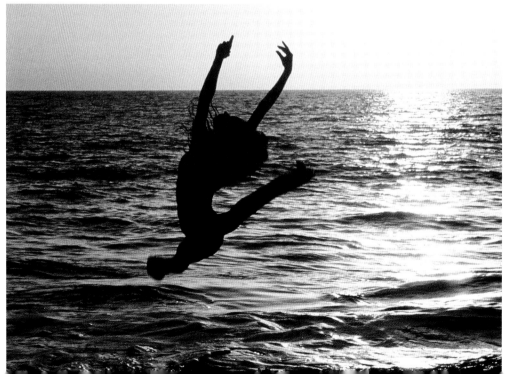

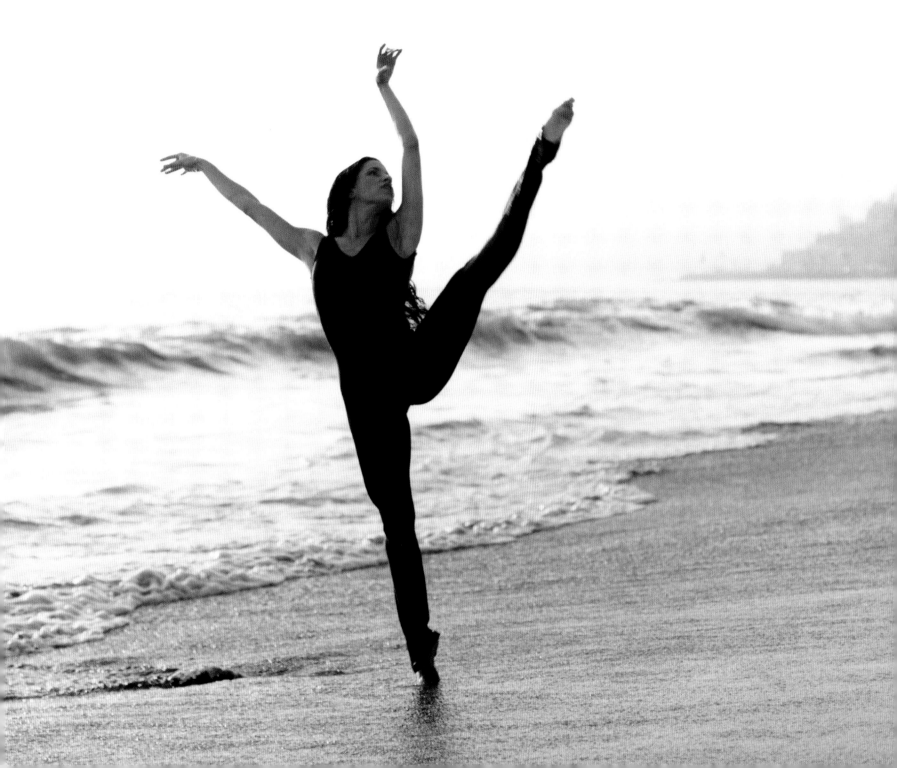

I dance because I must.
I cannot be stilled.
Natalie Willes

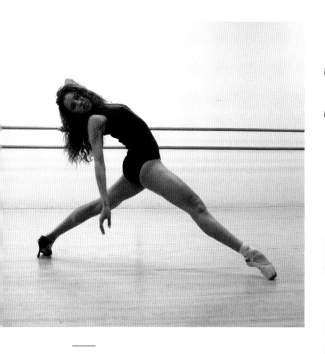

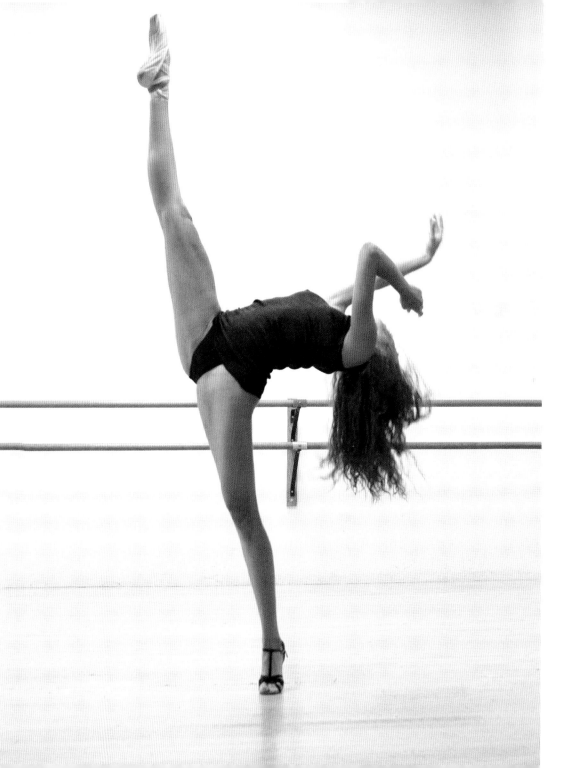

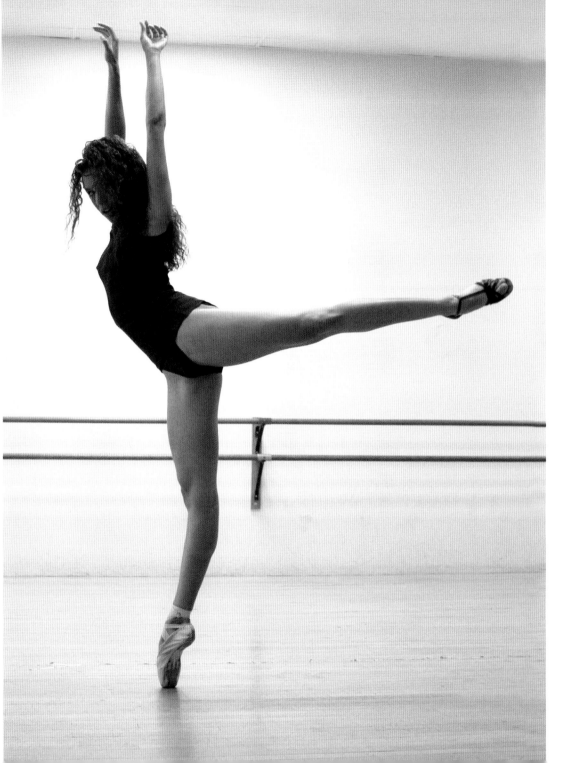
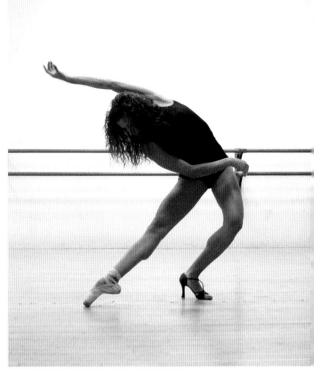
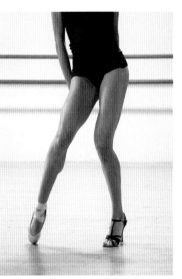

My dance is a soulful
articulation of
unspoken truths.
Julie Adams

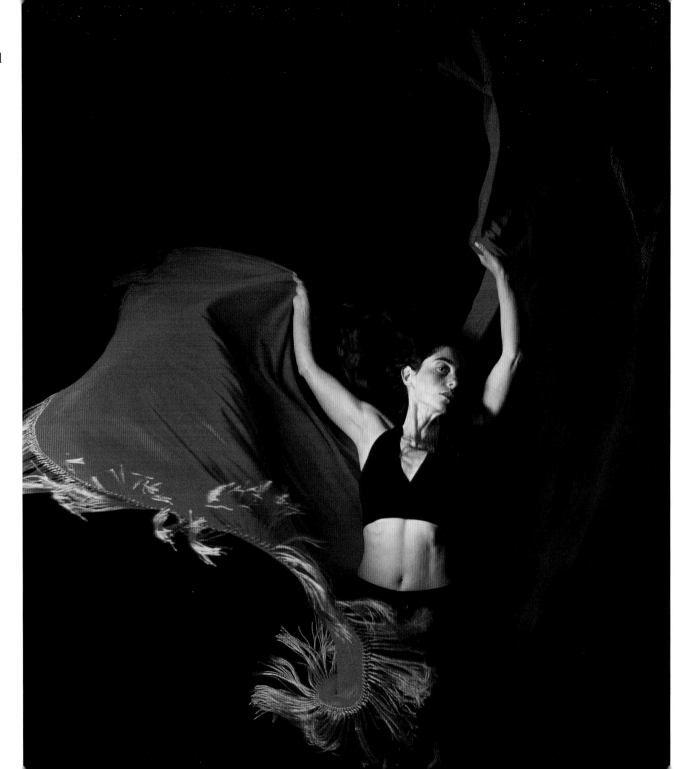

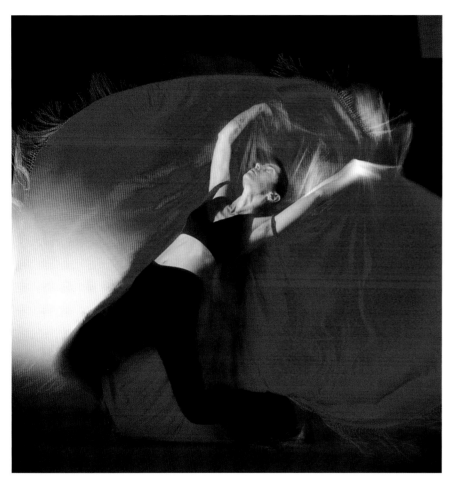
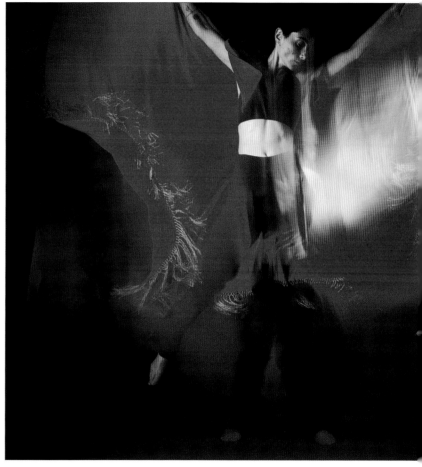

How I'd execute moves and steps—
attack them, embrace them, or shy
away from them—always had a
direct correlation to what was going
on in my mind, my heart, and in my
life at that time.

Stephanie Guiland

Donald Byrd's/The Group

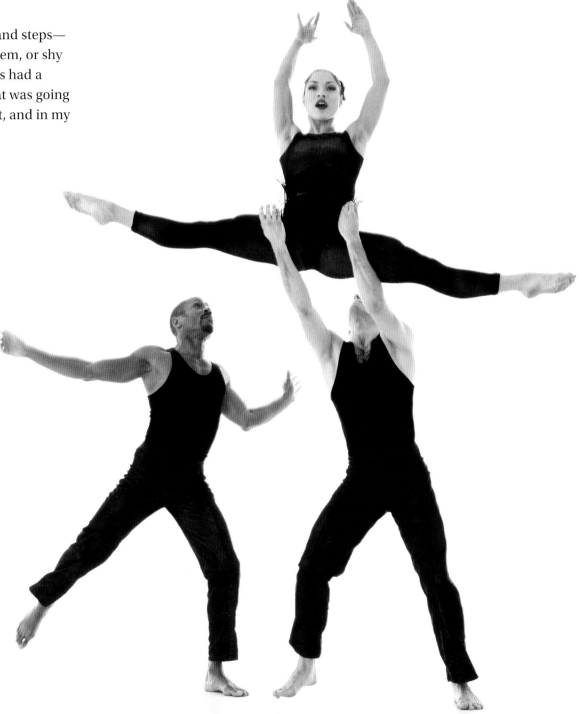

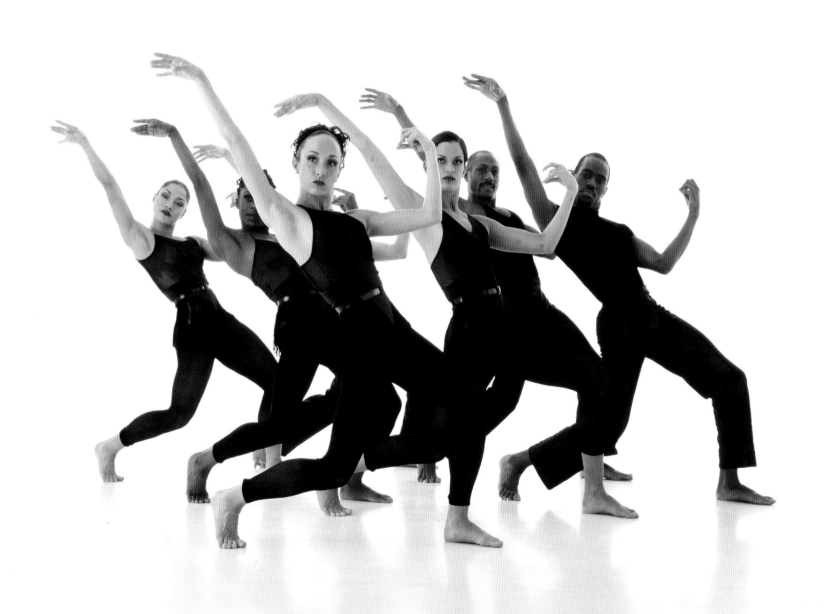

The doctors said I needed a hip replacement.
My career of more than two decades was over.
I cried for a month and hid in my apartment,
drinking heavily. Without dance I didn't want
to live. What other skills did I have? I went
from being the lucky dancer who was always
working to someone who had no income.
Michael Blake
Donald Byrd's/The Group

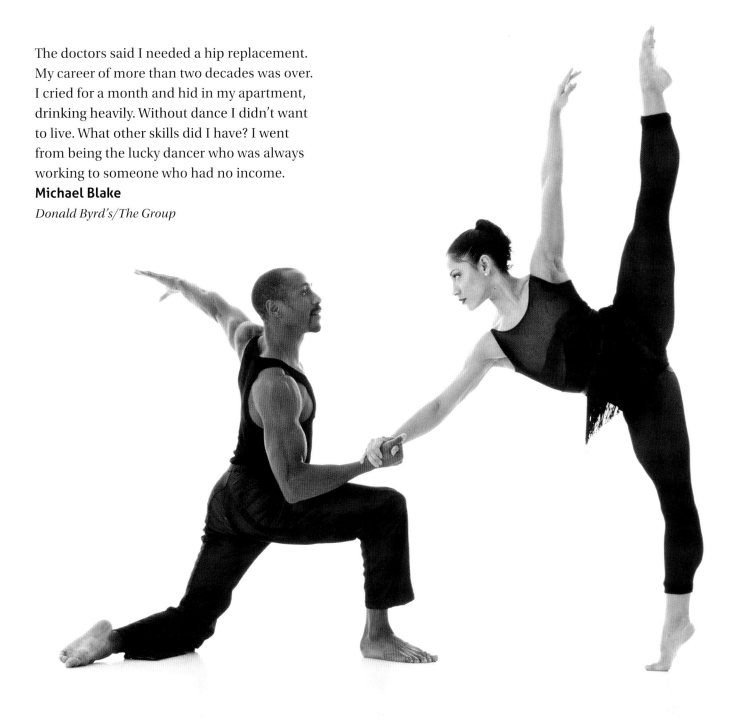

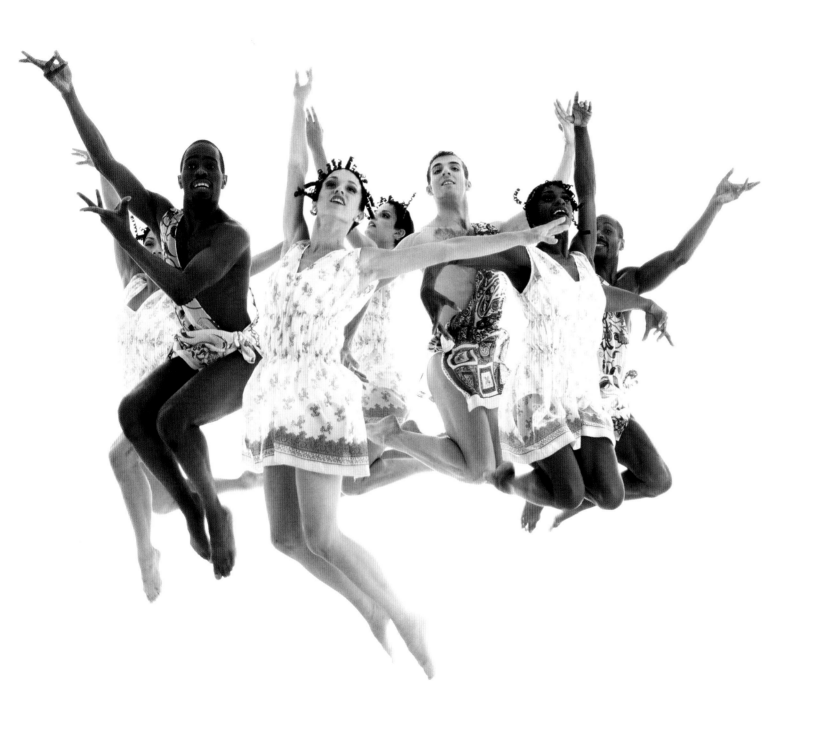

My agenda is to see
how far I can push the body.
I don't mean
just the physical body.
I mean the mind too.
Donald Byrd

Donald Byrd's/The Group

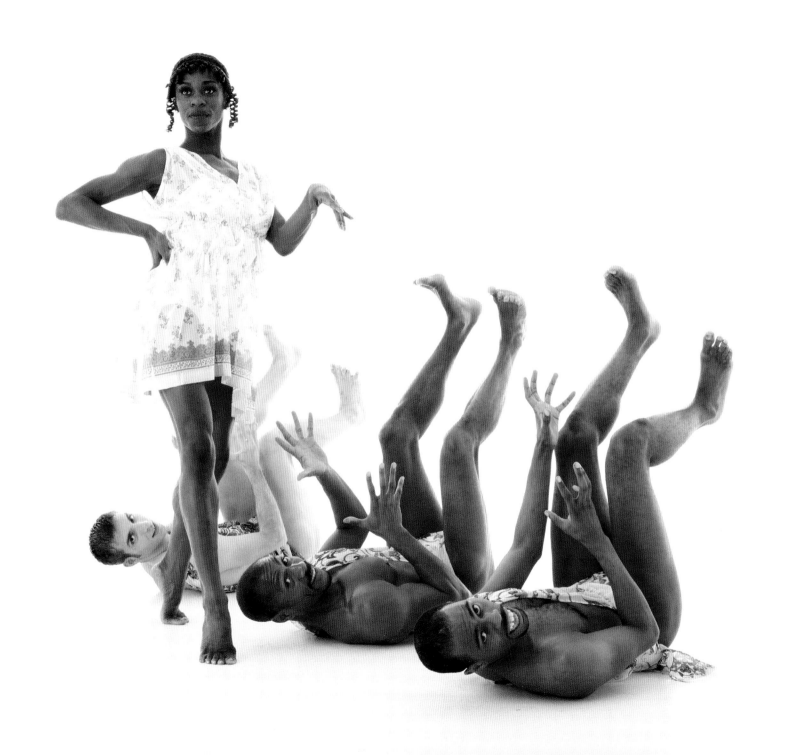

You can't discover new things about your soul unless you take risks—go out on a limb. The challenge to go out there becomes a challenge to the self. It's how you show your mettle as a person.
David Parsons
Parsons Dance Company

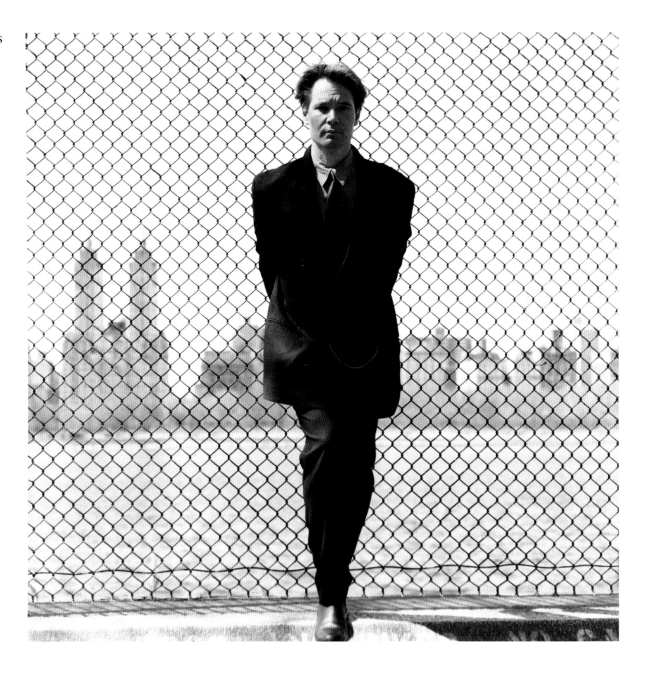

There is no manual, no road map to a successful dance career. You have to write your own.
Daniel Ezralow

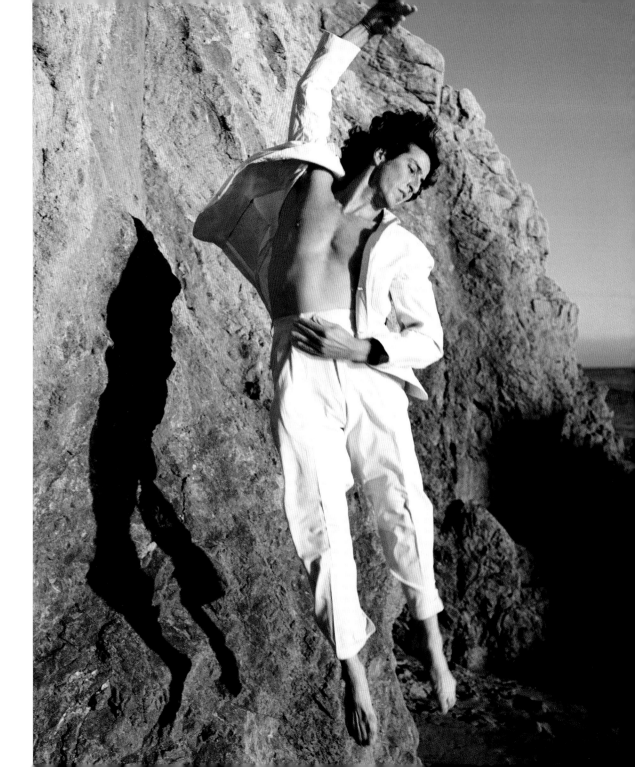

Every human emotion
can be conveyed and
shown through dance—
expressly romance,
passion, and joy.
Parissa
with Desmond James

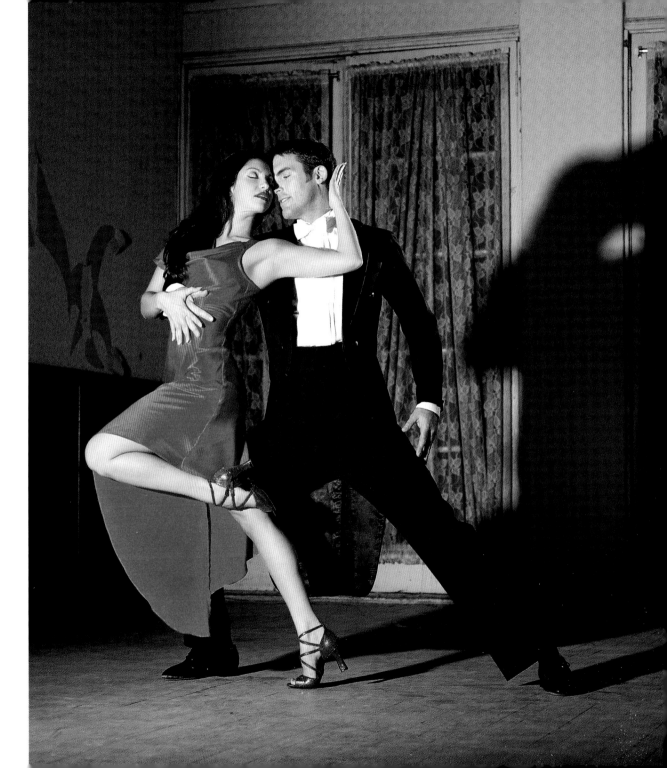

Movement and action are the only things that really communicate. I can use words, but if I don't include my body to support the words, then the words might not be believed.
Rennie Harris

Rennie Harris Puremovement

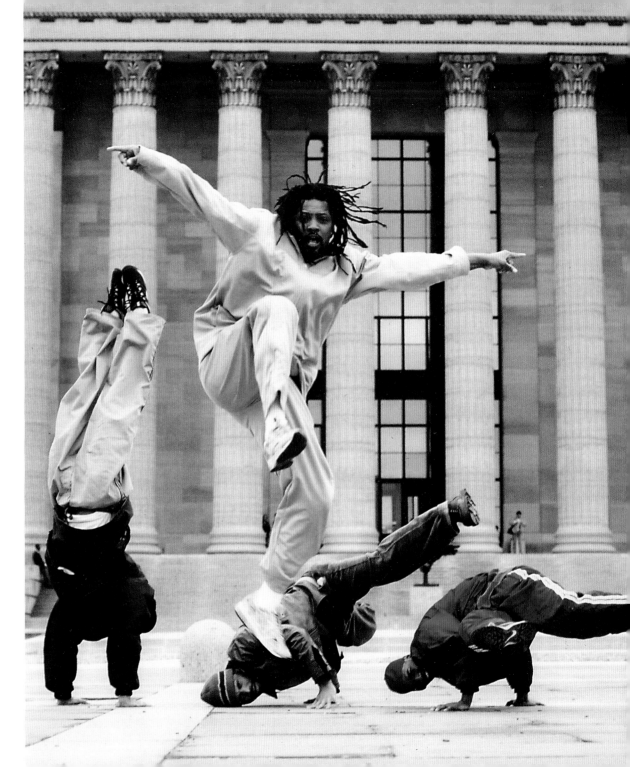

Bonnie Oda Homsey
John Pennington
American Repertory Dance Company

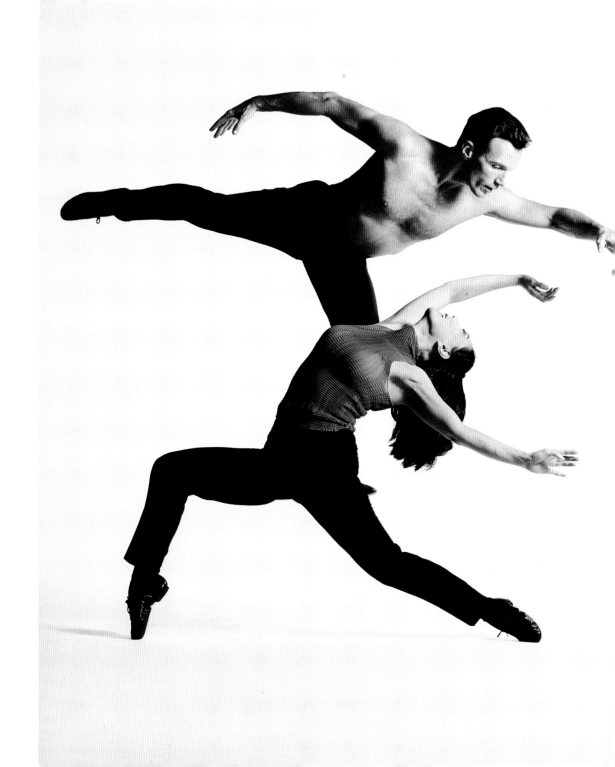

I am, and will always be a dancer.
Every cell in my body is primed to be so.
Nancy Colahan

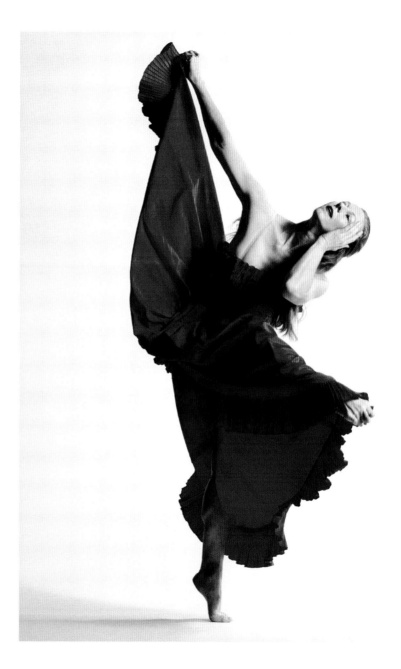

What empower me on stage
are the combustion of instinct,
physicality, imagination, and
the risk of being vulnerable.
Bonnie Oda Homsey

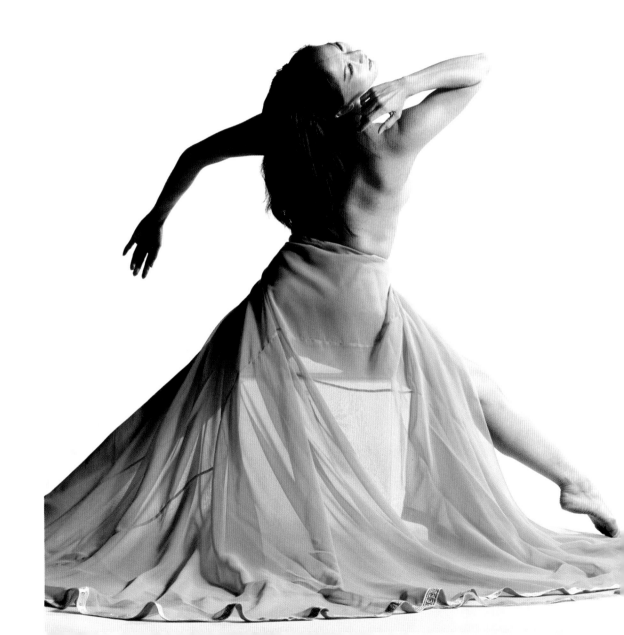

Dance is how you express
what you know about your
own spirituality.
John Pennington

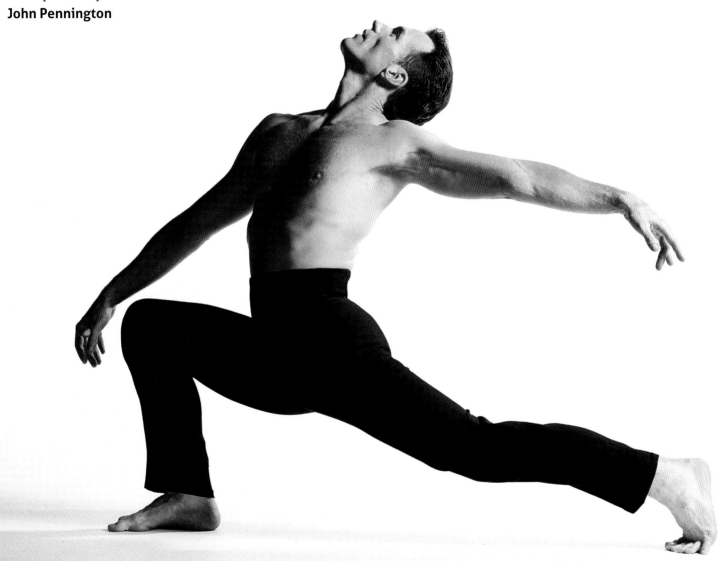

Know your own power and
use it to reveal to the audience
what you want them to
know about you.
Janet Eilber
Martha Graham Dance Company

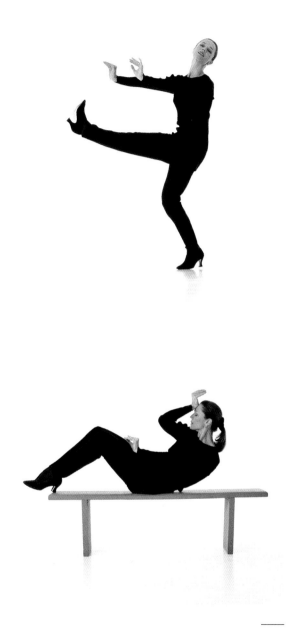

What has always driven me is the search for a new step.
Gregory Hines

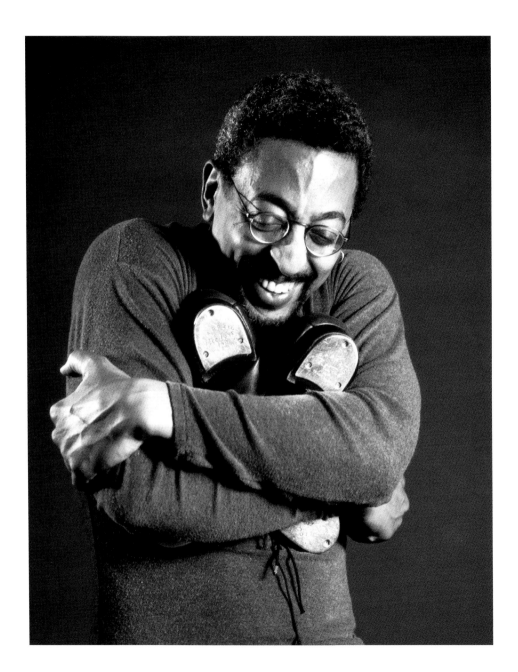

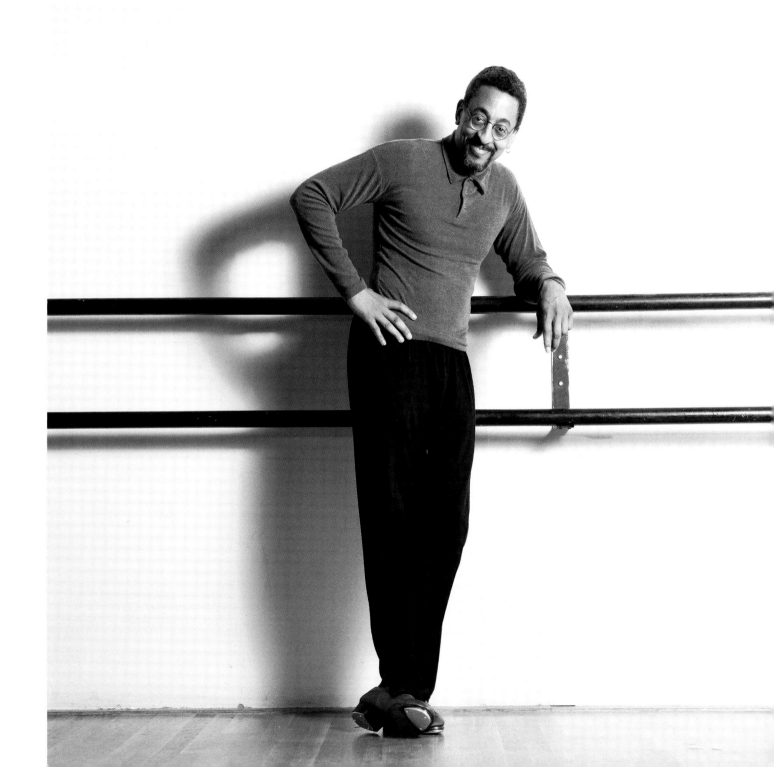

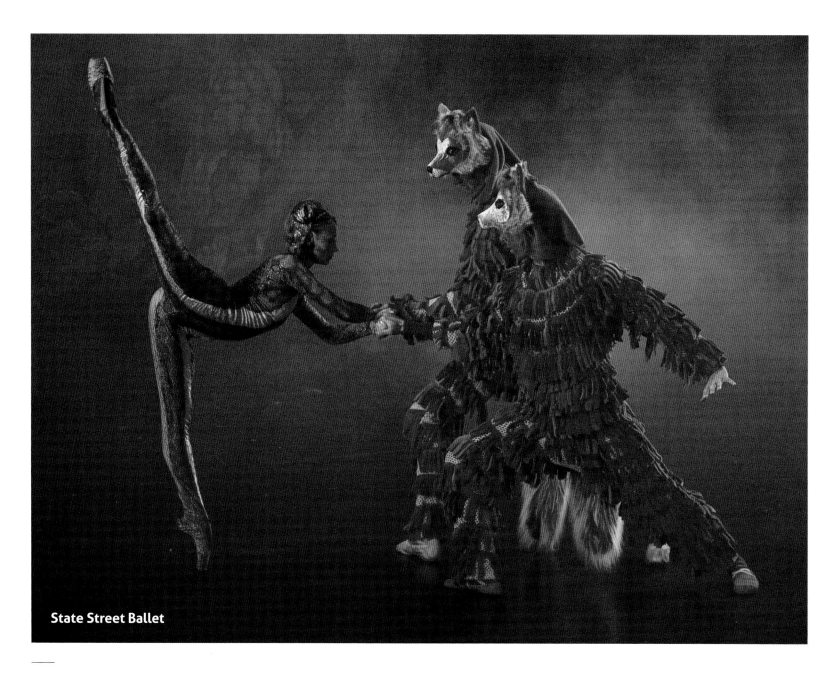

State Street Ballet

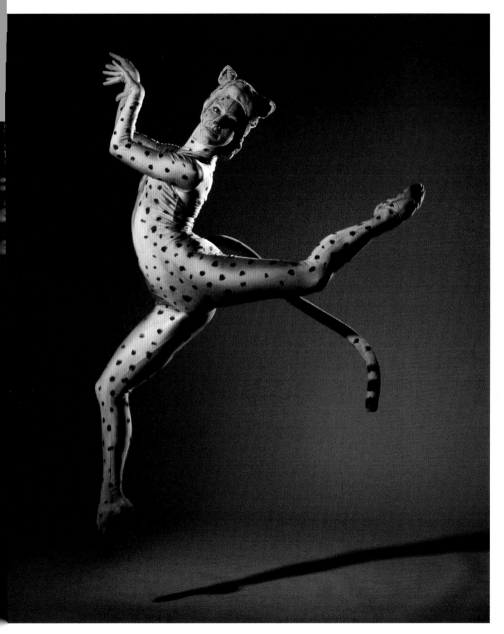

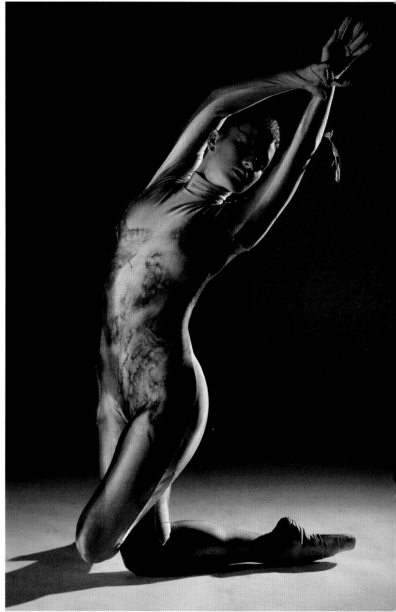

The power of imagination
can shine a light into our souls
where the essence of beauty is
discovered and the artistry
of performance is born.
Rodney Gustafson
Artistic Director, State Street Ballet

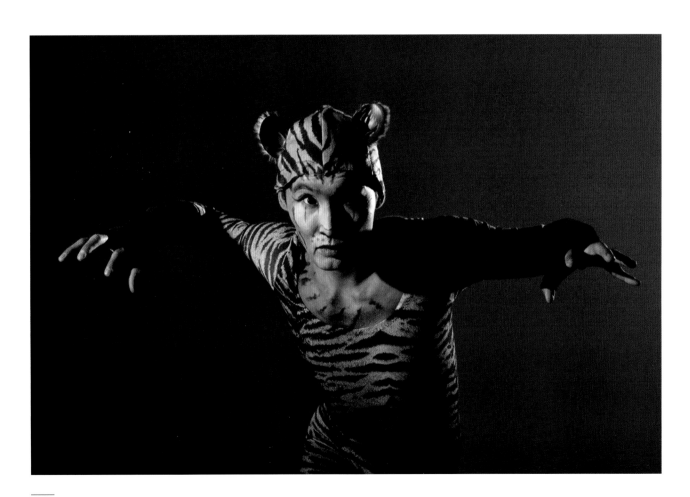

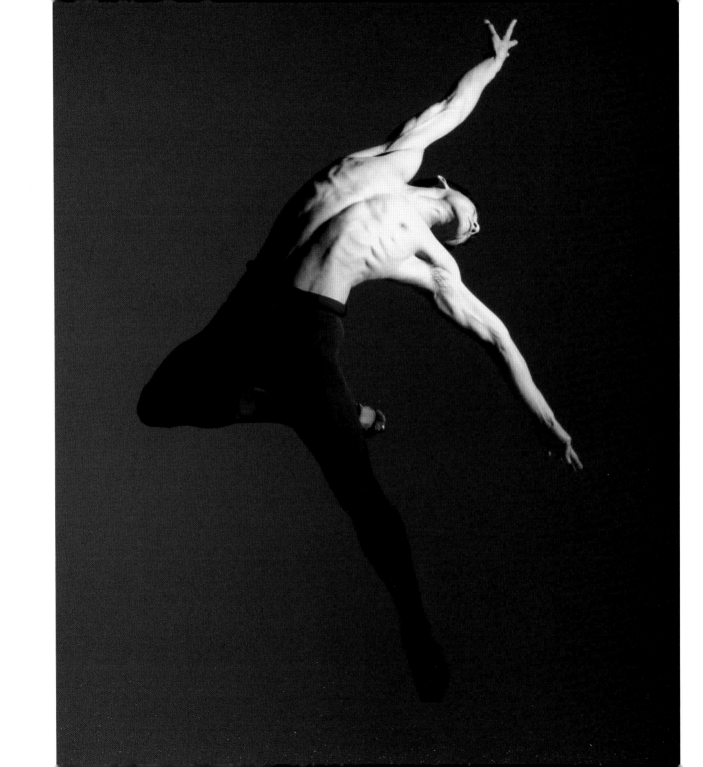

Yuan-Ming Chang
State Street Ballet

Ballet means everything
to me—like the air I breathe
and the sun that warms my soul.
Silvia Rotaru

State Street Ballet

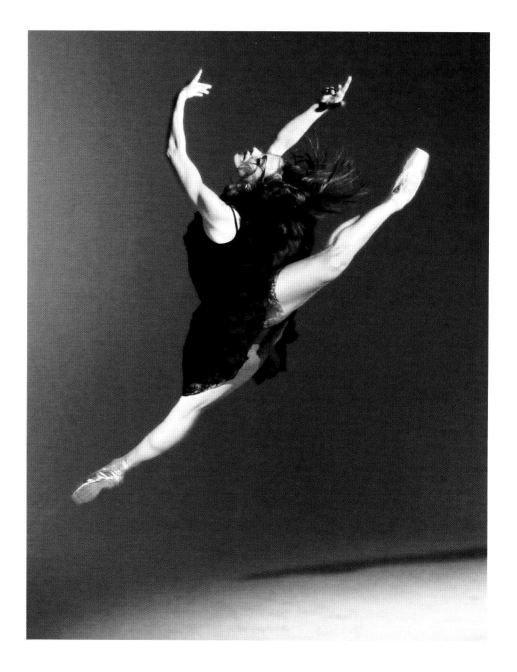

I feel ill before every performance. My stomach churns, my heart races, my palms sweat. But as soon as I step on the stage in front of an audience all that goes away. I become empowered— bold, confident, strong!

Alyson Mattoon

State Street Ballet

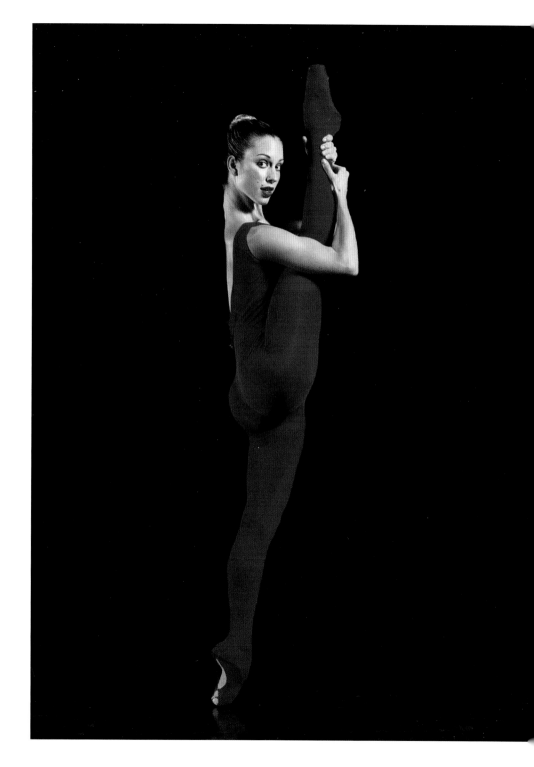

To move an audience
we have to be more than
just an instrument of the
dance. We have to become
the art form itself.
Silver Barkes
State Street Ballet

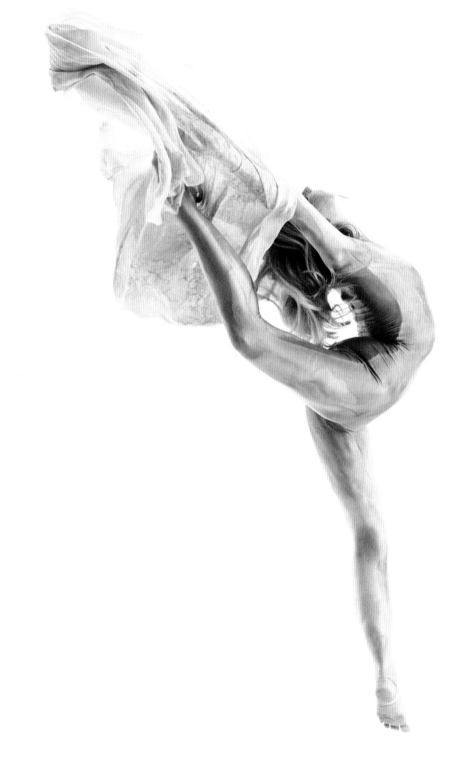

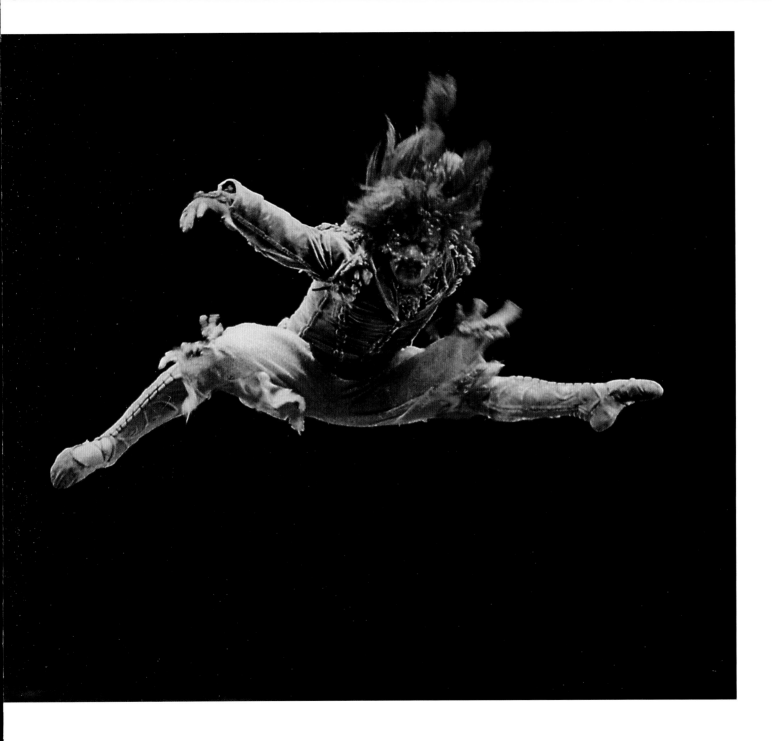

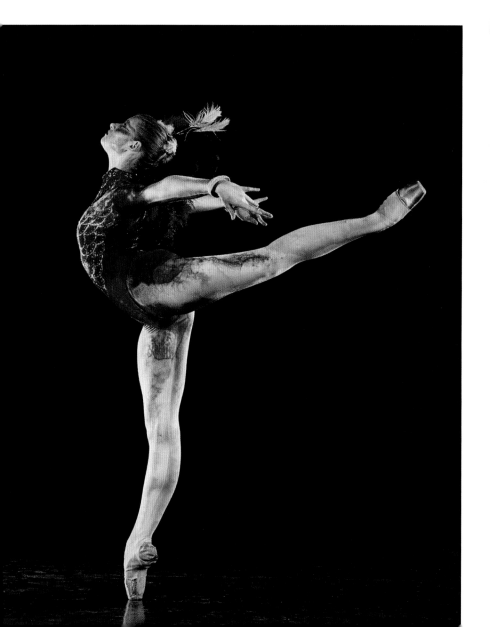

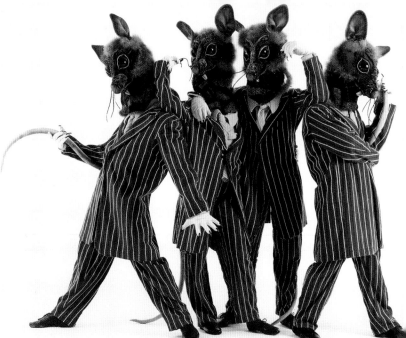

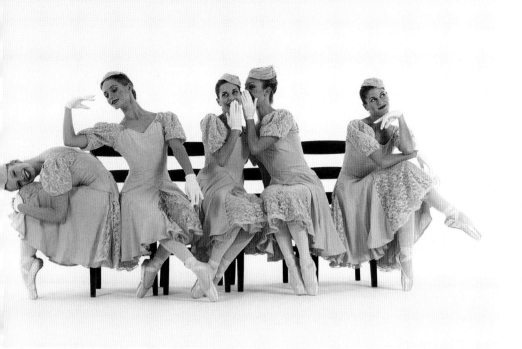

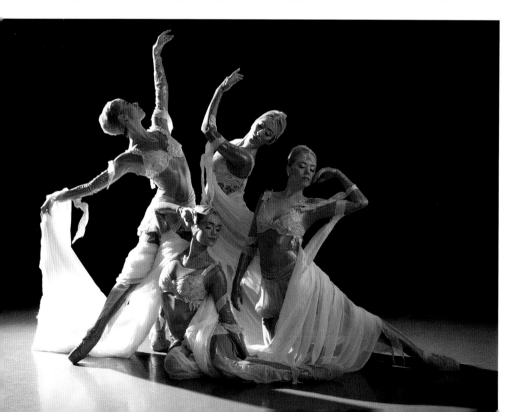

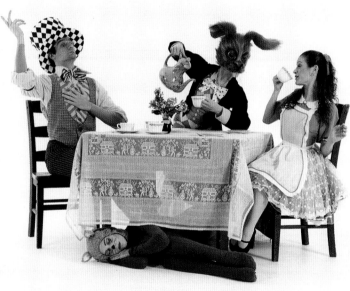

On stage, I am my truest self—
the person I want to reveal and
project out into the universe.
Leila Drake Fossek

State Street Ballet

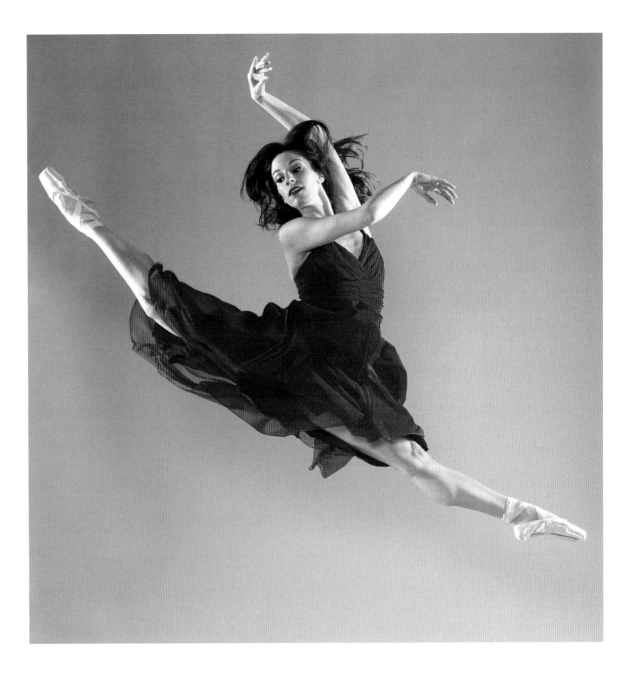

Lu Wang
State Street Ballet

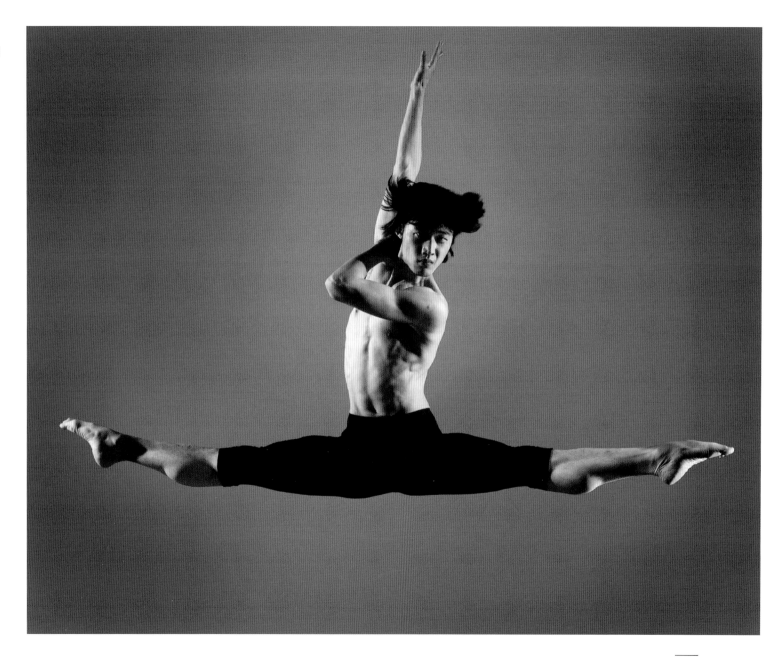

What my dancers and I try to do is talk about real life. I want to move people and inspire them to feel good about themselves. I want them to have the desire to have their spirits set free.
Ronald K. Brown

Evidence, A Dance Company

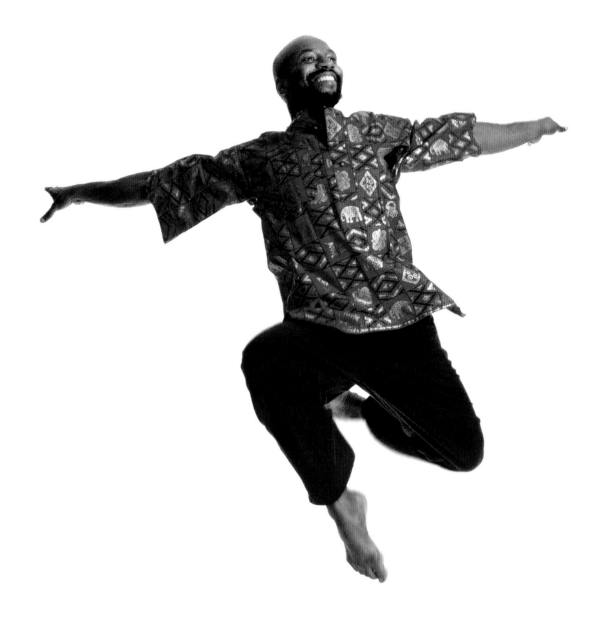

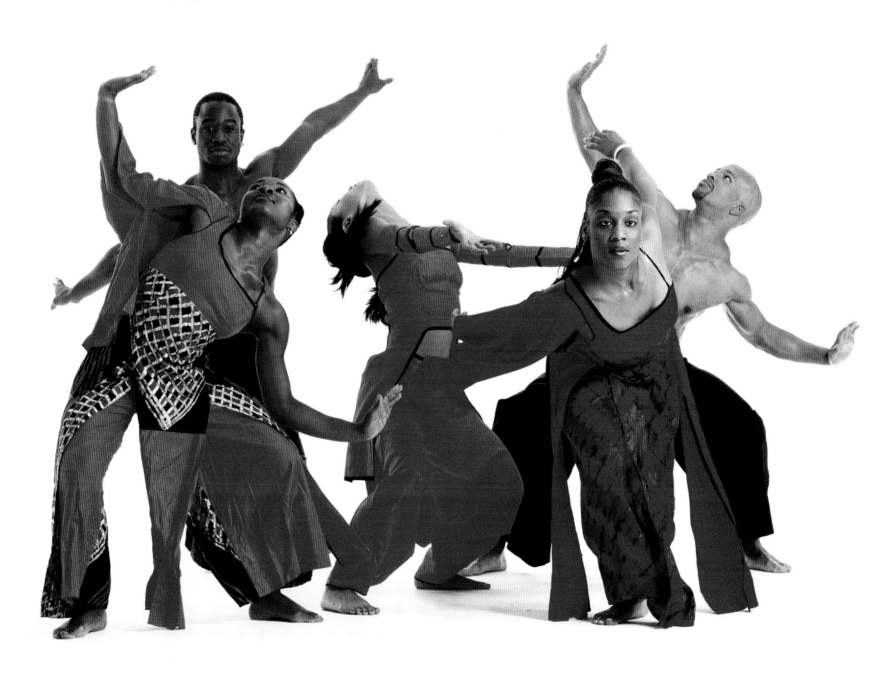

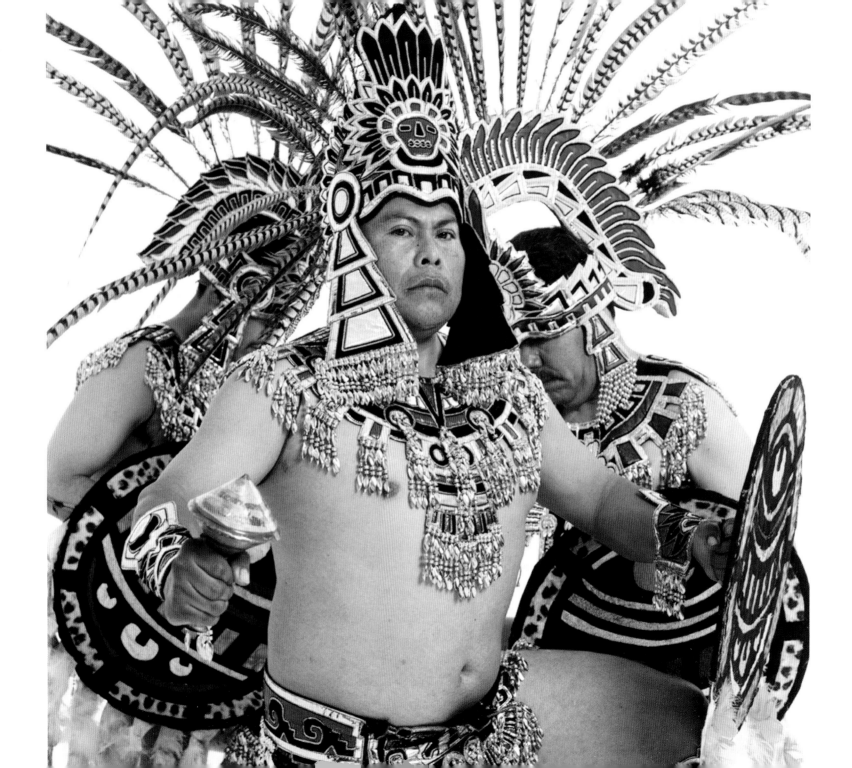

I have been a part of the history
of Mexican dance in California for
almost forty years. I have gone from
social activist to dancer, to dance teacher,
to dance artist, to choreographer.
I don't really know where one role ends
and the others begin. Maybe all of them
are very much still in me.
Gema Sandoval

Founder and Artistic Director,
Danza Floricanto

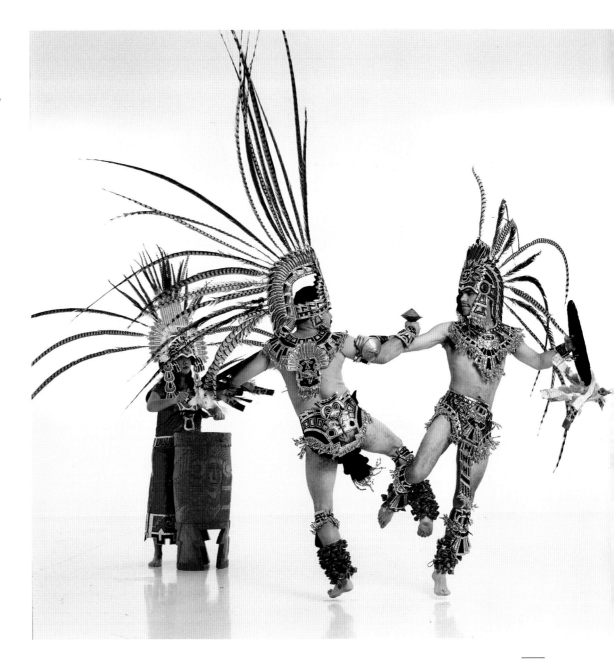

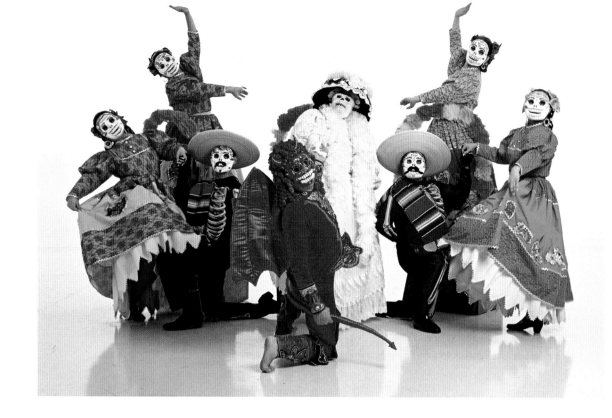

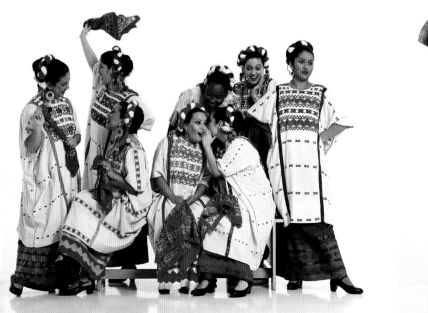

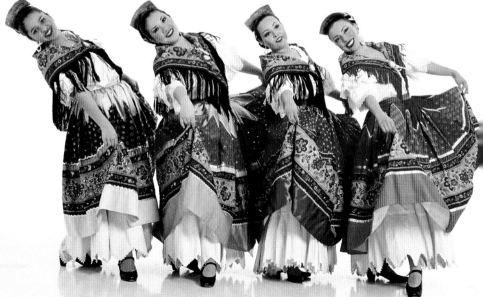

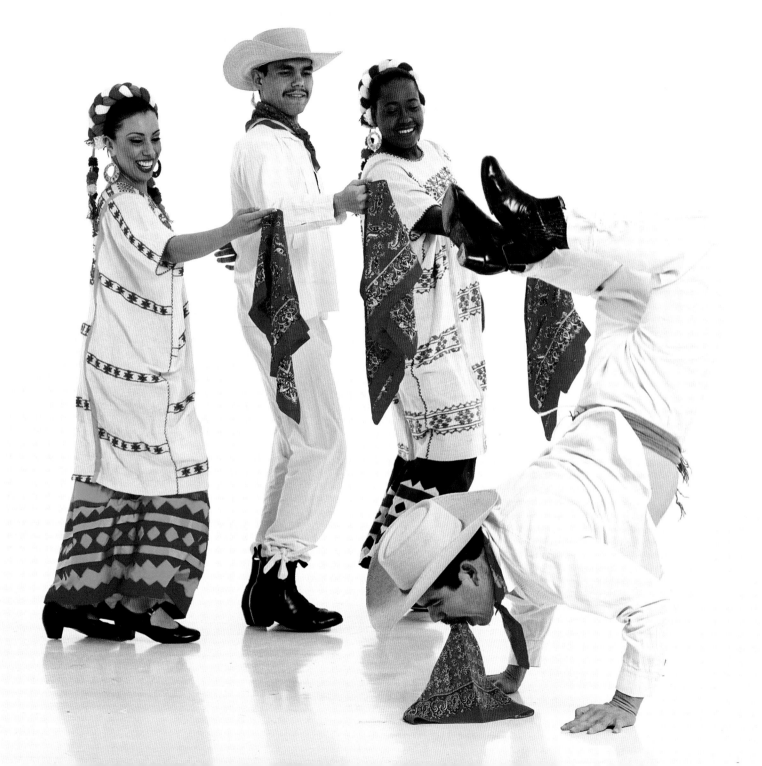

Once I felt the heat in my body, I could do anything. I felt such passion for the dance. I even performed when I was sick with fever because I felt the dance would heal me.
José Greco

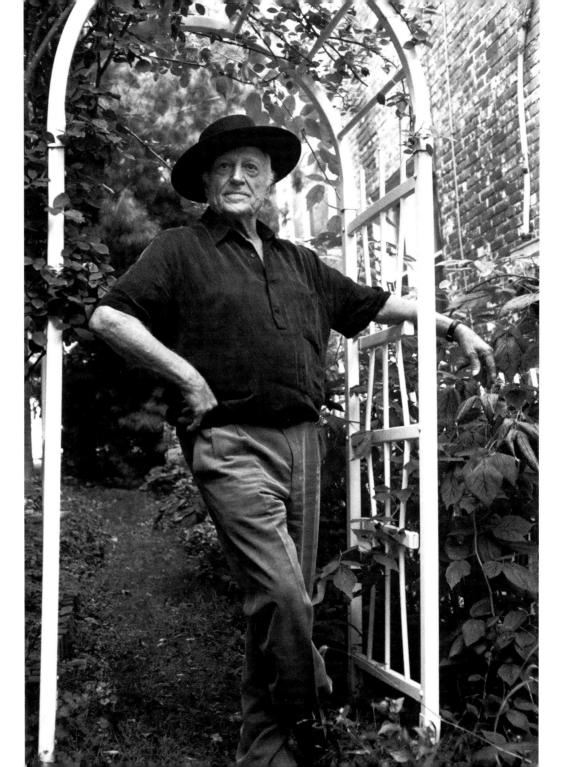

Before every performance
I feel a huge emotional weight—
the weight of my life. But once
I begin to move, the weight lightens
and lifts away.
Carmela Greco

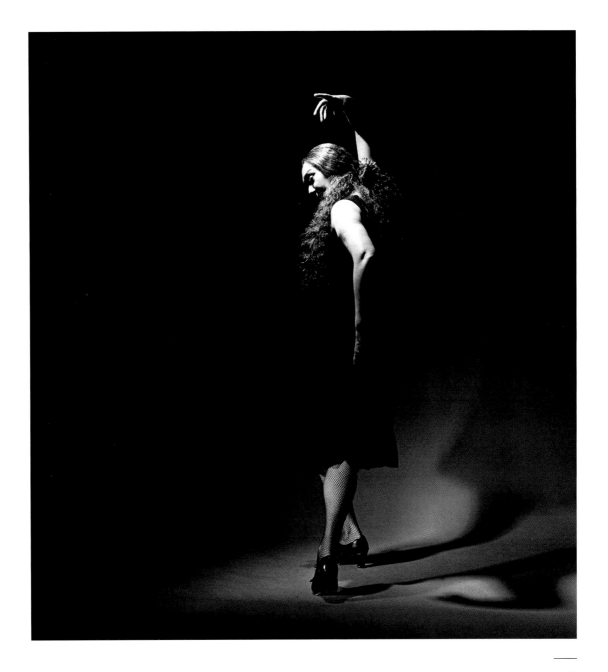

You usually don't know how your dancing affects people. But when someone comes up to you after a performance with tears in their eyes and says, "You touched my spirit, you touched my soul," that's when you know you've made a difference.

Matthew Rushing

Alvin Ailey American Dance Theater

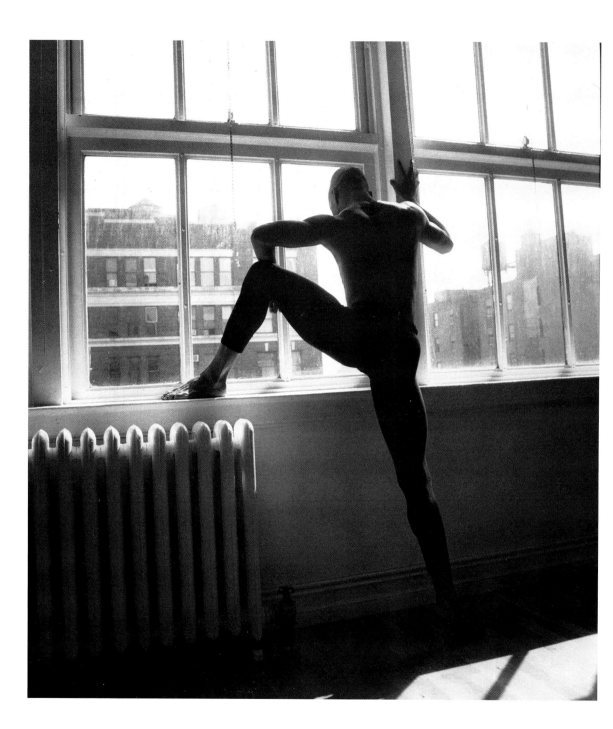

Nature is not a backdrop
to life but a dynamic influence.
When applied to movement it
leads to awareness, creativity,
and regeneration.
Anna Halprin

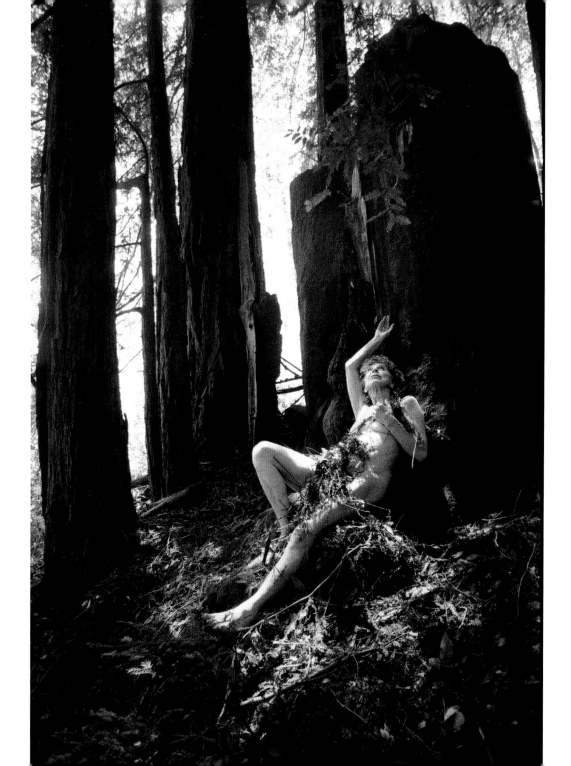

To me, the highest compliment
I could ever receive is to be called
a dancer. A dancer is someone
who is God-like.

Judith Jamison

Alvin Ailey American Dance Theater

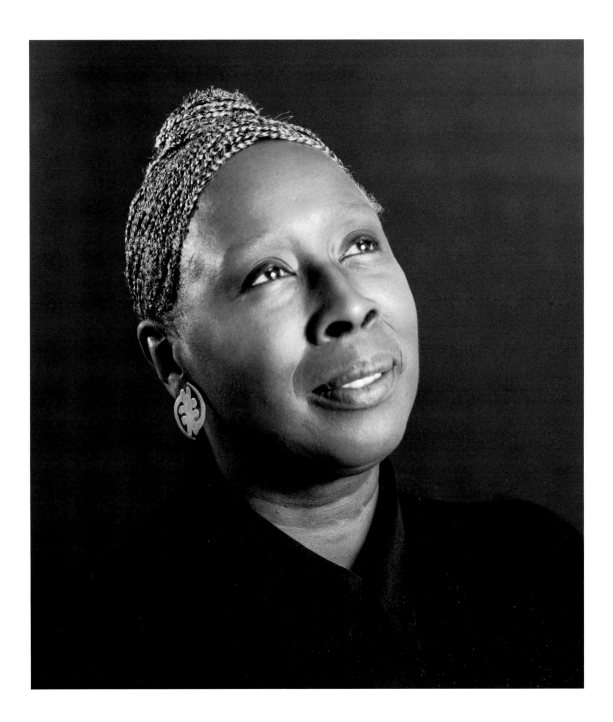

I do exactly what I want
and try not to lie too much.
Mark Morris
Mark Morris Dance Group

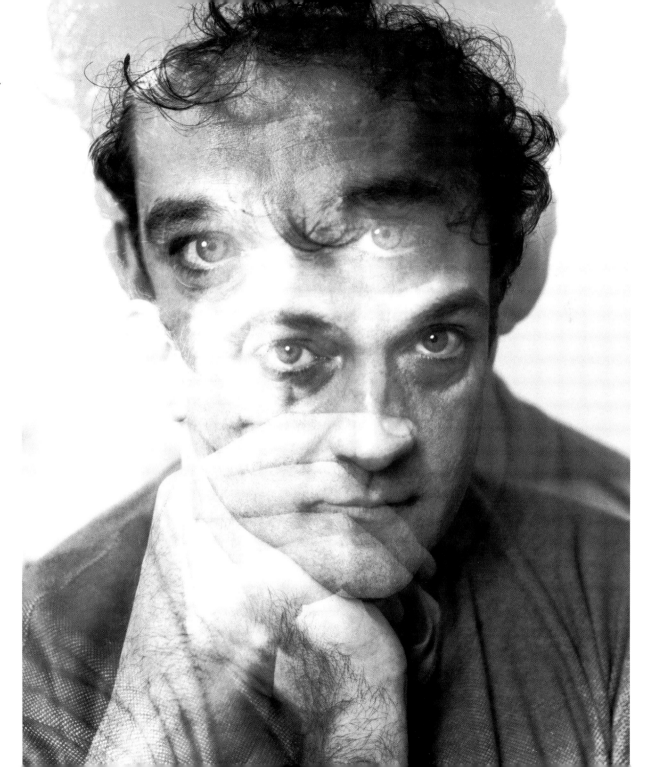

We have to know this body we're in. We might think of it as a shell. You fill that shell in a way no one else can.
Katherine Dunham

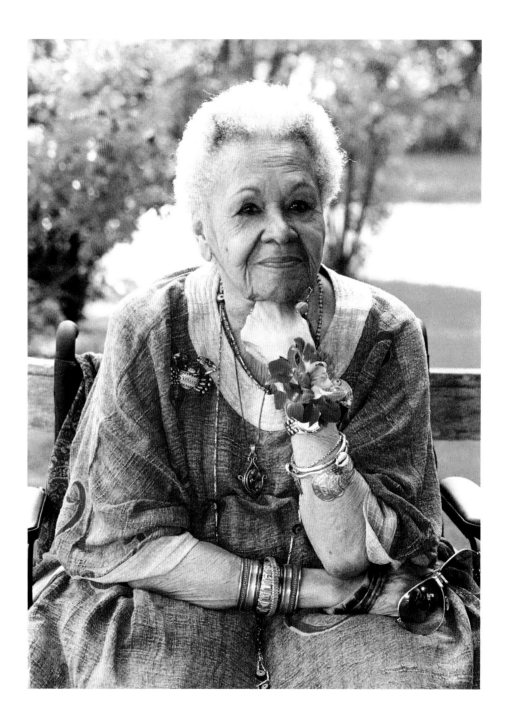

The artist should do what he feels he must and be as free as he dares to be.
Bill T. Jones

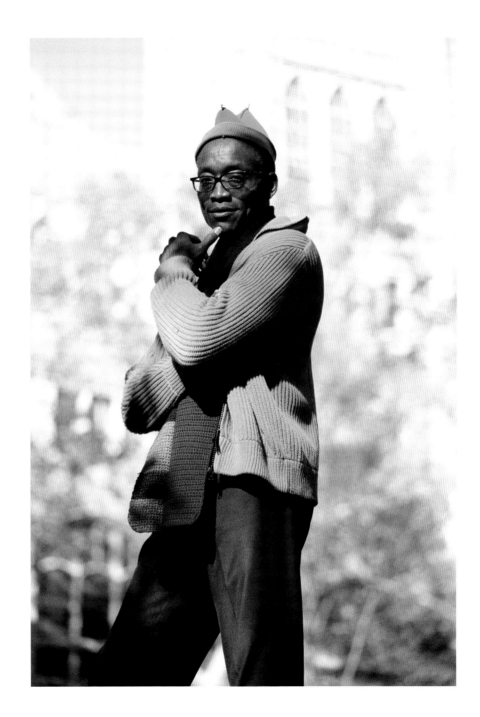

It doesn't matter how many pirouettes you own and how pretty you are. Usually the ones who get the role are the ones who do their homework, put their heart and soul into it, and want to serve.
Ann Reinking

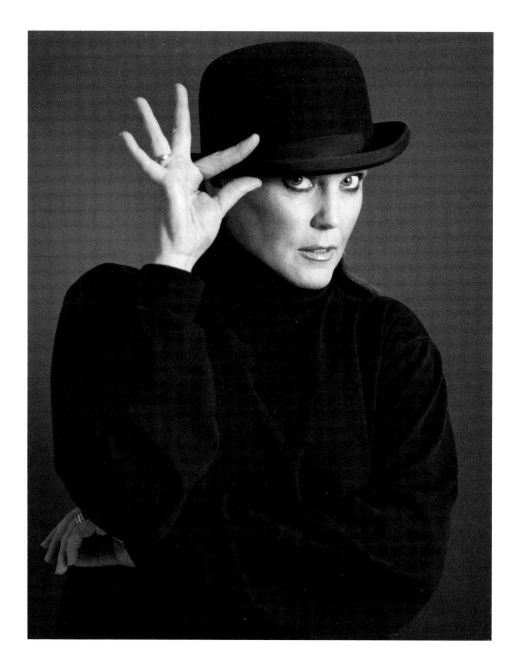

People often believe that it's angst and torment that inspires creative work, but for me it's love. Love is the most powerful source from which all creativity grows.
Tommy Tune

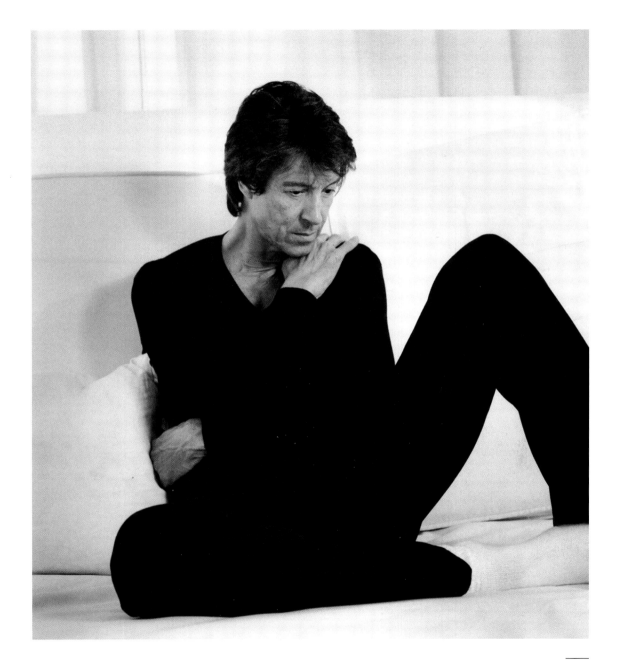

Dancers will do anything
they're asked. Dancers are
our artistic soldiers.
Shirley MacLaine

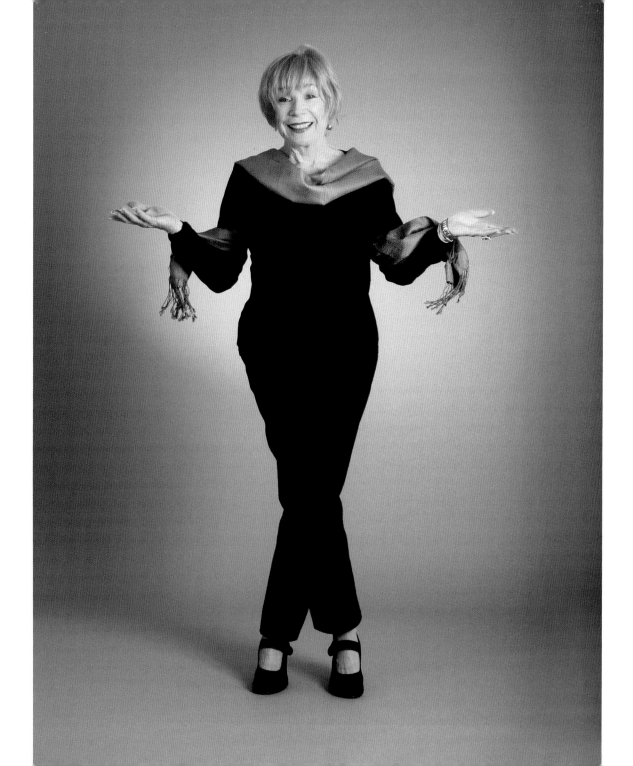

All I've ever wanted was
to touch that one person out
there in the dark.
Chita Rivera

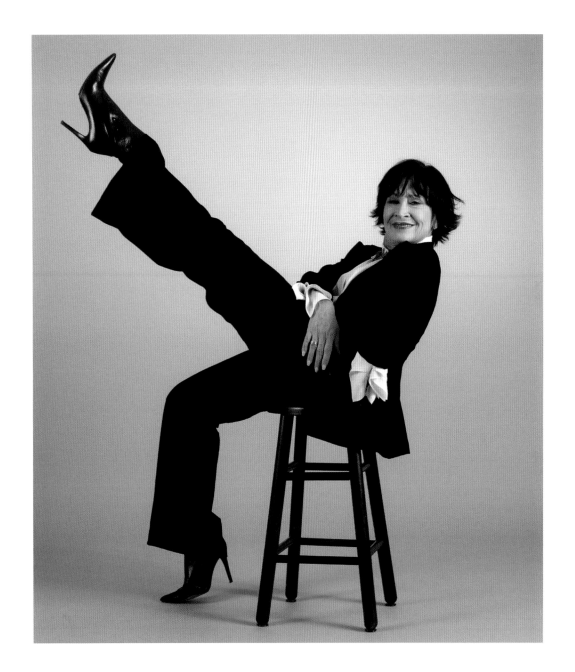

I was humbled by the power of dance and scared to death of it at the same time. For me it was life or death—everything or nothing!
Paula Kelly

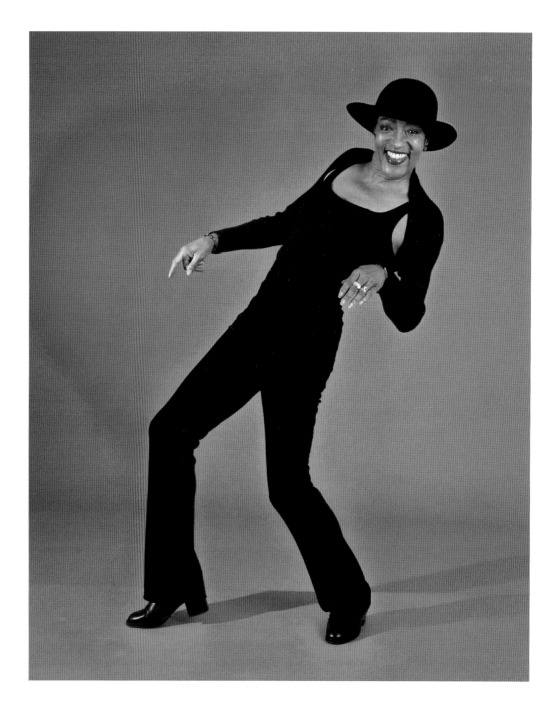

Bob Fosse showed me how to get inside my body, to slow down and focus. He taught me that it was never just about the steps but rather, why am I doing the steps and how do they make me feel?
Liza Minnelli

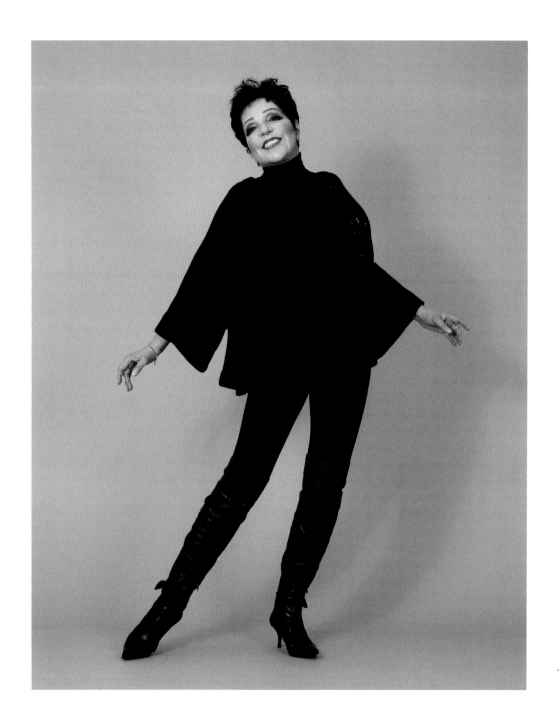

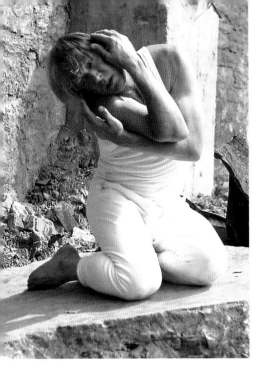

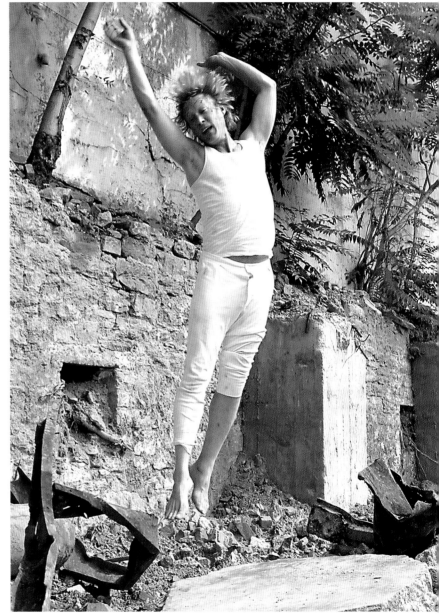

When you dance, your soul soars. Time does not exist. It can be centuries or just a second. It feels like there is no war in the world, no hate, no disease. It feels like anything you care to imagine.
Robert La Fosse

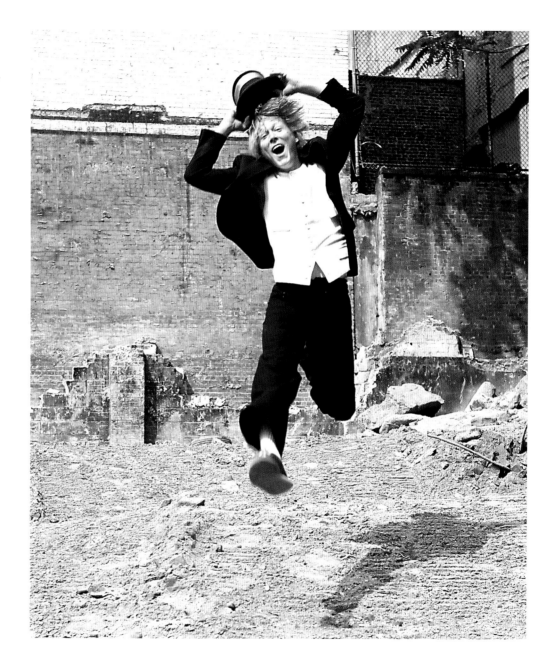

I was only twenty-three when I
found myself deeply conflicted—
become a movie star or prima
ballerina. I knew if I were to pursue
acting I would not be able to keep
up with my dance training. To be a
ballerina you have to be in top form
and possess a victorious attitude
toward every aspect of life. After
much soul searching I decided
to stop dancing. I gave away my
toe shoes and informed MGM
executives that I wouldn't dance
anymore. I was heartbroken.
Leslie Caron

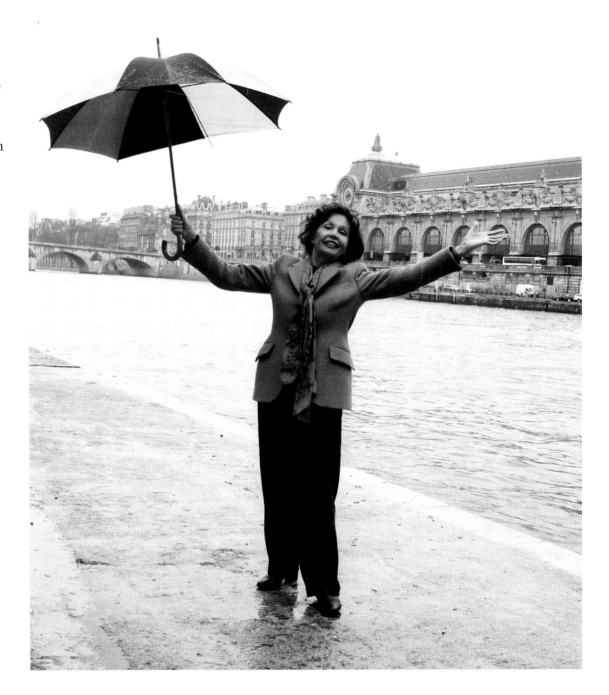

If there is no passion behind your movement, the audience will just sit there and watch you, but they won't be captivated by you.
Fernando Bujones

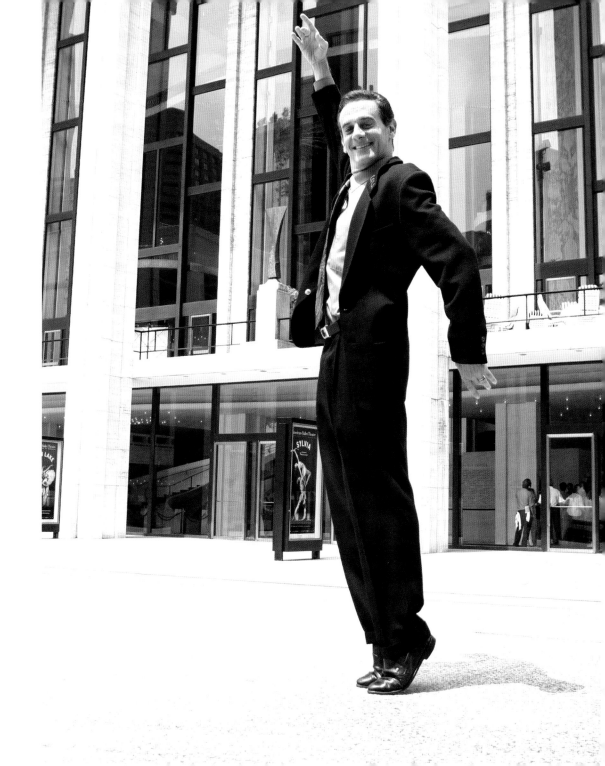

Dance is a spiritual
language we can use to feed
our souls, communicate
with each other, and show
respect for all peoples.
Cleo Parker Robinson

Cleo Parker Robinson
Dance Company

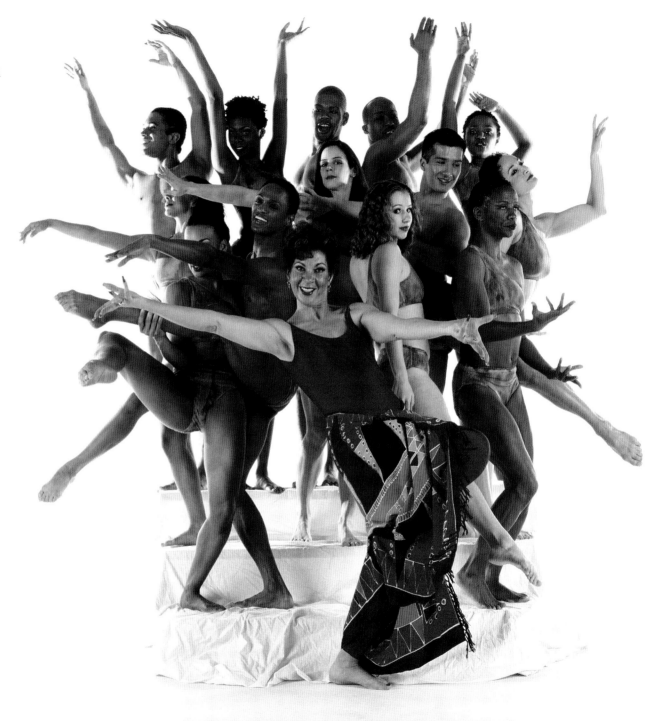

Cleo Parker Robinson Dance Company

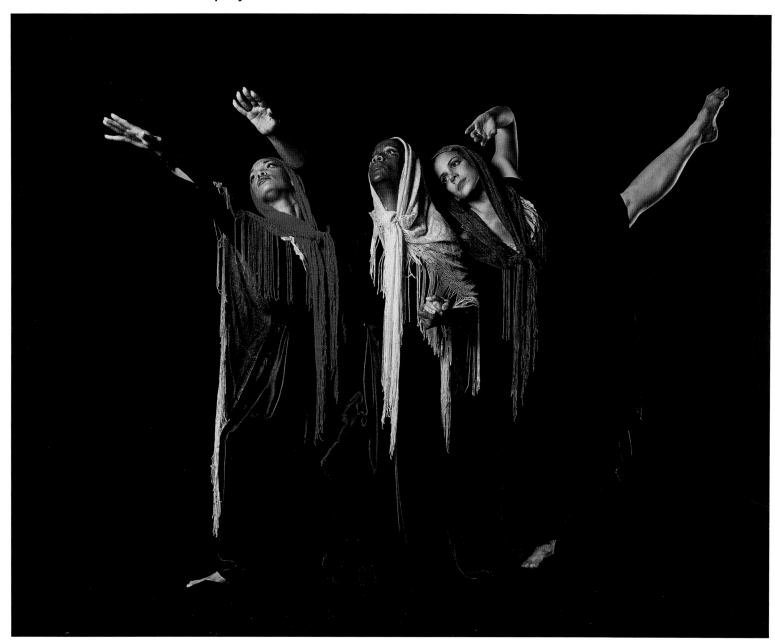

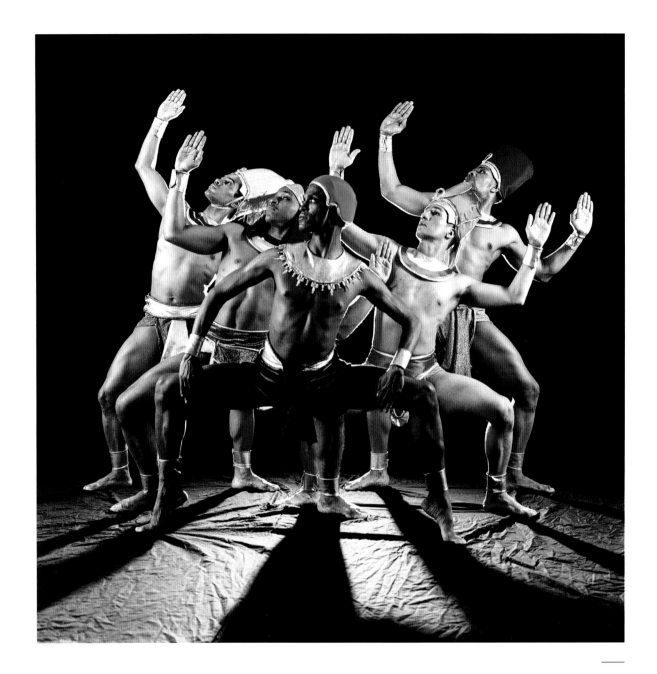

Art is created out of things you're reminded of. It's associative. Dance without reference is unlikely to evoke an emotional response.
Robby Barnett

Pilobolus

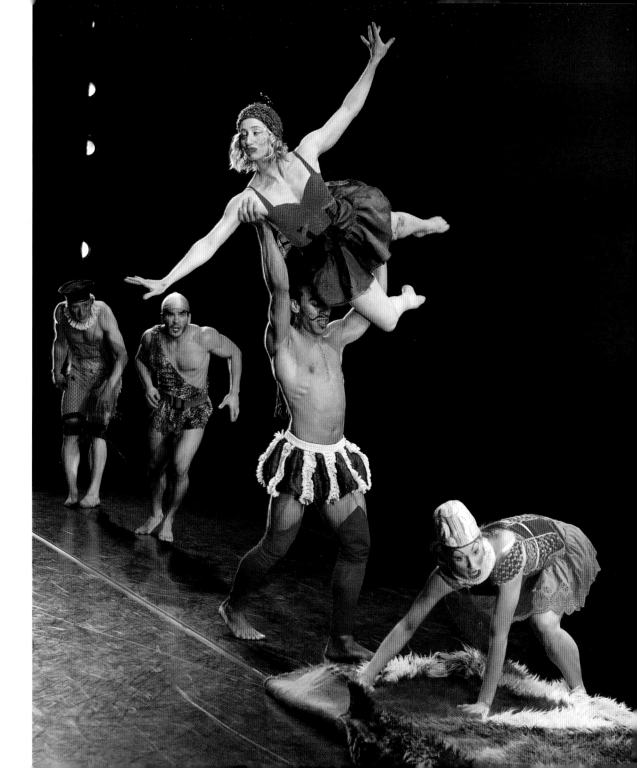

Dance is very much like language.
Its power is not in the meaning of
the words but rather in the syntax,
in the structure.
Édouard Lock

La La La Human Steps

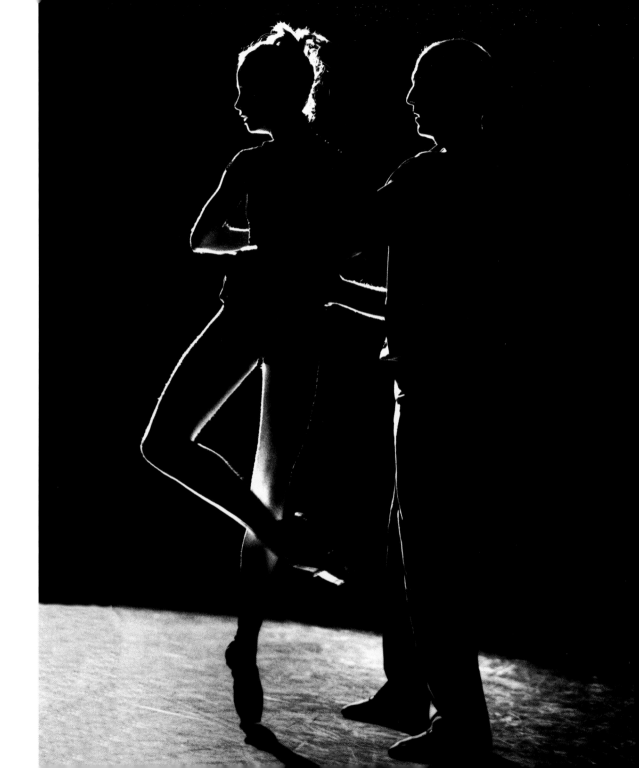

To dance the lead in a Graham ballet is to inhabit a world, to proceed on a journey, to experience emotions raw and unedited—and told from a female perspective. These roles capture and make visible the internal struggles of choice, secret knowledge, and inner dialogue. They reveal unspeakable information through movement.

Blakeley White-McGuire

Martha Graham Dance Company

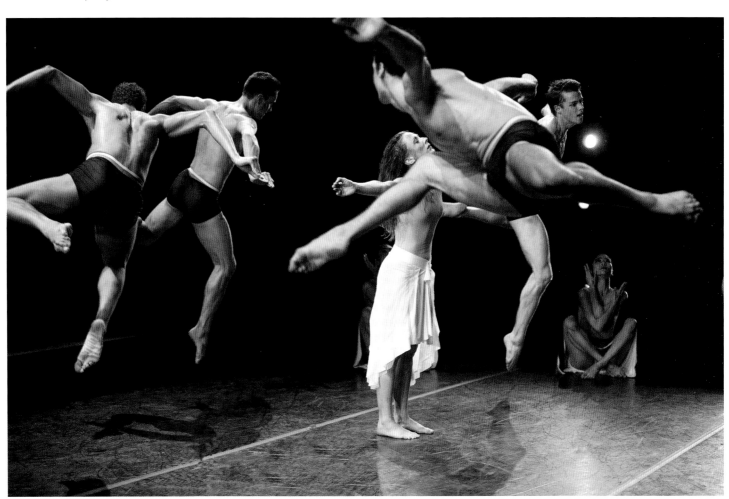

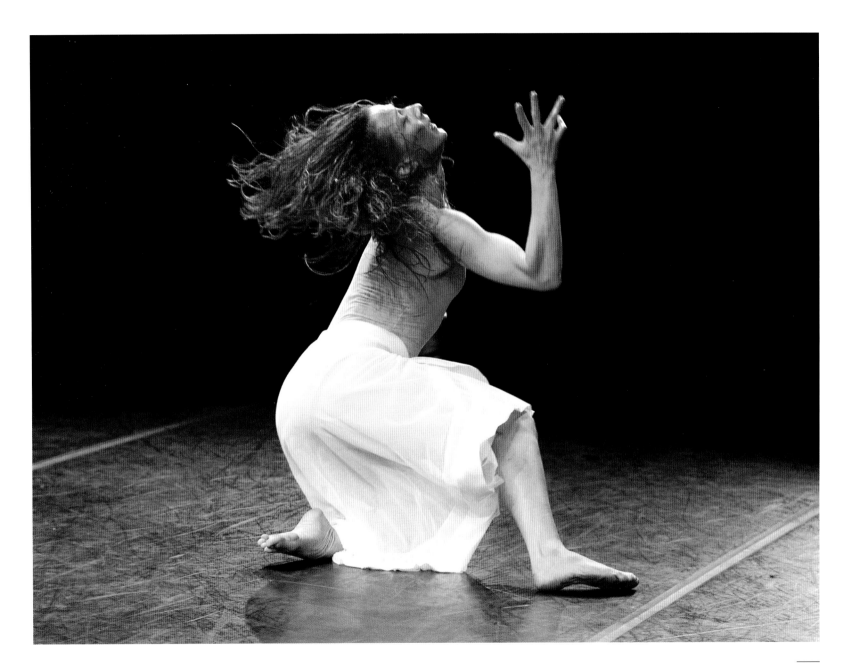

My identity as a dancer will never ever, ever, ever, be taken from me. It's who I am.
Michele Simmons

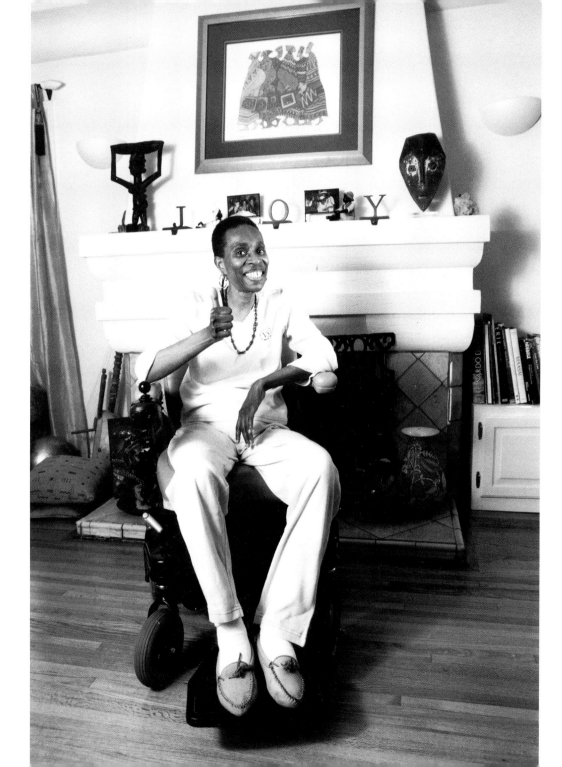

Hollywood was all about vodka and cigarettes back then, honey. We all smoked so we wouldn't be hungry and gain weight. Your dressing room was your home with its smell of sweat and cologne mixed with benzene. Benzene—that evil-smelling stuff that protected your feet from scrapes and blisters. And if you didn't have scrapes and blisters, you weren't really dancing.
Mitzi Gaynor

As a performer I didn't pay much attention to the audience. I was too busy dancing. When the curtain came down and there was all this applause, it really didn't matter much to me. I wasn't doing it for them. I was doing it for myself.
Paul Taylor
Paul Taylor Dance Company

I do not try to dance better than anyone else. I only try to dance better than myself.
Mikhail Baryshnikov

Dancing . . . naked . . . between heaven and earth . . . in the moment, exalted, at peace. One!
Rachael McDonald

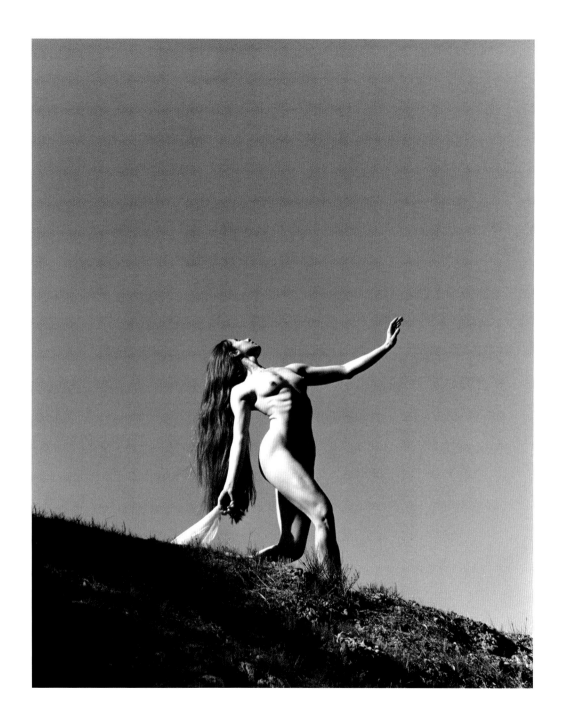

Look at what's happening in our world, in our century. Use your imagination and the human body to demonstrate life and the human condition. That's dance!

Yuriko

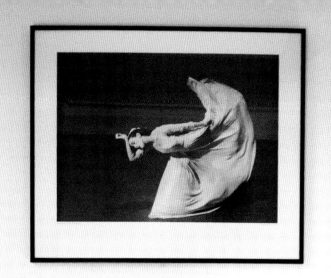

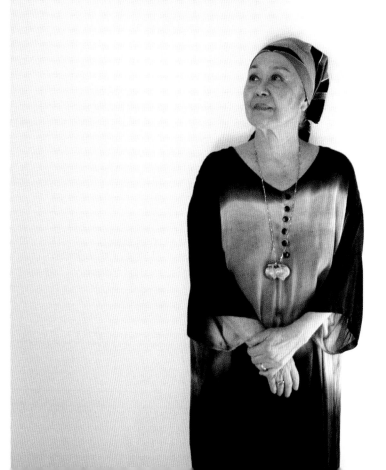

If you want to be a great dancer, first discover who you are as a person. Then integrate that into your dancing.
Cynthia Gregory

What does it feel like to communicate with an audience? First there is fear—this nervousness in the stomach. But something inside says, embrace the fear, for inside the fear there is courage. Soon there is no me, no them—only us.

Ben Vereen

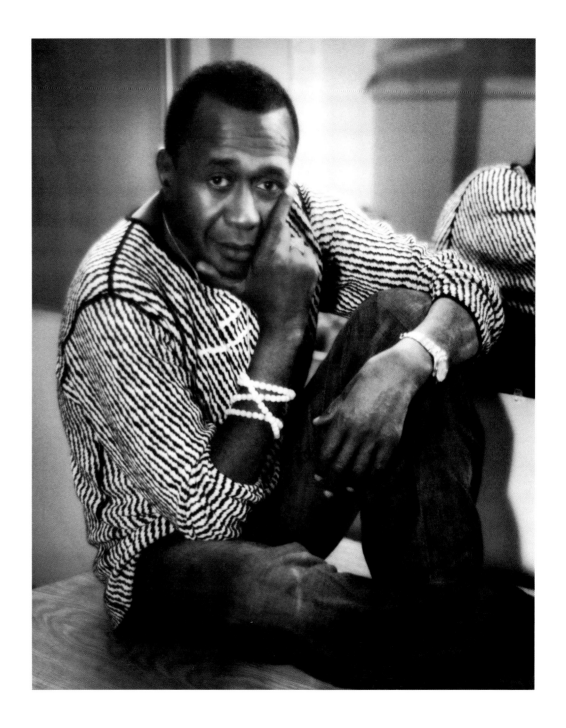

Be dedicated to your spirituality
as it will inform your art.
Francesca Harper

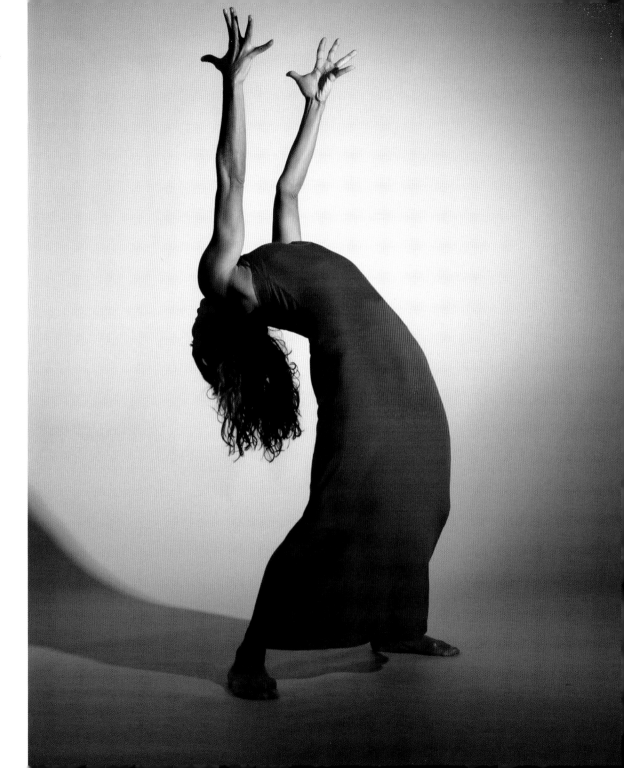

If you can't do it, don't do it. Why get on the stage and just hobble around? Don't give us some watered-down version of what you used to be.
Mary Hinkson

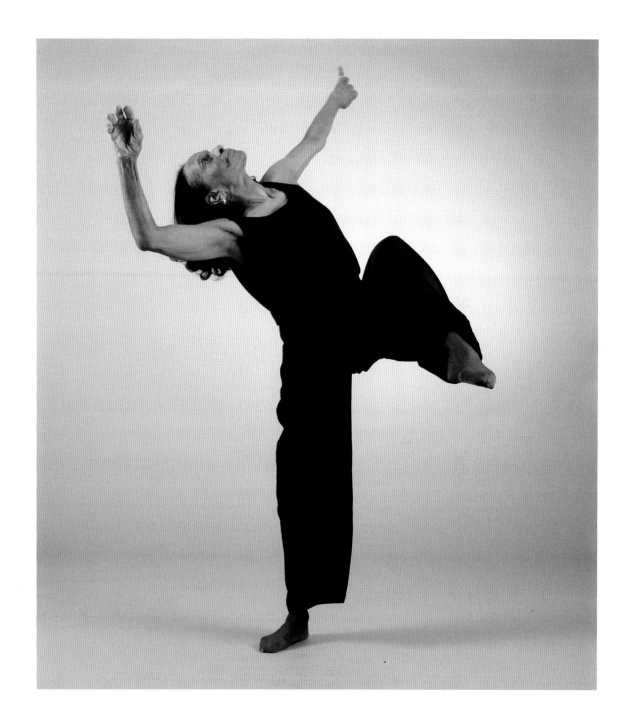

Dancers have always been infatuated with beauty.
Rasta Thomas

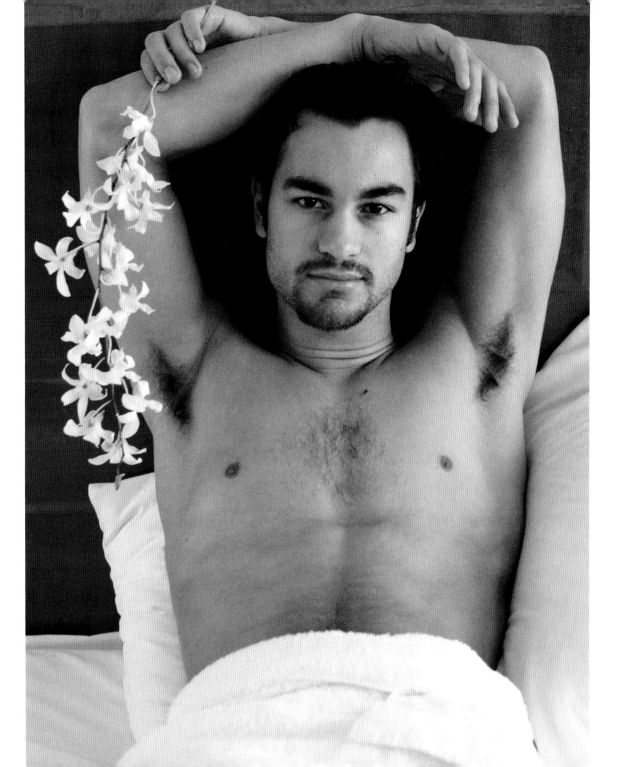

Everyone can do steps, but it is the interpretation of those steps that is the key to making magic.
Rasta Thomas

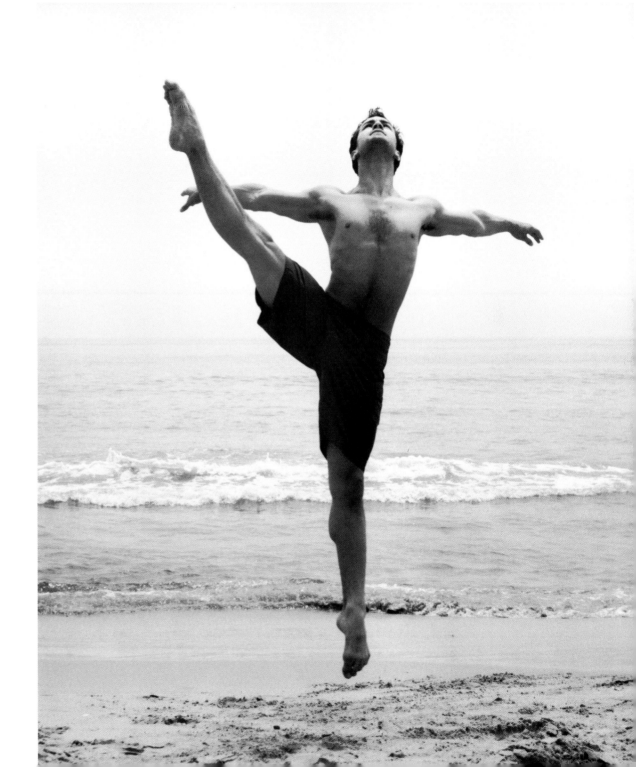

I came to Hollywood with the dream of dancing on the stage. I went to many auditions where you had to fight your way to the front of the room just so you could see the combination in order to learn it. And then, you had to learn it very quickly and perform it better than everyone else.
Marine Jahan

I need to dance. I need to perform.
If I don't continue as a dancer, who
am I as a person?
Jean Butler

What keeps me going is the possibility for greatness. It's not about vanity; it's about testing the limits of humanity—being a vessel to reach great heights and inspire others to do so as well.

Ethan Stiefel

I can't think of anything I love more than the challenge of getting inside a choreographer's head, bringing his vision to life and creating a dialogue that can be shared with an audience.
Dudley Williams

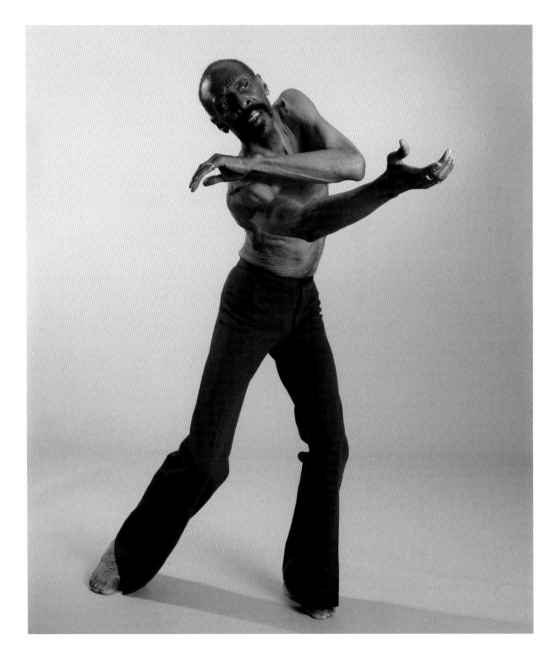

Dancers are self-absorbed
and they have to be.
Susan Jaffe

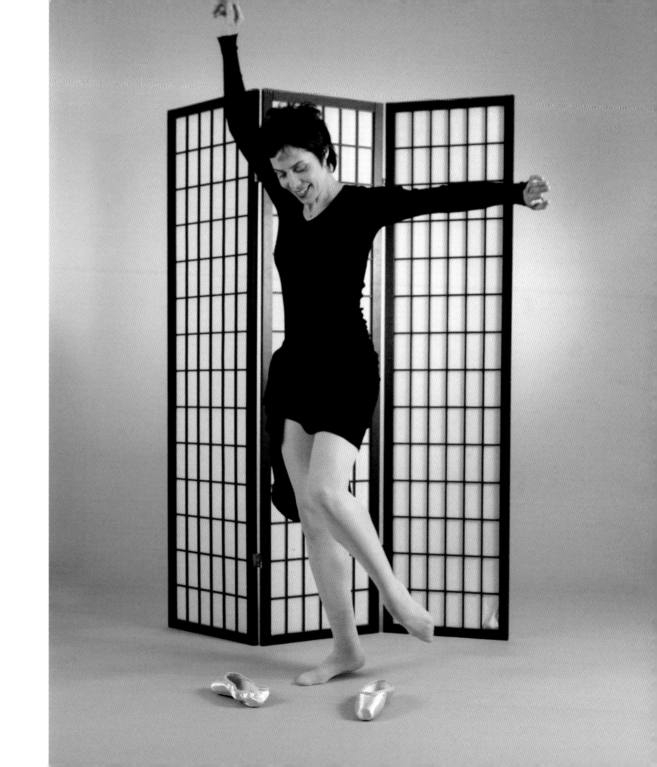

The sound of your taps is like the tone of your voice. Young as they are, each of these dancers has begun to develop their own signature sound. In time, their flaps, time steps, and shuffles will define them.

Lynn Dally
Artistic Director,
Jazz Tap Ensemble

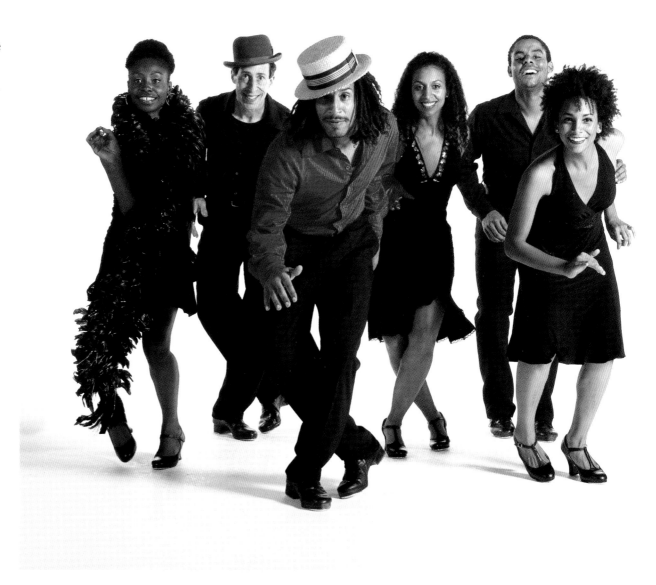

Tap dance gives me the freedom and the power to express who I am as a woman with infinite possibilities—rhythmically, stylistically, emotionally, and beyond!
**Chloe Arnold
with Phillip Attmore**

I am my most honest when
I'm dancing. No one can own
my thoughts, or my actions, or
tell me how to feel.
Jason Samuels Smith

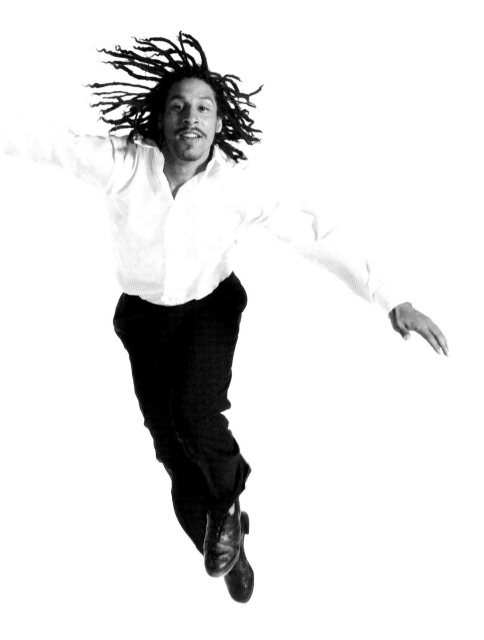

Improvisation is one of the most honest forms of self expression that there is because it renders you bare, exposed, vulnerable, and transparent.
Josette Wiggan-Freund

**Chloe Arnold,
Josette Wiggan-Freund,
and Maya Guice**

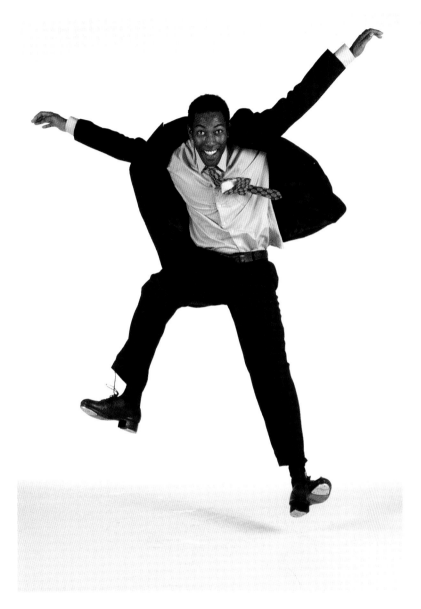

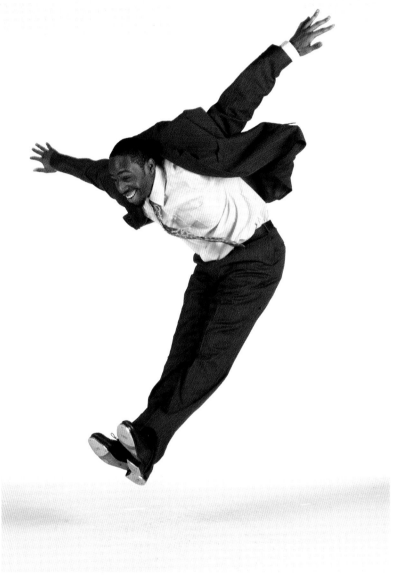

Kenji Igus

B'jon Carter

I tap dance because of the thrill of its improvisation, the complexity of its music, and to show its endless possibilities. I tap dance to simultaneously lose myself and be myself.

Michelle Dorrance
with Josette Wiggan-Freund

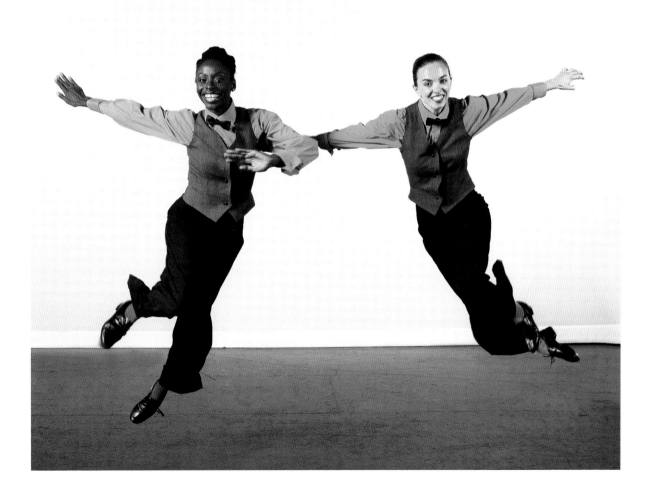

The essence of Isadora strips away
artifice to reveal one's authentic self.
Lori Belilove

*Lori Belilove and the
Isadora Duncan Dance Company*

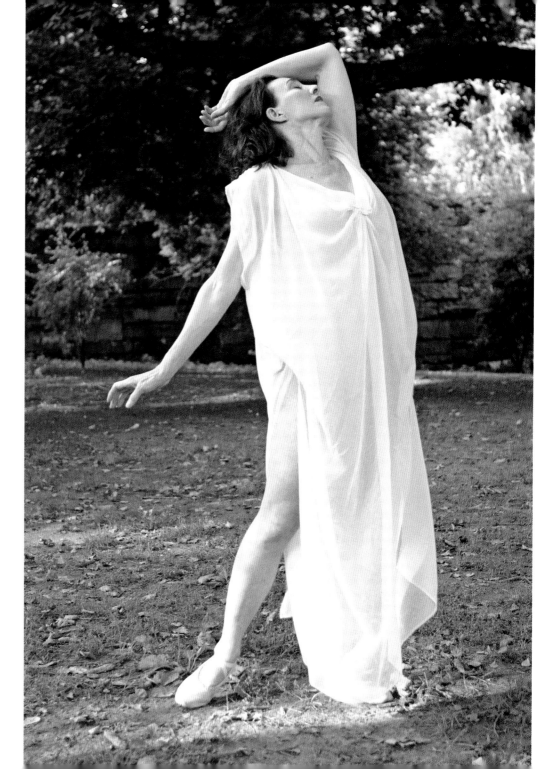

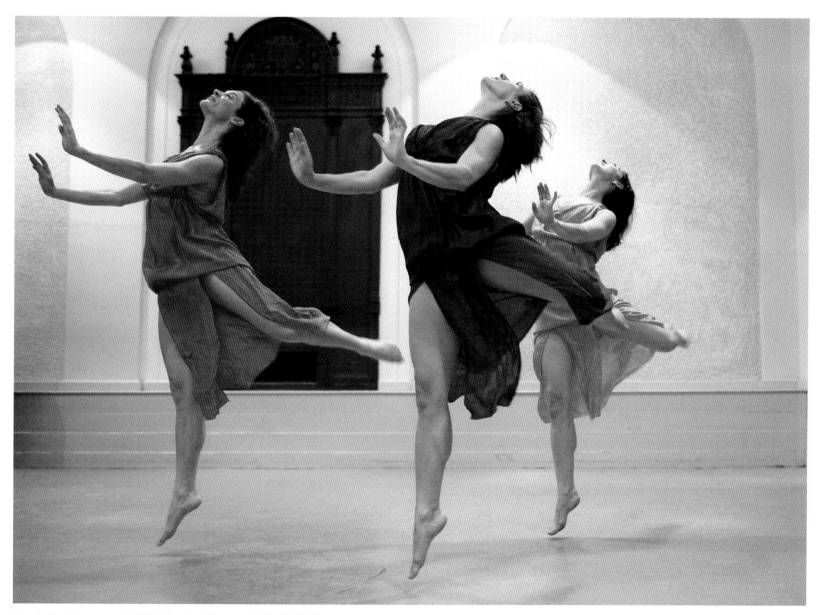

Danielle Kwozko, Faith Kimberling, and Beth Disharoon

I don't think most people really know what an artist is. You only know when you become one—when you find your true voice and see the world differently.
Russ Tamblyn

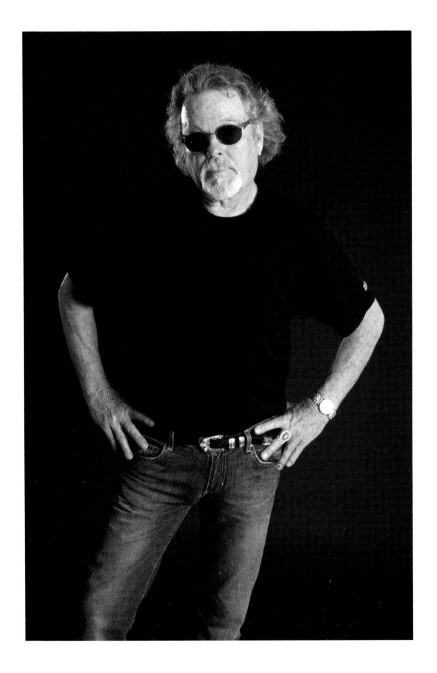

Moments before a live performance my hands turn to ice and my knees literally knock. That's how terrified I get. I ask myself, "Why are you doing this? Why are you torturing yourself?" I do it because I must. I simply must. And the terror that I feel comes from wanting to be perfect.

Rita Moreno

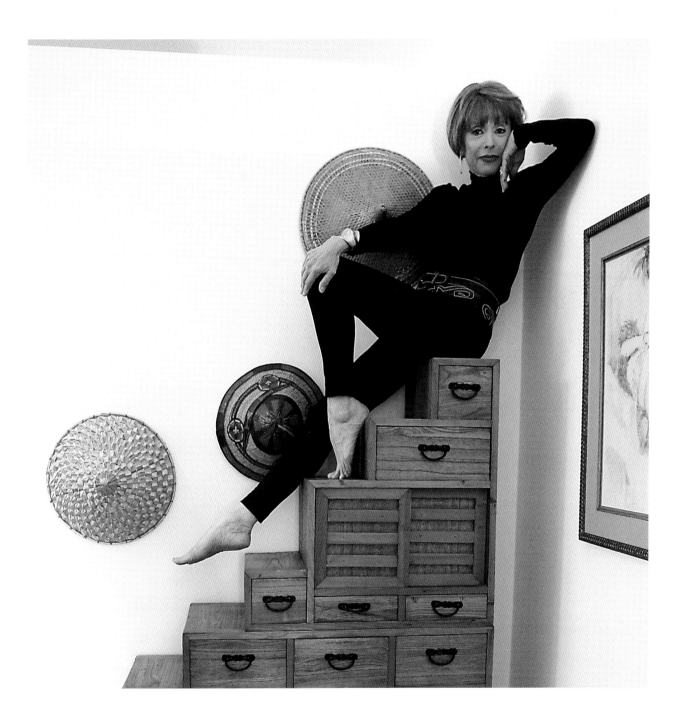

Dance is my destiny.
It's really all I know how
to do. It's the only
constant in my life.
Mia Michaels

When the applause stops, you go to your dressing room, remove your makeup, take a shower, and go home. Then the loneliness sets in. Even when you go home to someone you love and they ask, "How'd it go?" You tell them, "It was great." But the feeling is already evaporating. The whole thing is so fleeting, so totally temporary.
Peter Boal

New York City Ballet

Dance is transformation! You spend your entire life trying to elevate an audience to another level. You also spend your entire life afraid you might not.
Carmen de Lavallade

With gesture, movement, and energy you can say so much, express your deepest emotions and thoughts, more so than if you wrote a book. Movement is not corrupted by words and their various definitions. Words require the brain for interpretation, but movement is experienced with the heart.

Ivan Putrov

Royal Ballet of London

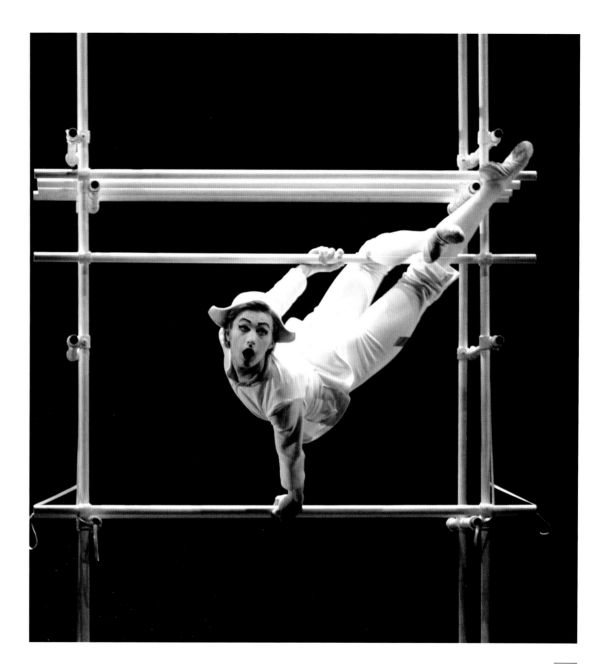

It's only when you're willing to show yourself openly as an artist that you truly begin to share with others. You don't need to give it all up—expose yourself entirely—but it's the realism that makes your work accessible.
Desmond Richardson

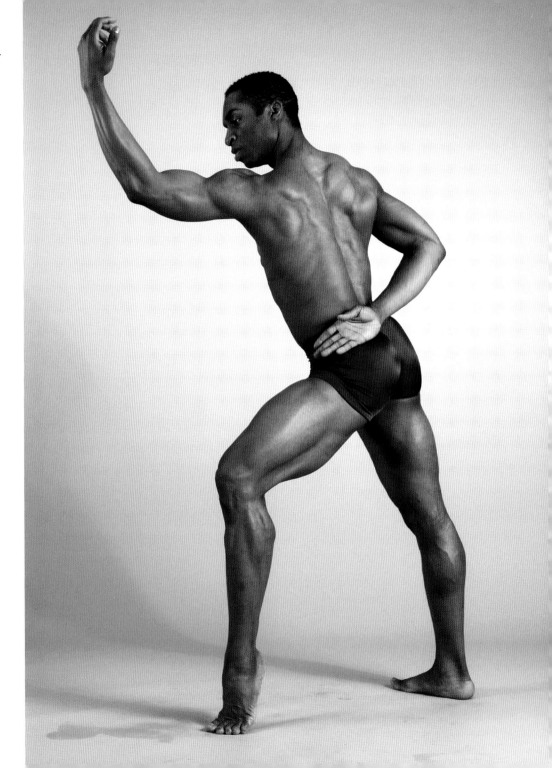

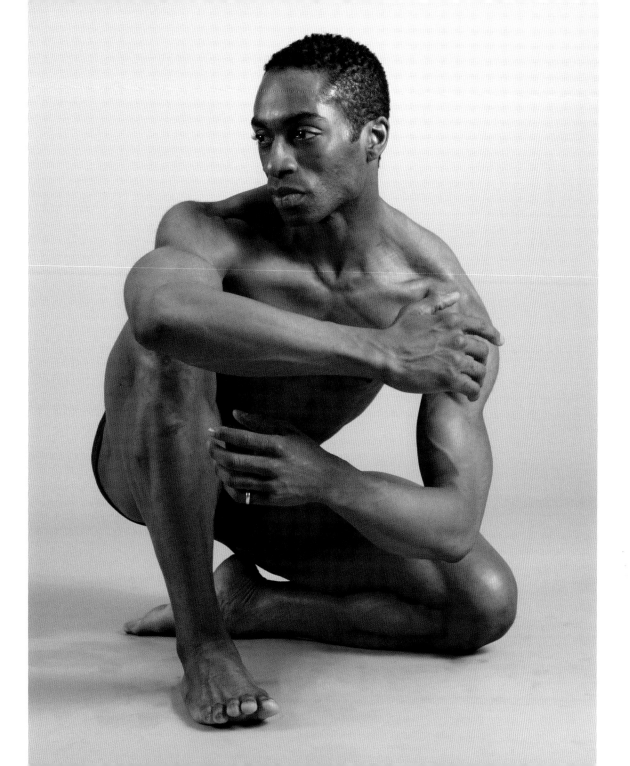

I'm not interested in how people move. I'm interested in what makes them move.

Pina Bausch

Tanztheater Wuppertal Pina Bausch

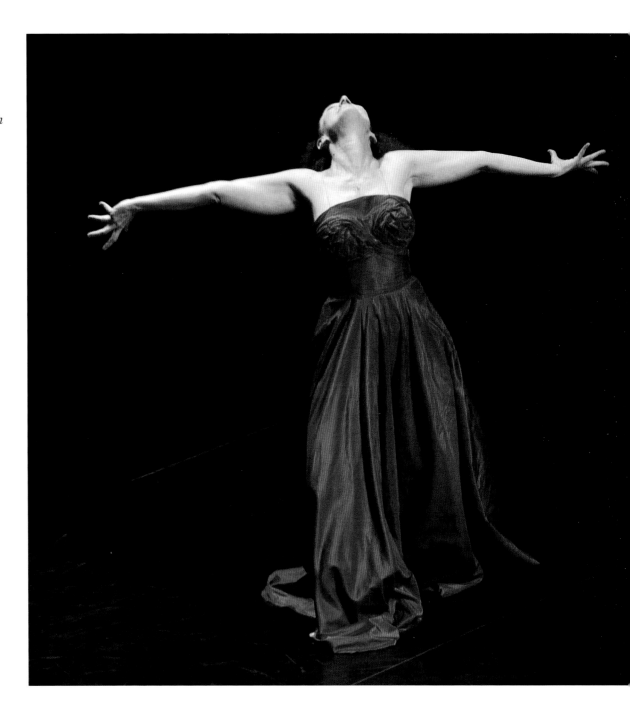

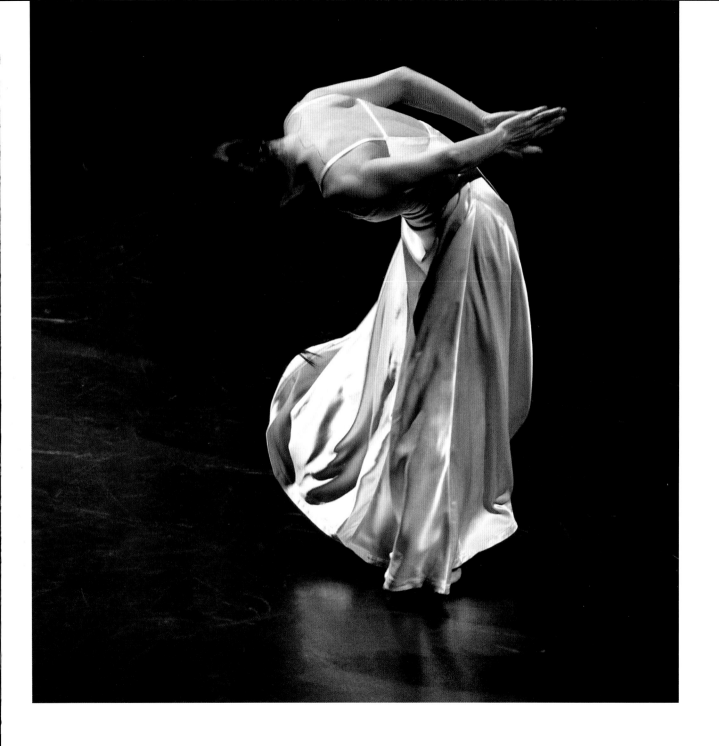

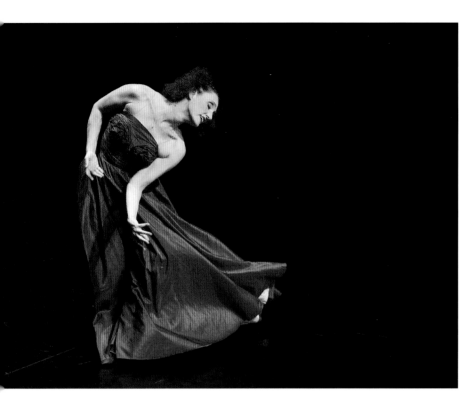

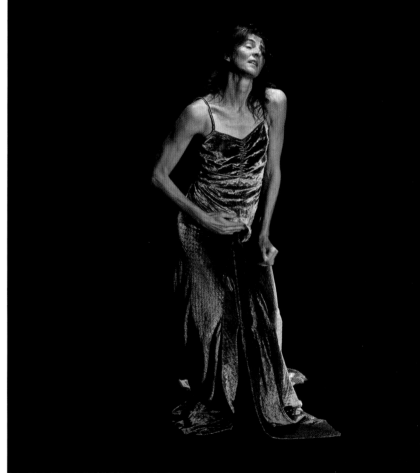

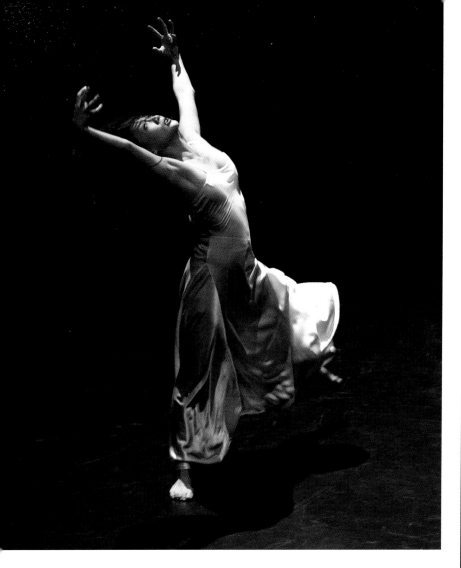
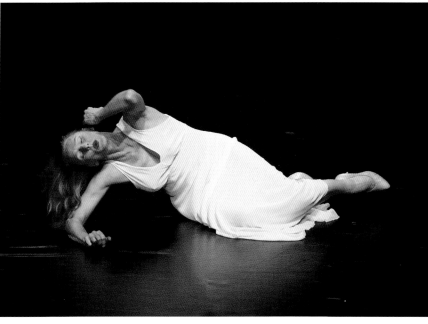

I dance and create dances to explore what it means to be the sensuous woman, the nurturing woman, the businesswoman, the warrior-woman. Look for experiences that are going to help you gain a sense of your own power.
Jawole Willa Jo Zollar

Urban Bush Women

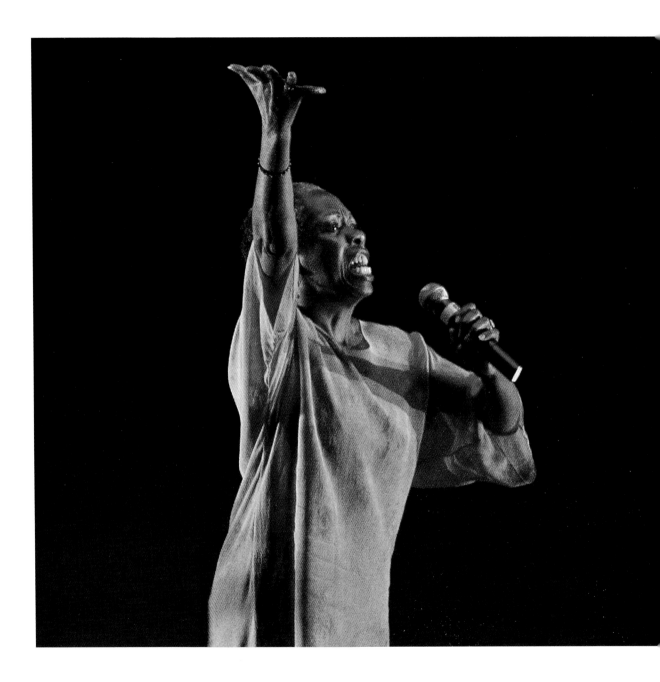

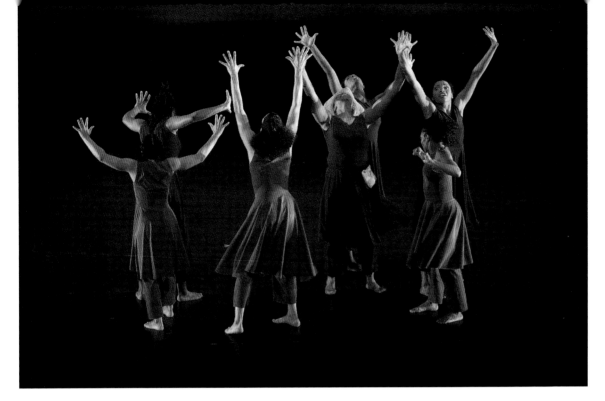
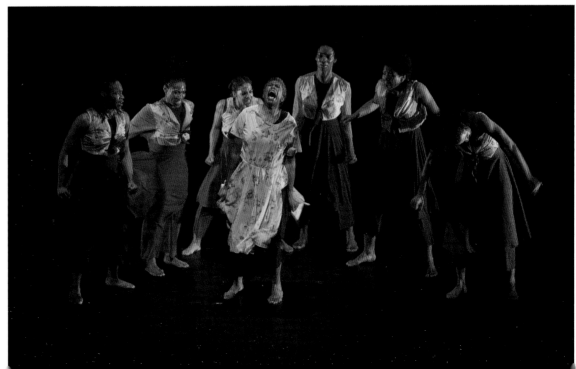

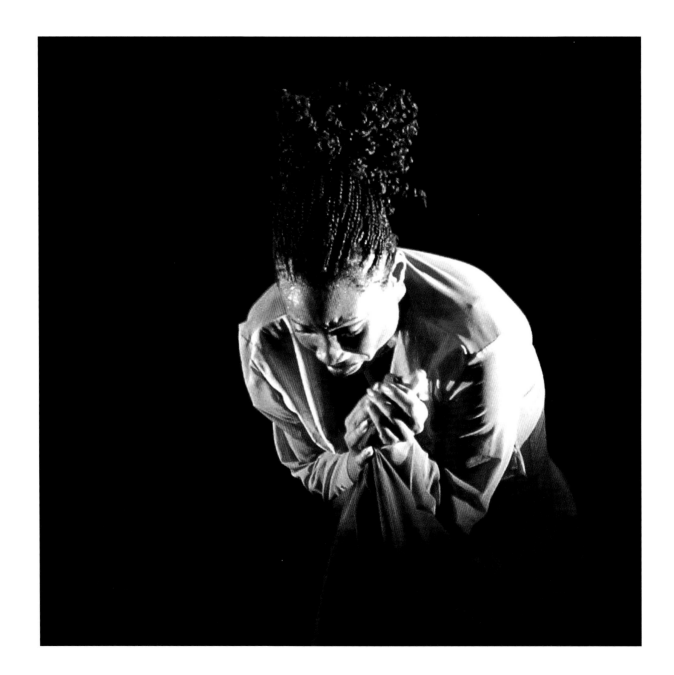

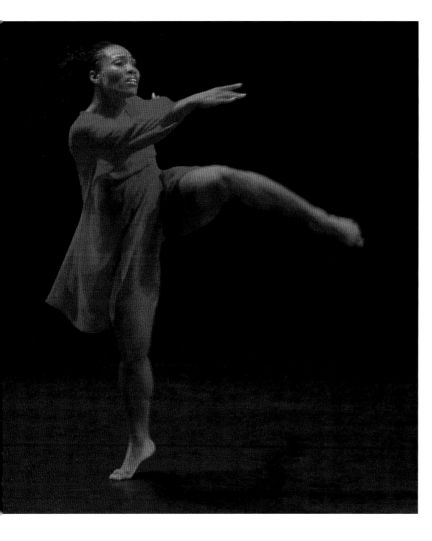

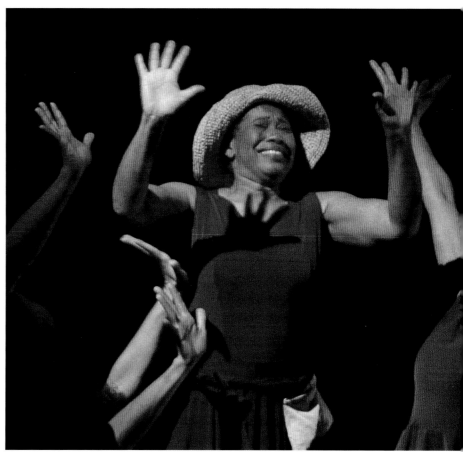

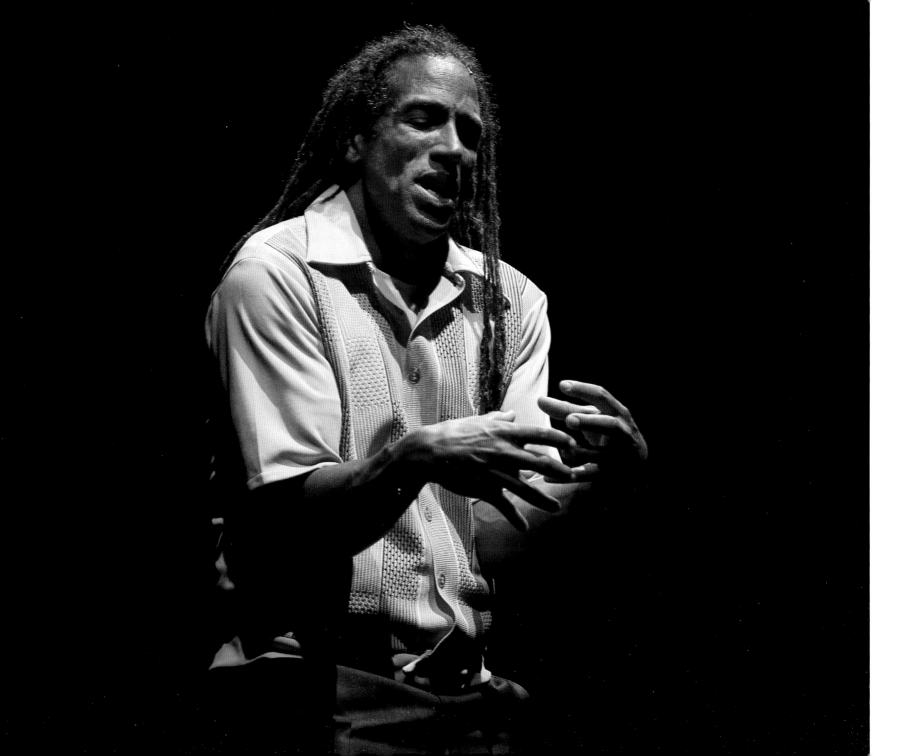

Dance is about the excavation and
communication of ideas that reside
at the deepest level of the soul.
David Roussève

David Roussève/Reality

Butoh is a dance of being, a dance of transformation and cathartic release—a dance of oneness with all things.
Don McLeod

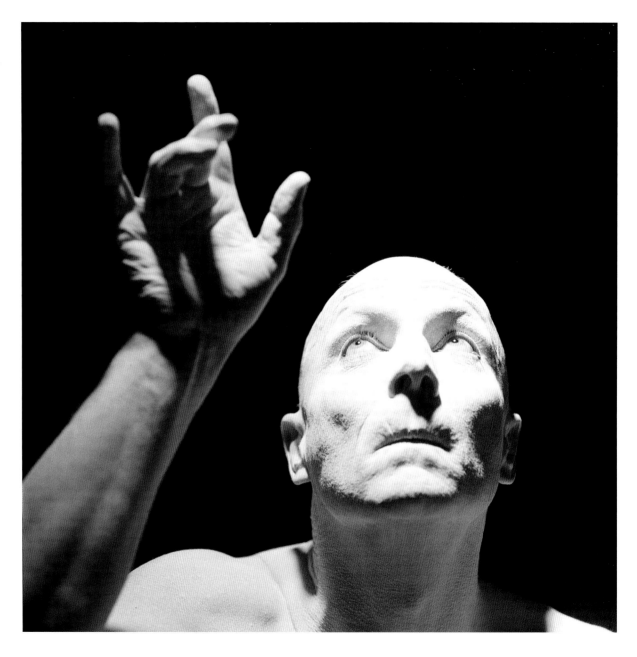

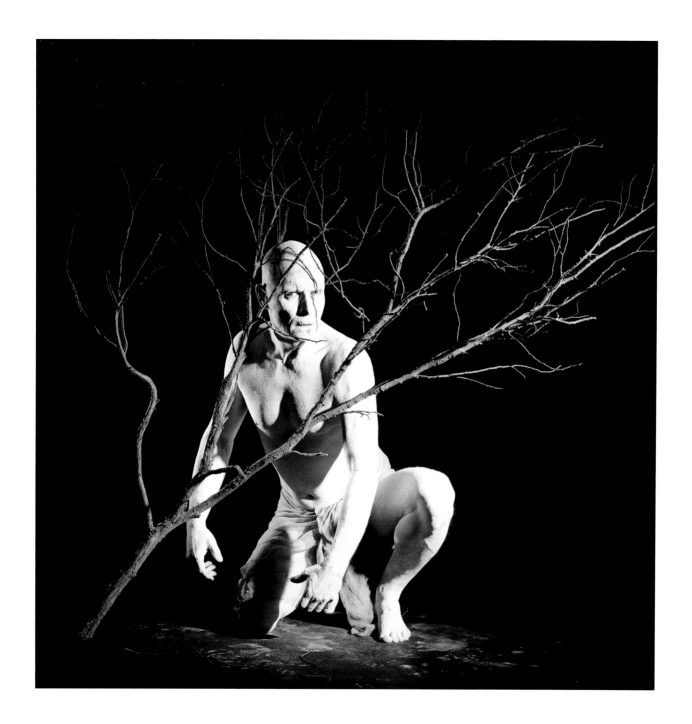

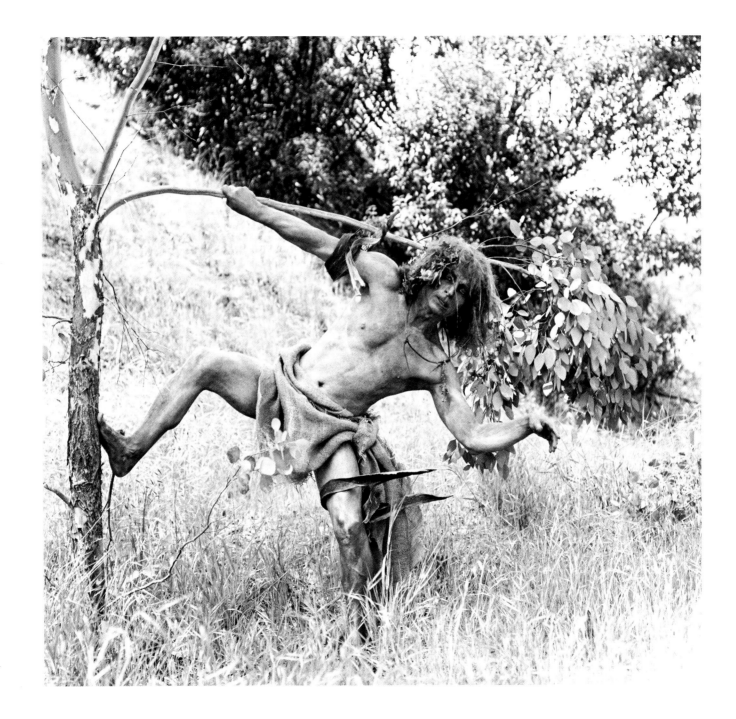

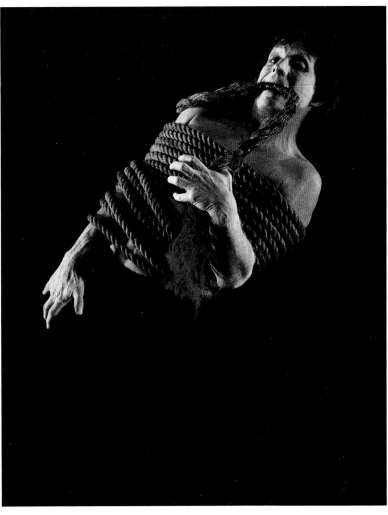

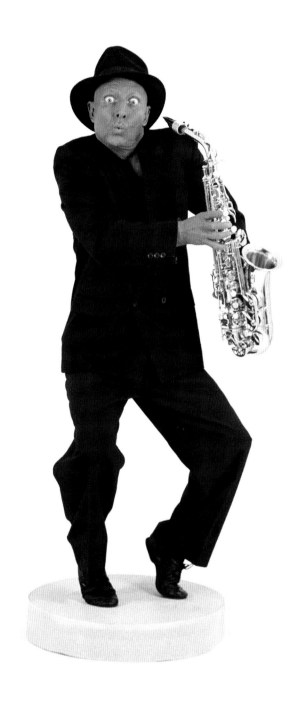
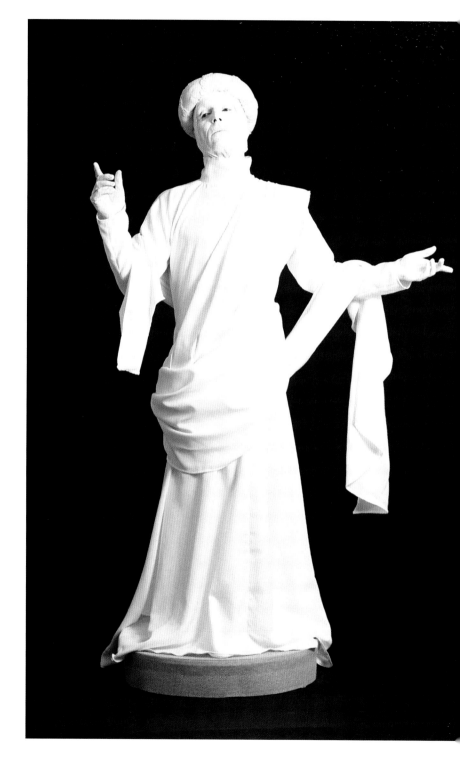

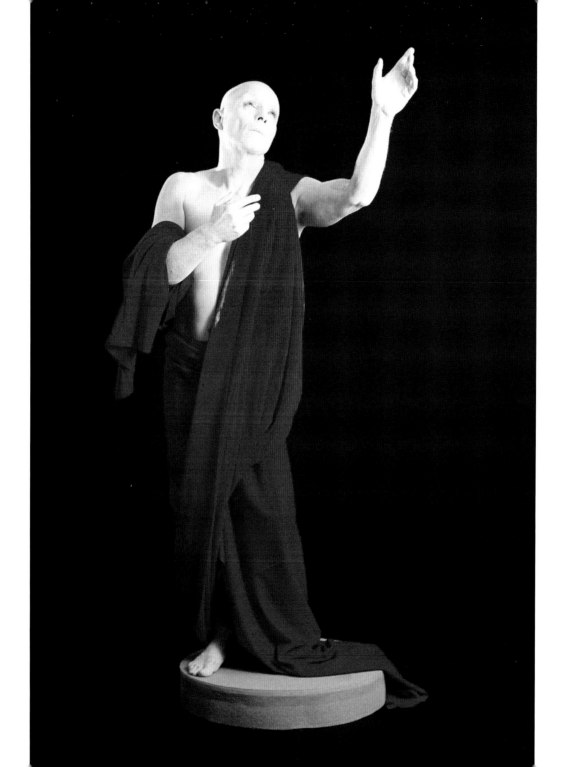

Our performing became a way for us to see ourselves—and for the audience to see themselves in our own reflection—like a mirror of a flower floating in a river.
Eiko and Koma

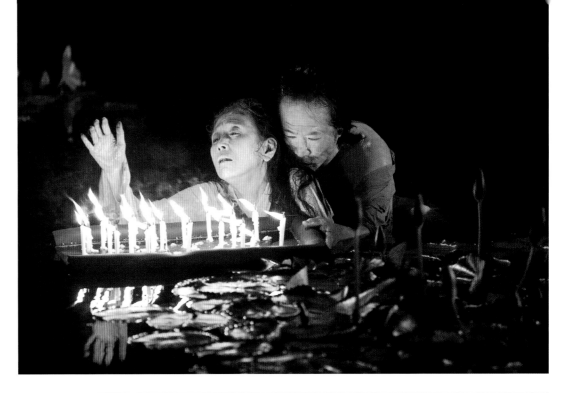

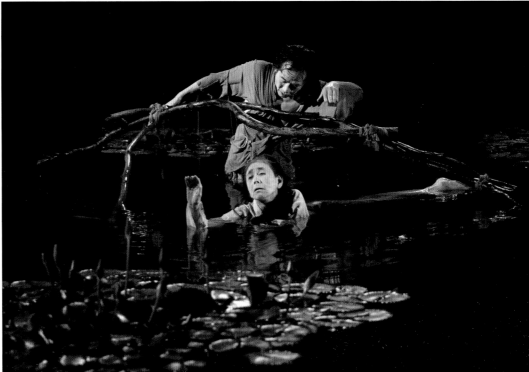

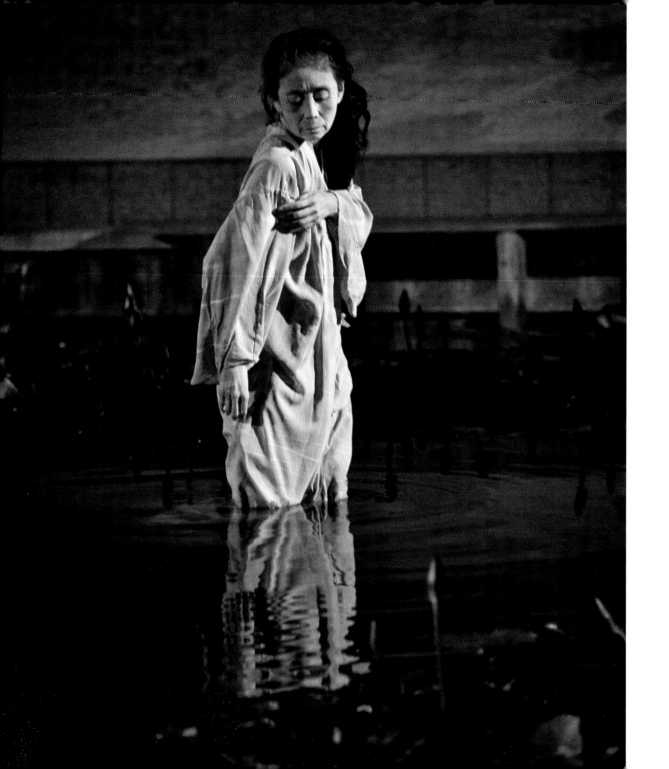

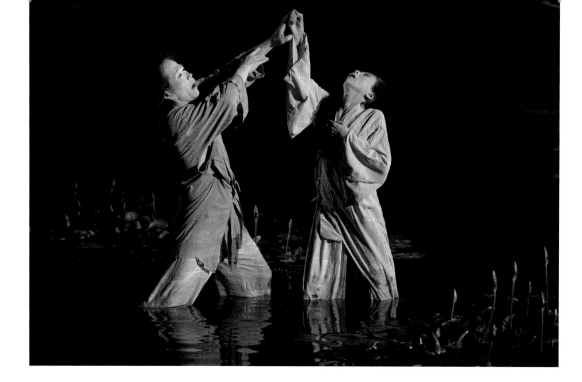

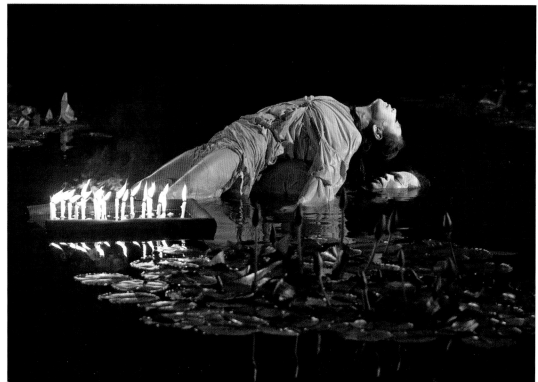

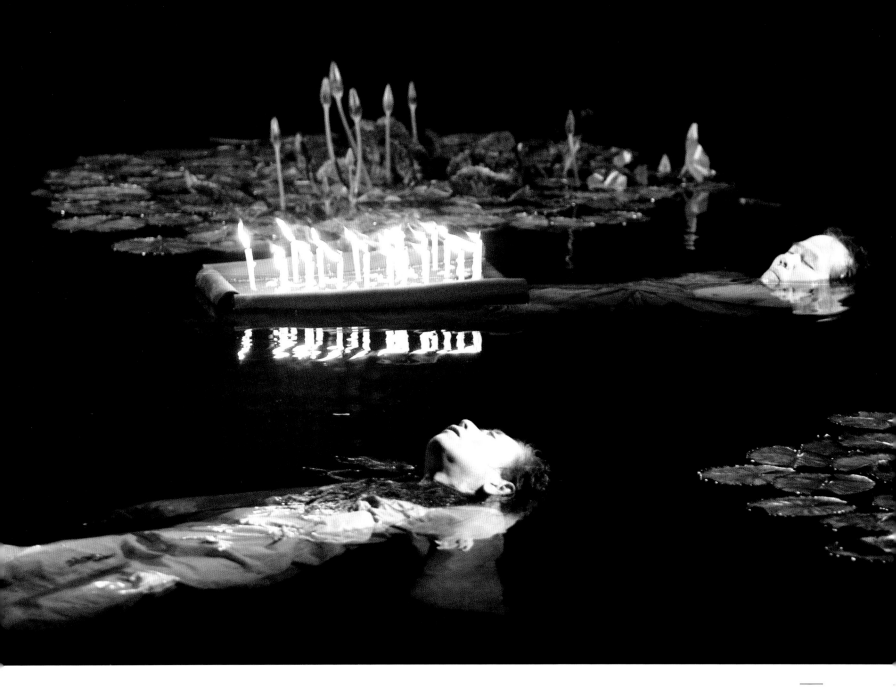

The body is a repository of emotional memories and imprints, stored in the muscles and in the mind. Dance has the ability to tap into and externalize this non-verbal landscape.
Donna Sternberg
Donna Sternberg and Dancers

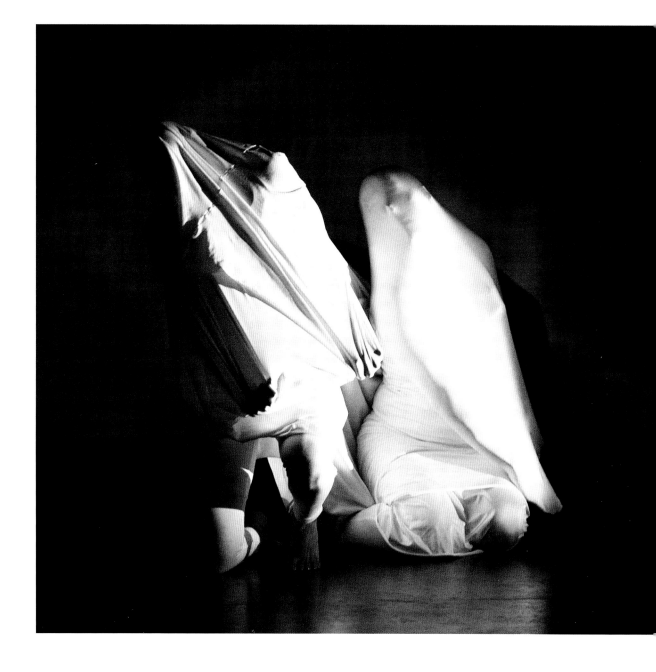

Vince Hederman and Alheli Montoya

The tools of dance-making
are always within us.
Doug Varone
Doug Varone and Dancers

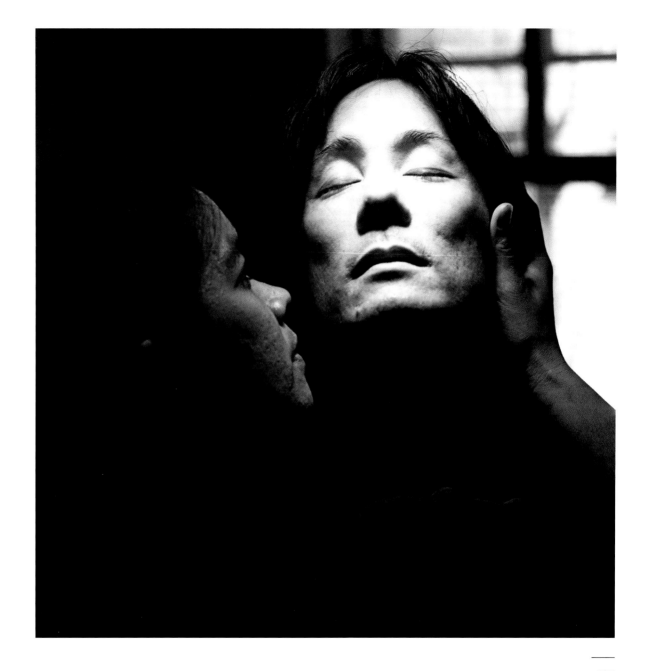

**Eddie Taketa and
Merceditas Mañago**

Deidre Dawkins and Princess Mhoon

Evidence, A Dance Company

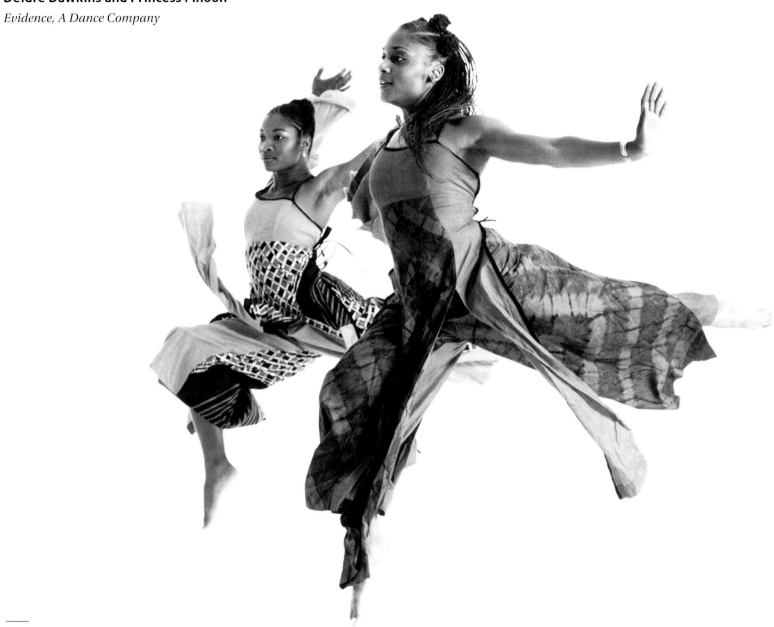

I am seduced by moments of
suspended movement in time
and space and the emotional
truths that are conveyed
in them.
Regina Klenjoski
Regina Klenjoski Dance Company

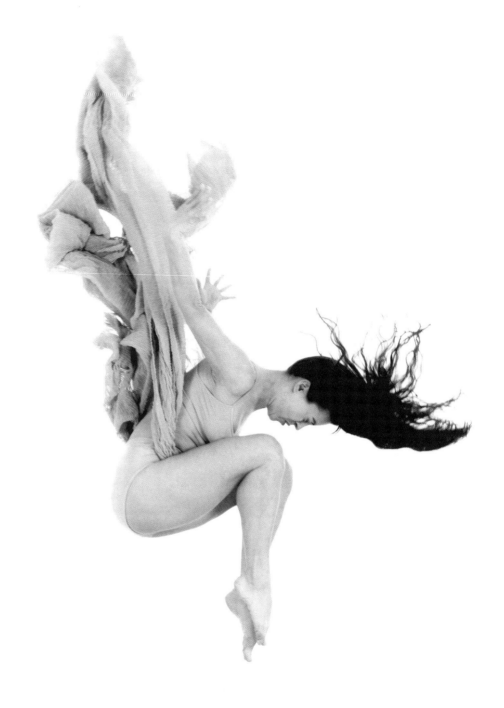

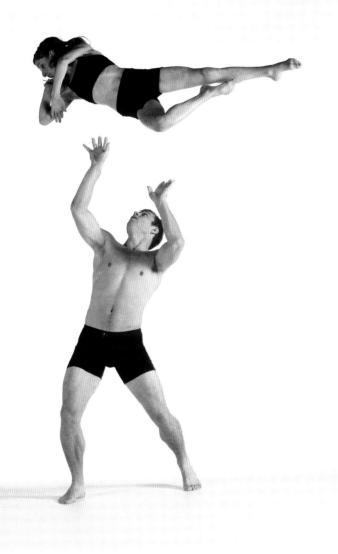
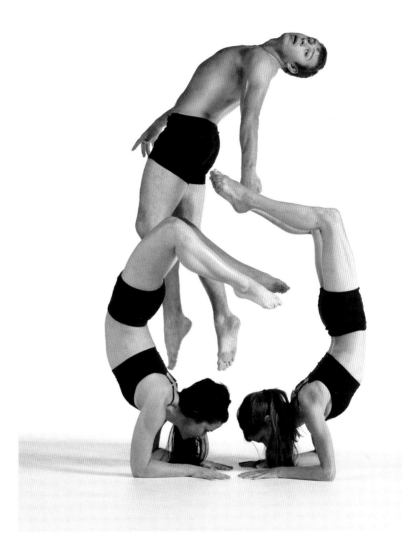

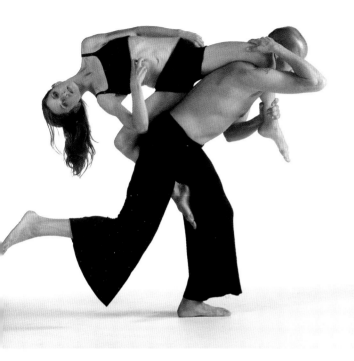

Regina Klenjoski Dance Company

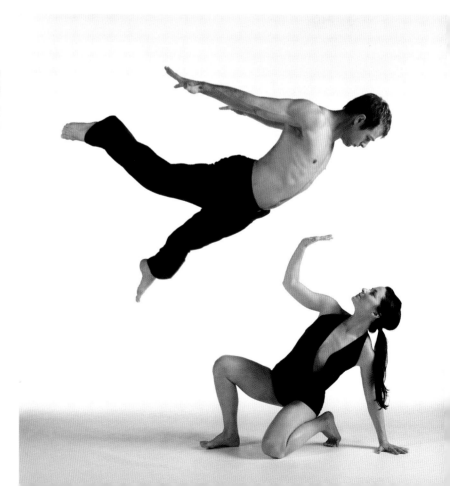

Dance is the most primal art. To dance
is to mimic and embody the ancient and
eternal rhythms of the universe.
Anna Bowden

Regina Klenjoski Dance Company

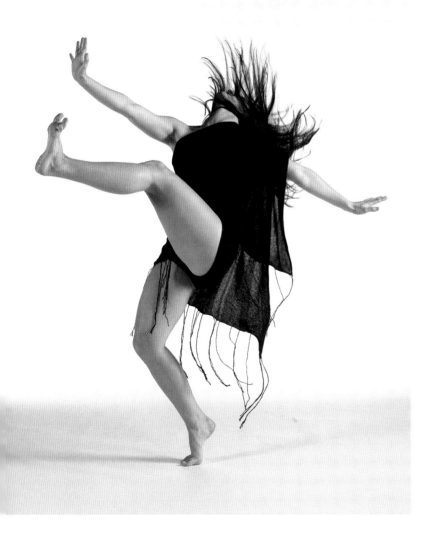

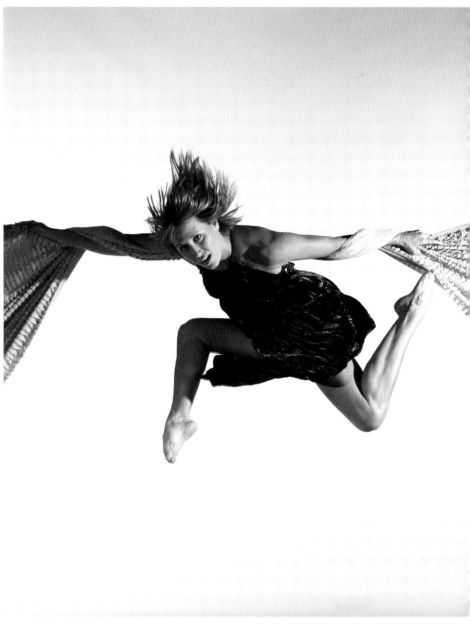

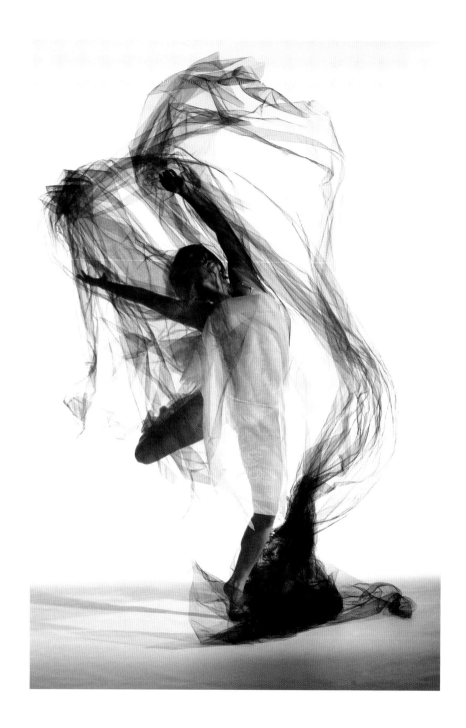

Dance is not something that you find. Dance is something that's inside of you. Dance is a part of life. It's about sensations that connect us to the art of living. When you put these sensations into a form—a movement language—you can also present it on the stage.
Ohad Naharin
Choreographer

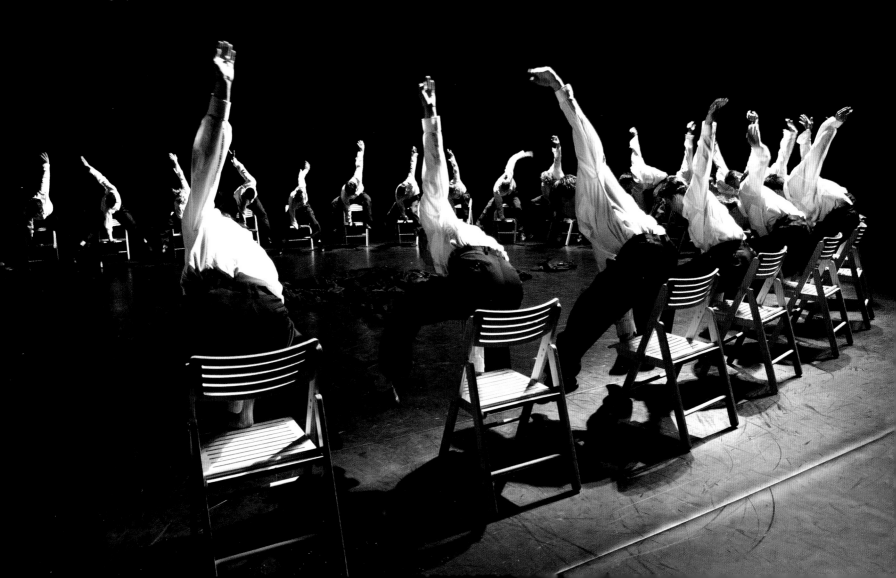

Les Grands Ballets Canadiens de Montreal

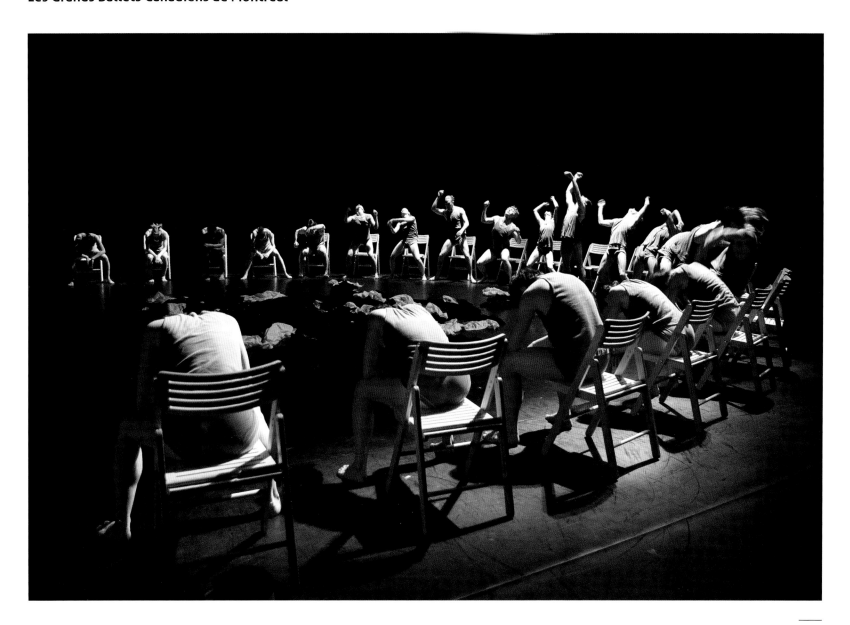

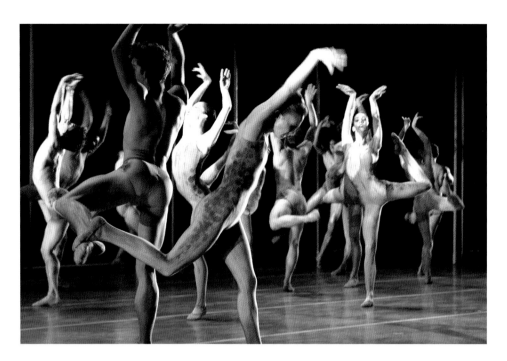

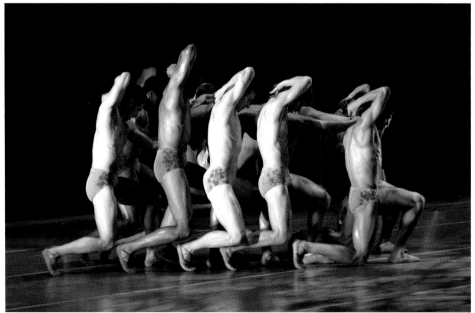

You spend your whole life creating something that is brilliant, exciting, on the edge, but it exists only during the physical act of performance. The curtain goes up, the dancers dance, and the curtain comes down. You might revel a bit in its afterglow, but it doesn't remain. It's the most quicksilver, precarious, and volatile way of creativity. And because of that, you are compelled to create again and again and again and go on to the last breath.

Glen Tetley

Choreographer

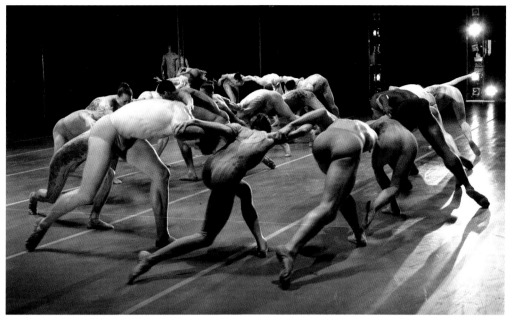

Pacific Northwest Ballet

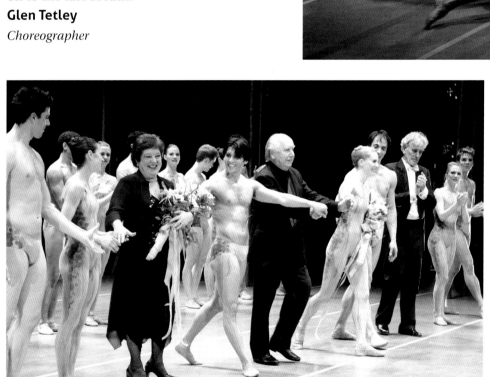

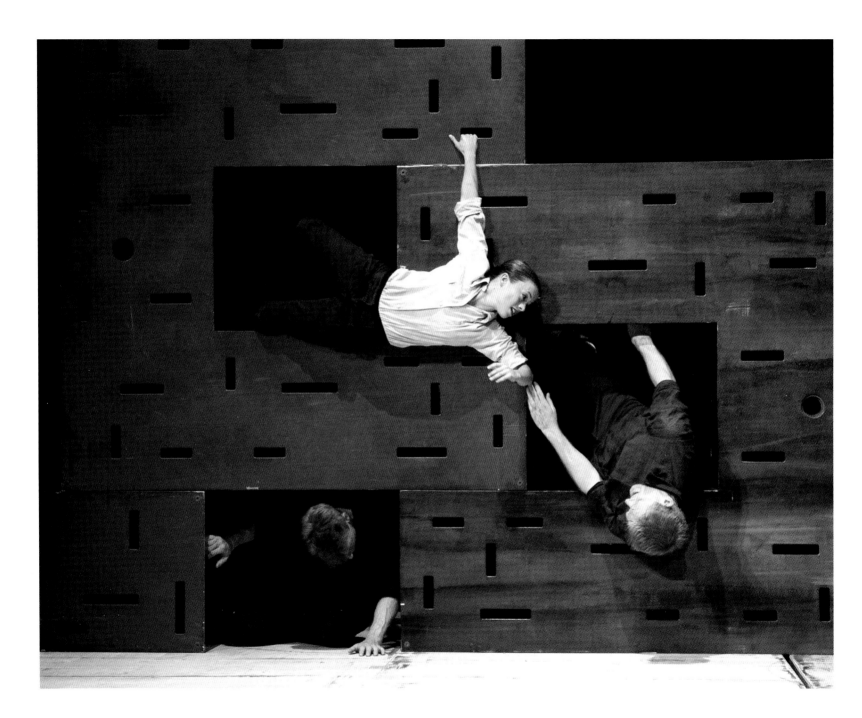

I'm interested in the analysis of us—in relation to our architectural environment. I explore themes of struggle, danger, chaos, fear, faith, survival, destiny, love, and a celebration of the human spirit.

Jacques Heim

Artistic Director, Diavolo/Architecture in Motion

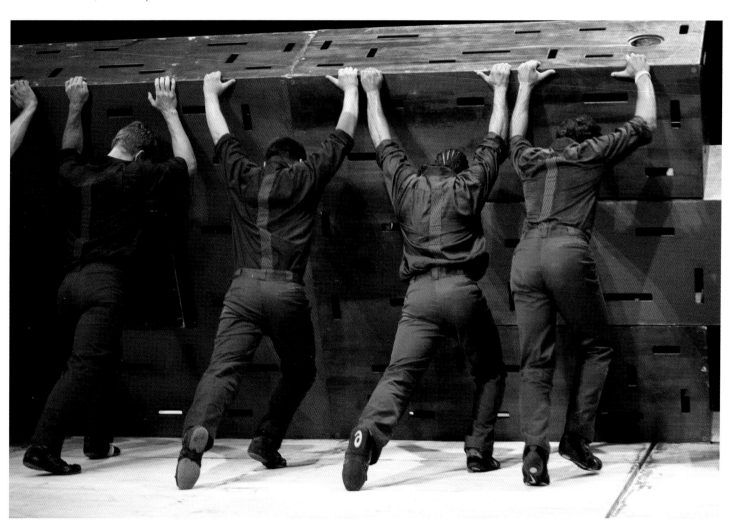

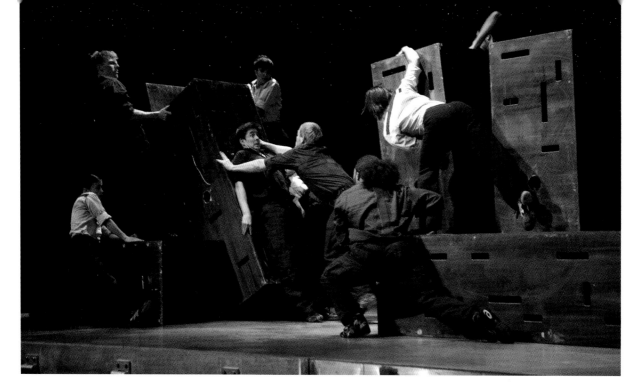

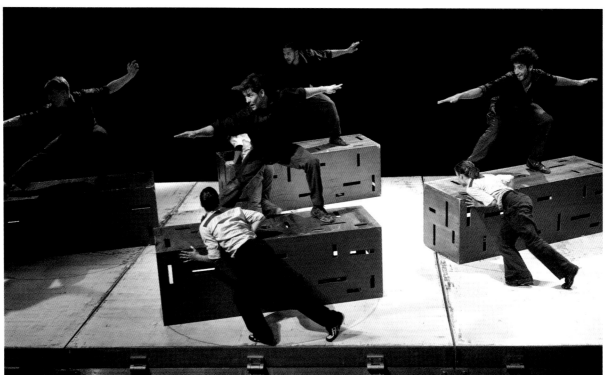

Performing enables a woman to take charge. And yet, she fully submits and beautifully, to the vision of the choreography and to that of a man's brute strength.

Shauna Martinez

Diavolo—Architecture in Motion

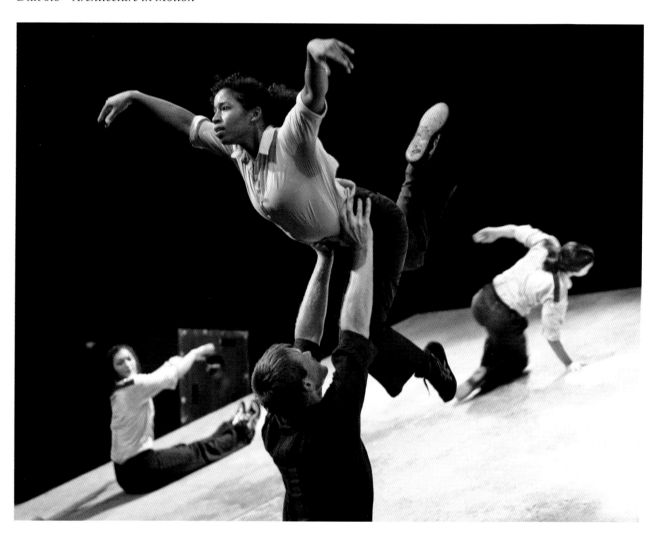

Dance can make you very bold. The dancer always says "yes," thinking, "Oh my God, how do I do this?" Then she goes out and figures out how to do it.
Debbie Allen
with Vivian Nixon

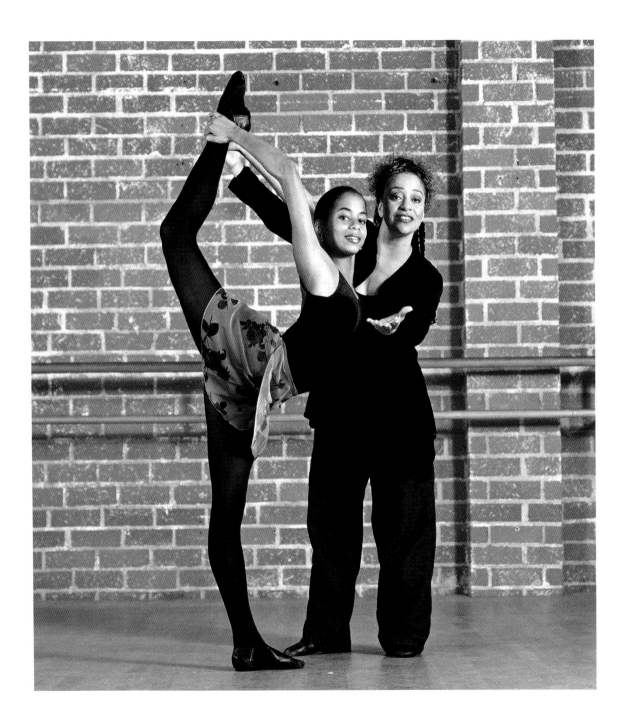

The essence of time, the duration of a show, a lifetime contained between walls, within the very structure of theater—suspended disbelief!
Aurelia Thierrée

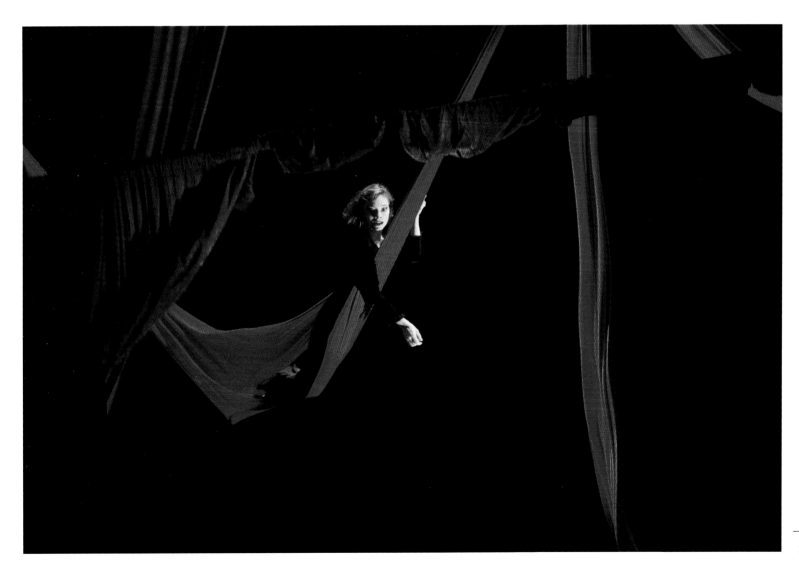

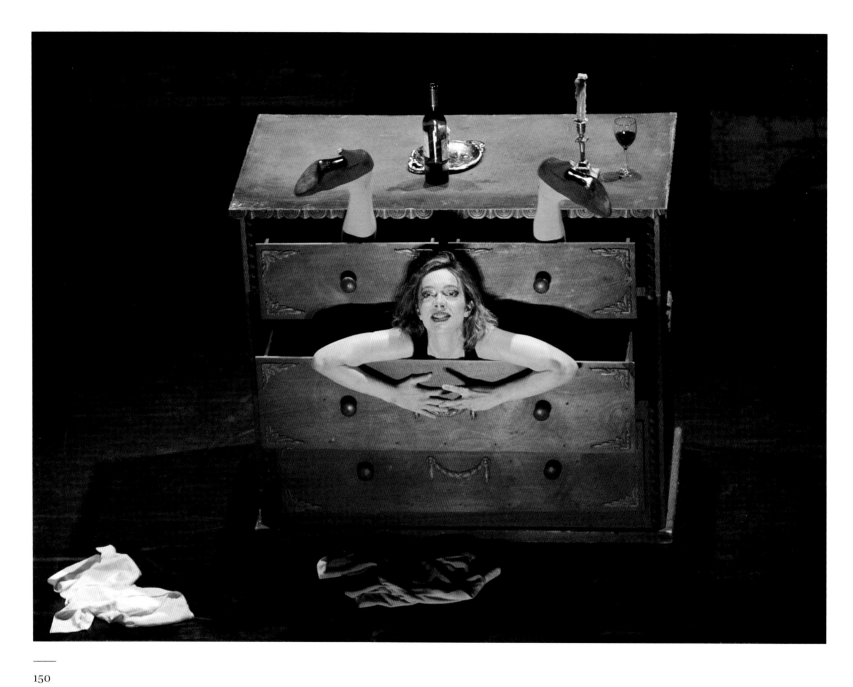

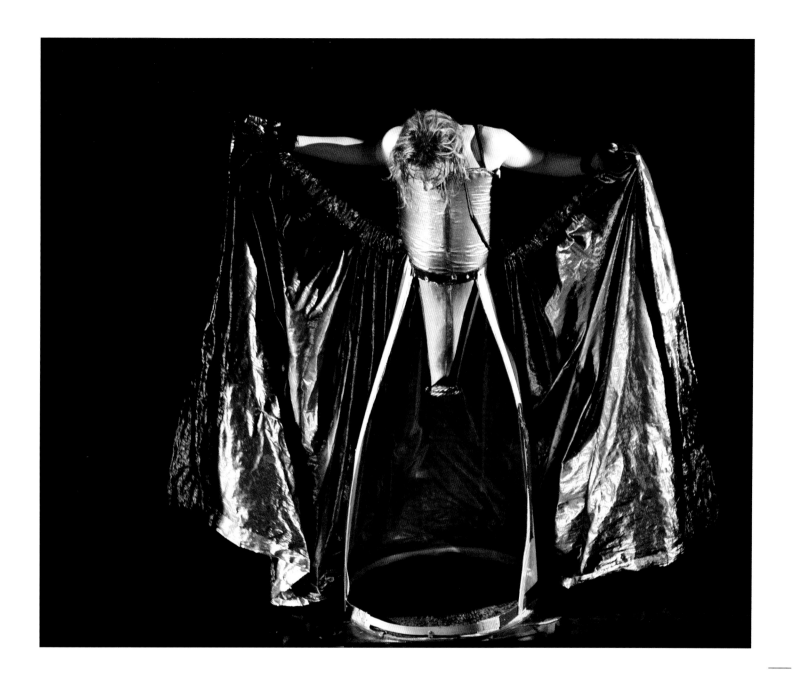

Ballet is addictive! I never stop
thinking about it. I make sacrifices
for it. I accept how emotionally and
physically challenging it is and how
unfair it can be at times. But . . . it's
worth it because dance transports me
to an extraordinary place where I can
explore another side of myself.
Jolie Moray

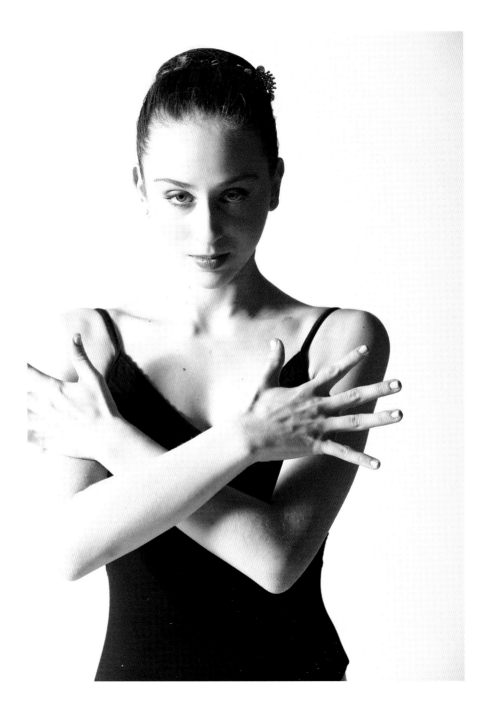

We all make dances alone in our room. It's how we cope with the emotions bubbling up inside. I'm still trying to find a way to blend those internal hard-edged realities with an outward corresponding movement vocabulary.
Kyle Abraham
Abraham.In.Motion

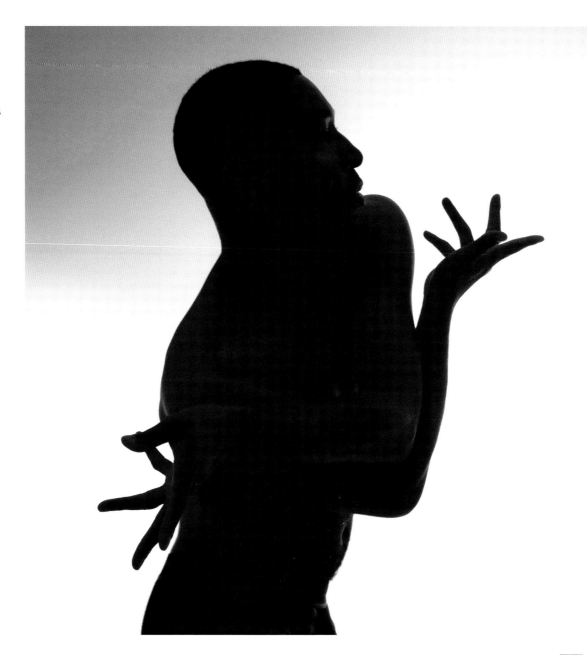

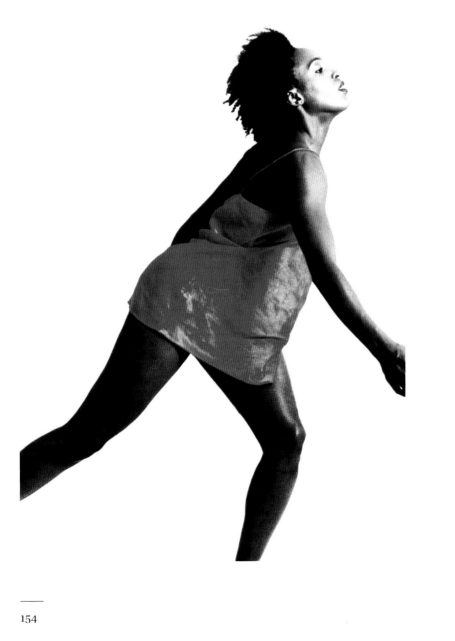
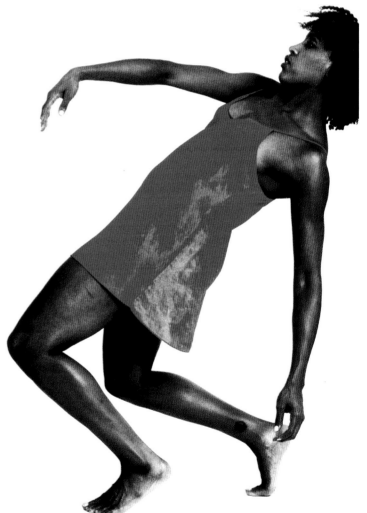

My personal life and dance life have always been so totally interrelated that I don't know any other way to live. Dance is the filter through which I experience my world.
Tamica Washington-Miller
Lula Washington Dance Company

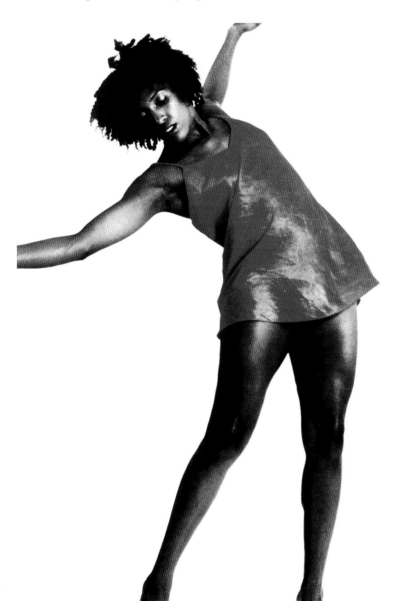

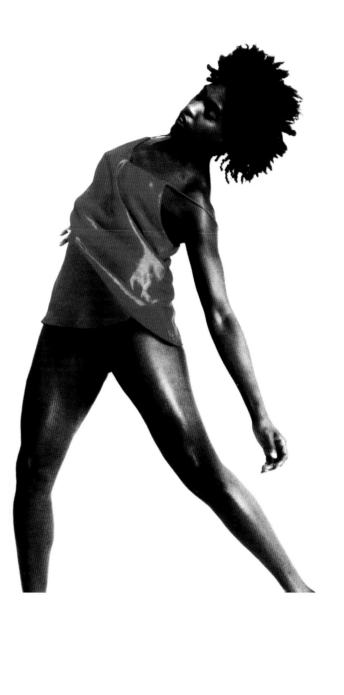

I don't want to dance in something where I can't be me.
Tyne Stecklein

Physical comedy and dance is how I connect with people. I invite them to laugh with me about the tragedy of our junior-high-school days, divorces, and unexpected heartaches. Yes, this is funny what I do, but it's also a way of helping us cope with the darker side of life and being human.
Deborah Lohse

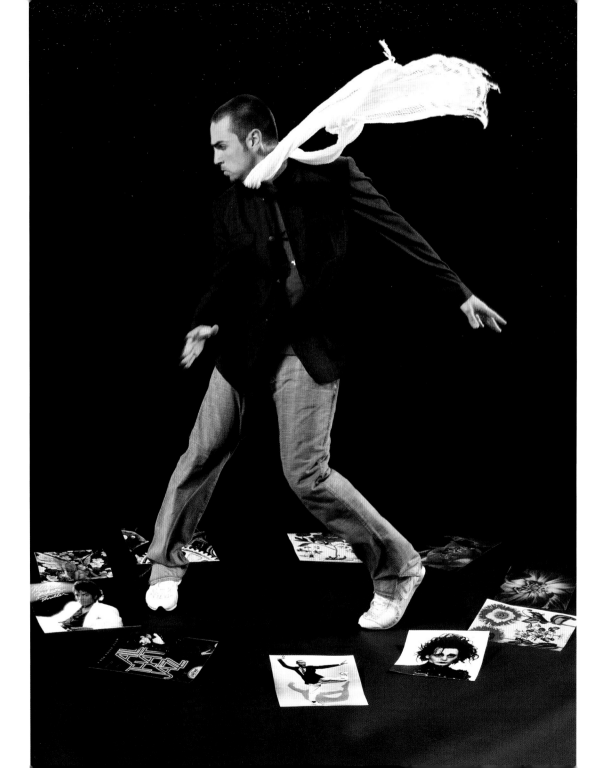

My relationship with dance has been profound—playful, provocative, evolutionary . . . and tainted.

Wade Robson

In that moment when the
stadium filled with thousands
of people goes dark, the music
drops, and the crowd goes crazy,
excited to see the artist they love,
something transformative and
powerful takes hold of me.
I cease to think, I just feel.
Amanda Balen

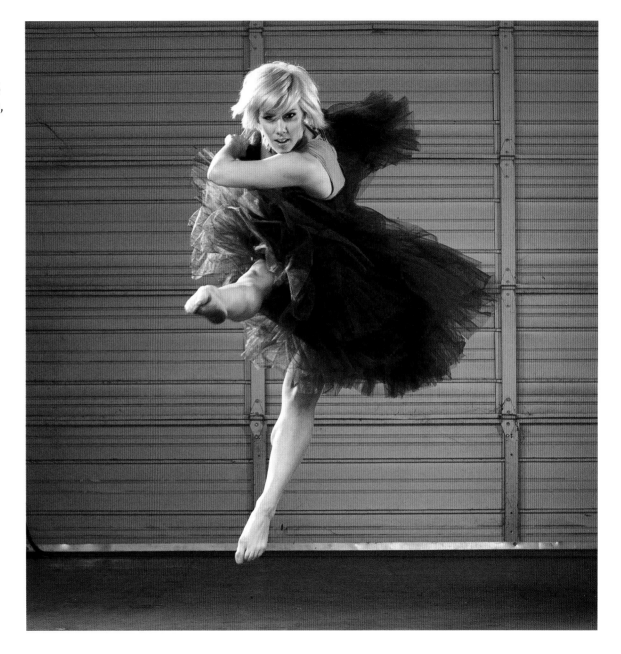

Ever since I was a child words hindered me—and often still do. But movement and dance free me, and give me the courage to express things that are deep down inside of me—the raw, the real, the life. My heart beats . . . I breathe . . . My limbs move . . . revealing more and more who I am, and exposing my authentic voice through my body, through my movement.

Mark Kanemura

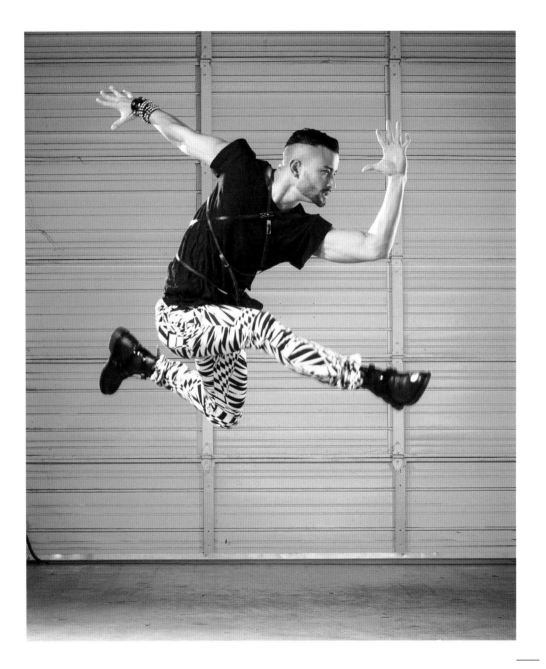

It's so romantic to dance with someone who makes you feel beautiful.
Jeraldine Mendoza
The Joffrey Ballet

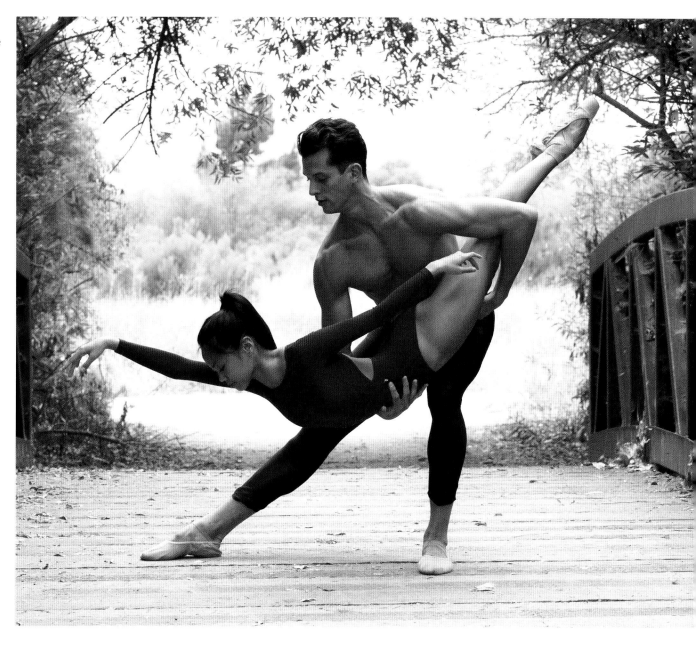

I'm always looking for that perfect moment
when I fall in love with my partner.
Dylan Gutierrez
The Joffrey Ballet

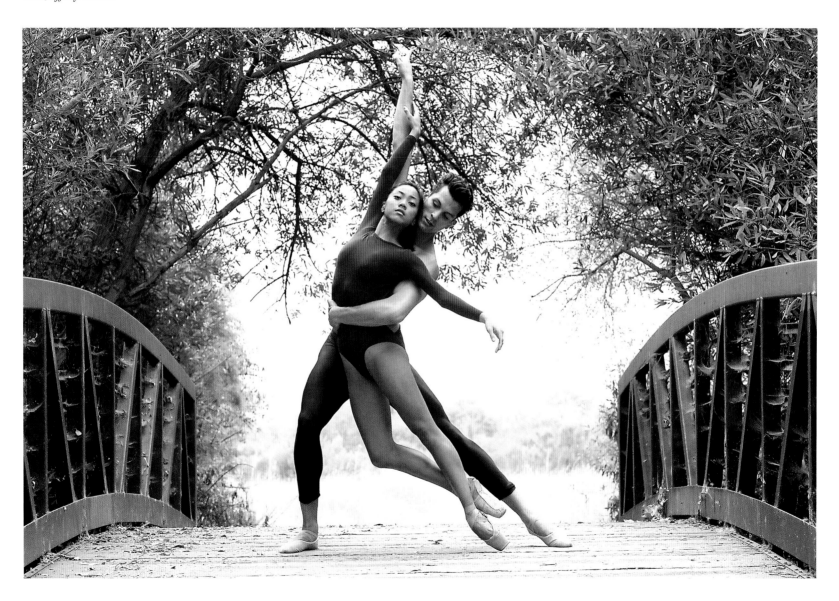

You know in the first few minutes how an audience is going to be. Sometimes you feel like there is a big wall between you and them—a distance, a coldness. When that happens, you feel like you're dancing like a machine. But, that's not happening tonight. Tonight I feel the audience is with me.
Julio Bocca

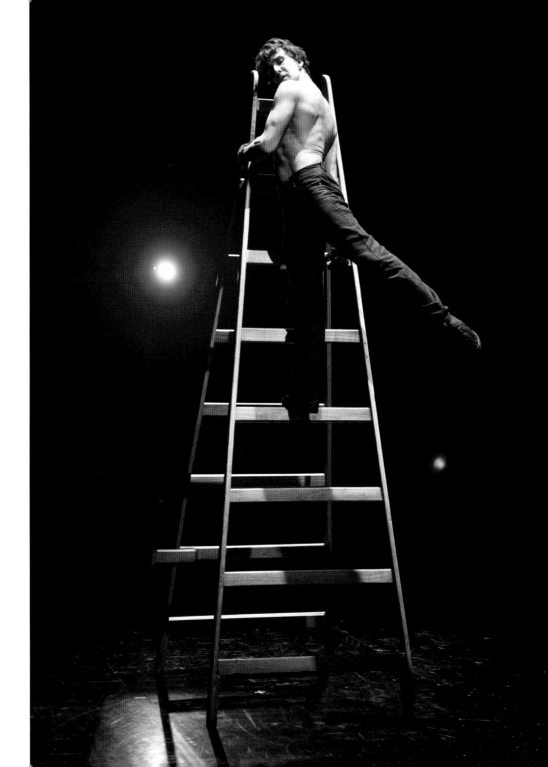

To be a dancer is to work within
an art form that lives and dies in
nearly the same instant.
Wendy Whelan

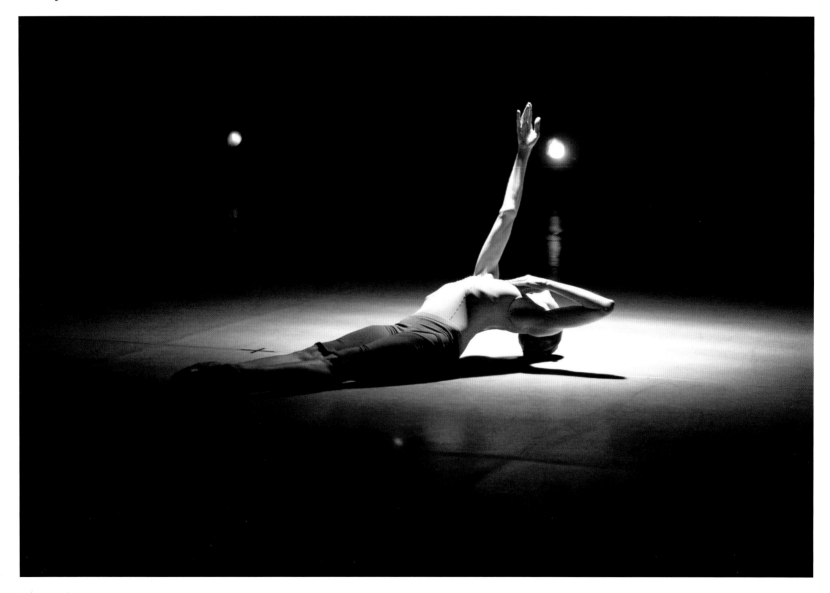

Dance taught me that I'm in control of myself and my life.
Nicole Whitaker/Trinity

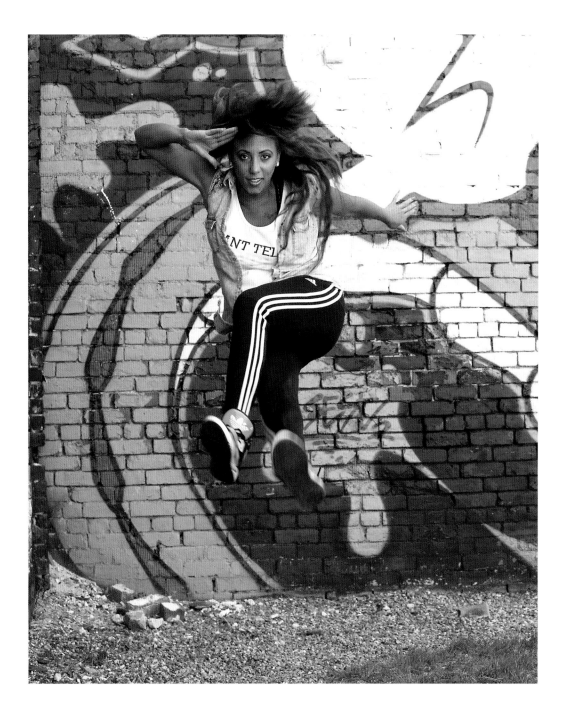

Dance equals total freedom.
Luis Espinosa/Sweet Lu

Dance allows others to enter my world
and join me on my journey.
Alicia Quinones/N'tegrity

Do you have passion?
You need to be on fire in
order to express yourself
and convey your own
power and strength.
Sonya Tayeh

I want to be a great ballerina.
I want people to know how
much I love dancing and see
my passion. And if someone is
physically unable to dance, they
can feel it through me.
Britain Grady
Los Angeles Ballet Academy

Be patient with the process . . .
Be patient with yourself . . .
Quiet all your fears and take
the time that it takes to create.
Own up to your true voice and
trust that what you make has a
place in this world.

Lar Lubovitch

Lar Lubovitch Dance Company

Often before I make my entrance, I have flashbacks of myself dancing as a little boy back in Brazil. You carry with you on your back your life experiences, your personal history. It's with you every time you step on the stage.

Marcelo Gomes

American Ballet Theatre

There is a general stereotype about ballerinas—that we are mean spirited and self-centered. We're not. It's just that when your body is your instrument it needs daily conditioning and a certain amount of introspection in order to express something meaningful with every step.
Gillian Murphy

American Ballet Theatre

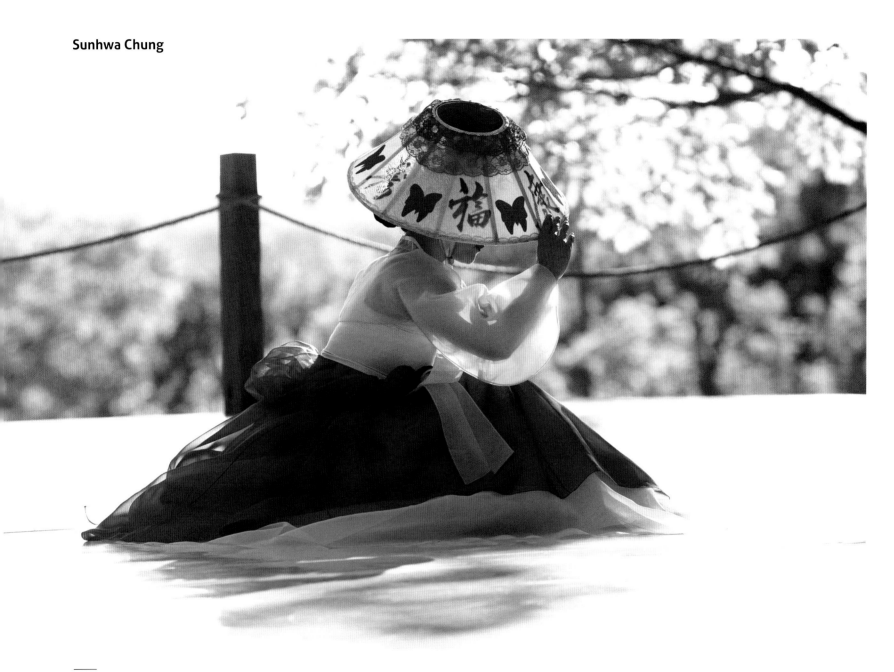

Bharatanatyam is a devotional form of dance. Through it we learn mythology, cultural practices, and traditions. It's not just about a technique or its execution—even though they are very important, there must be an ever-present feeling of spirituality, elegance, beauty—and salvation.

Lakshmi Iyengar

Rangoli Dance Company

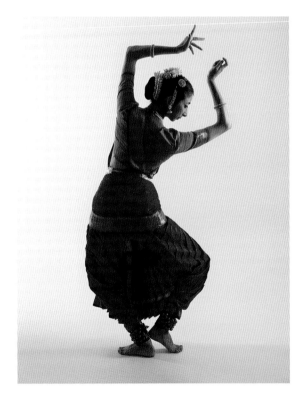

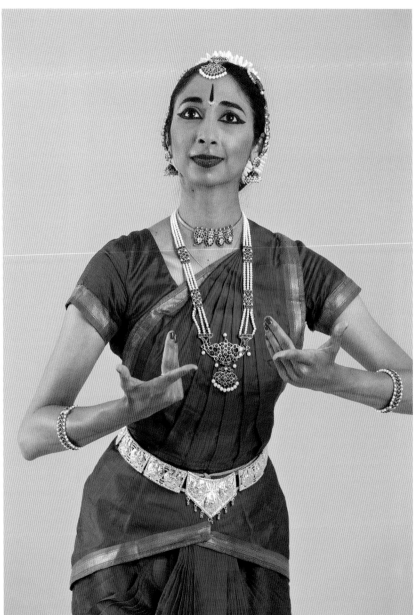

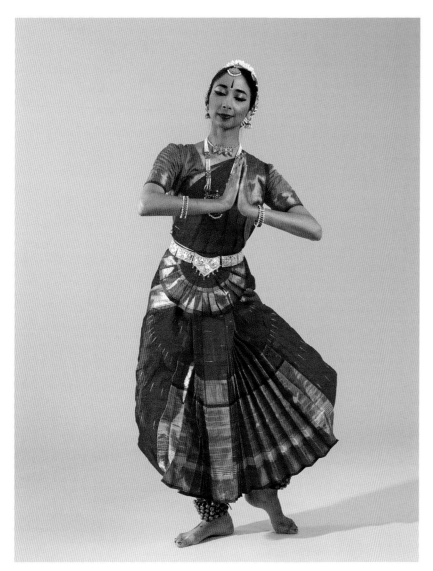

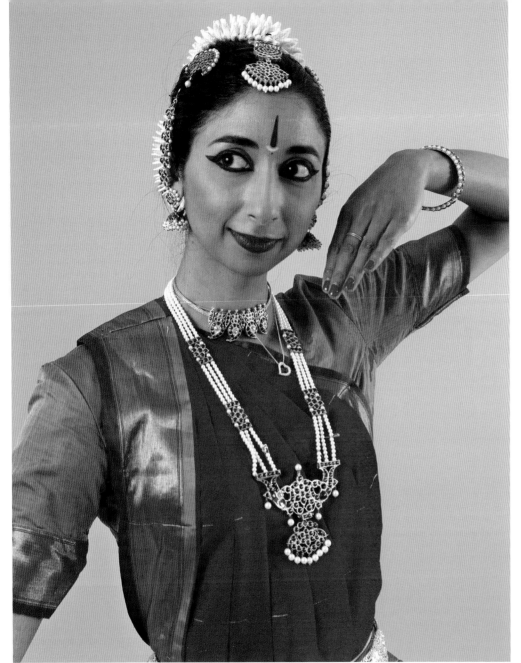
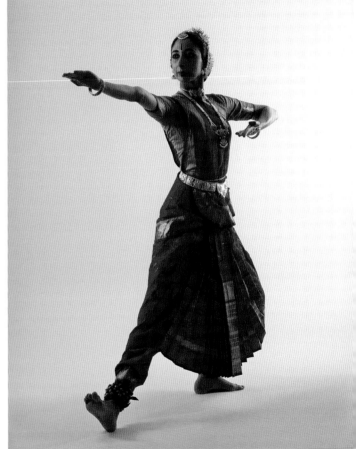

Ballet is an art form that has a great element of struggle. You can't just pay for it and have it. You can't Google it and have it. You have to come in, get on the floor, and do it over and over again before you get what you want out of it.

Andrea Paris-Gutierrez

Artistic Director, Los Angeles Ballet Academy

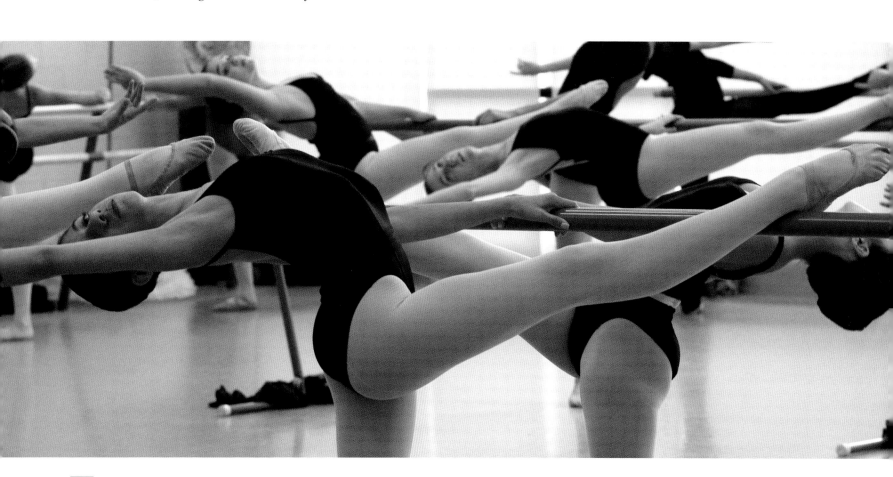

Dance can be intimidating—even when you've made a name for yourself. You're not always going to be the best one at an audition. There's always going to be someone younger than you, prettier than you, skinnier and more flexible than you. In order to succeed you have to put your ego aside and allow your genuine talent to show through.

Ashley Everett

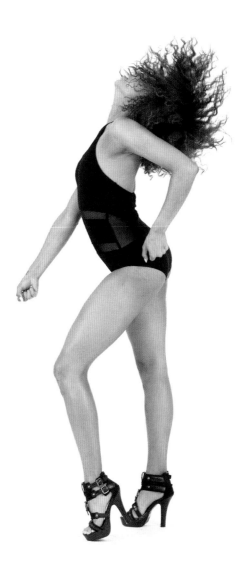

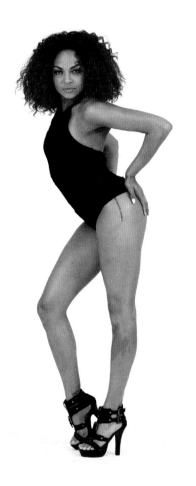

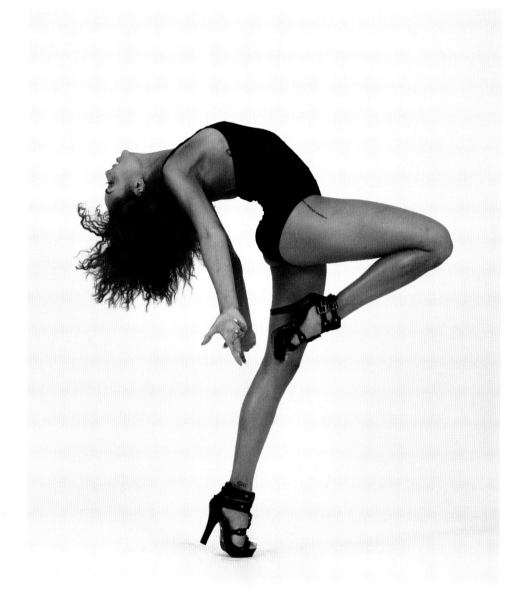

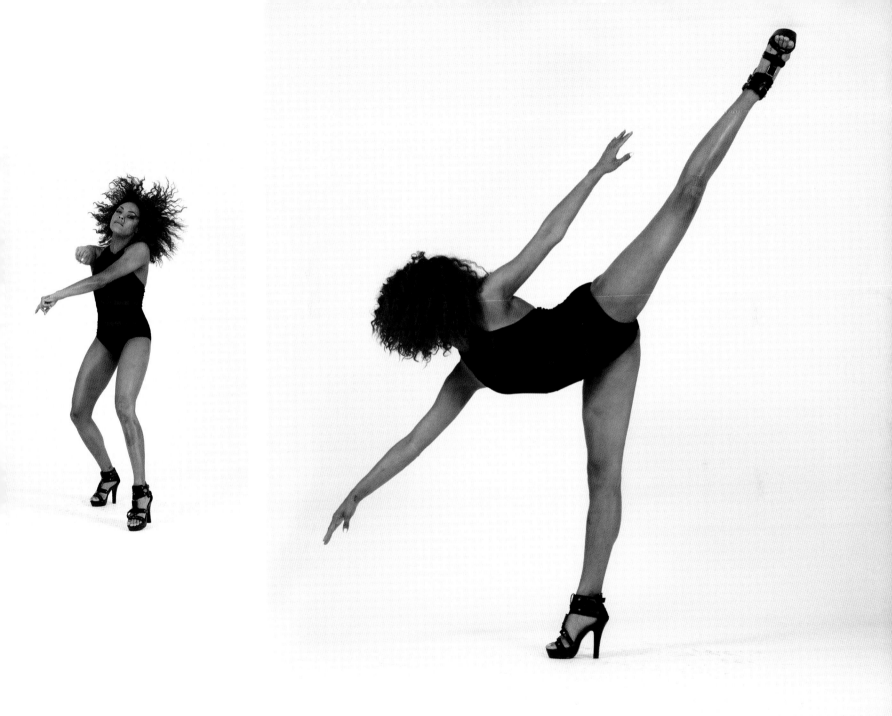

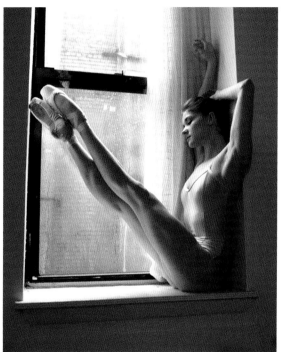
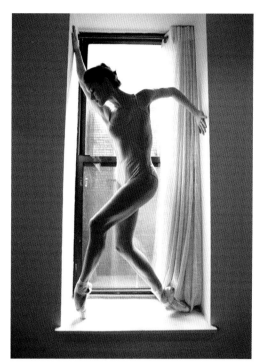

It's easy to feel restricted by technique, but it's essential because without it, you can't do the things you do. You can't create the magic that moves and transports an audience.

Cassandra Trenary

American Ballet Theatre

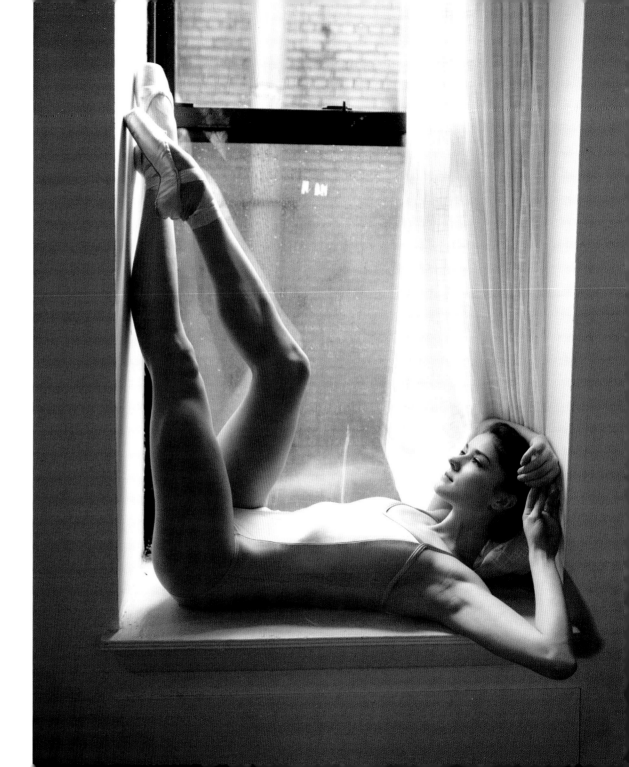

What I experience in my body I deliver to the audience. A dancer is a medium. So when I'm in the wings about to perform one of Martha Graham's works I say to her in my mind, "Martha, now it's your turn!"
Xai Ying
Martha Graham Dance Company

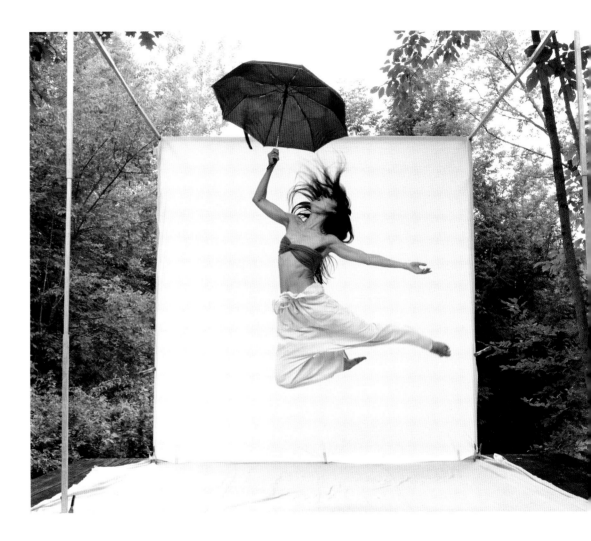

Don't be self-conscious or worry about other people's eyes on you. Have no fear. Dance because you love it.

Nia Davis

Dance Theater of Harlem School

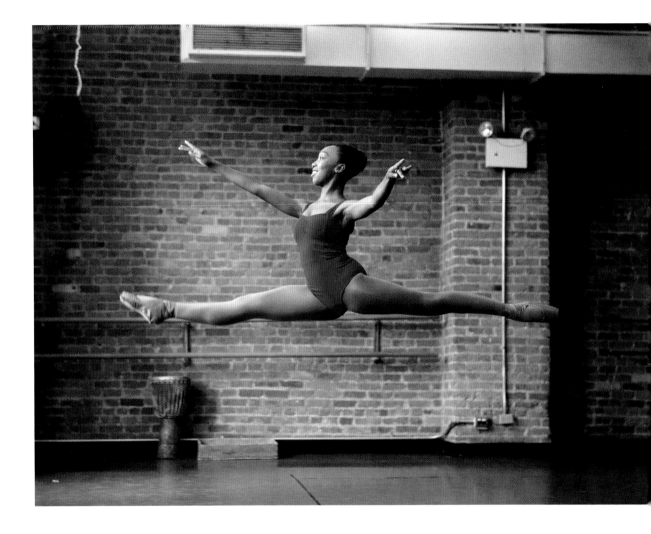

I don't have a choice.
I need to dance.
I have to dance.
Siobhan Harvey

*Dance Theater of
Harlem School*

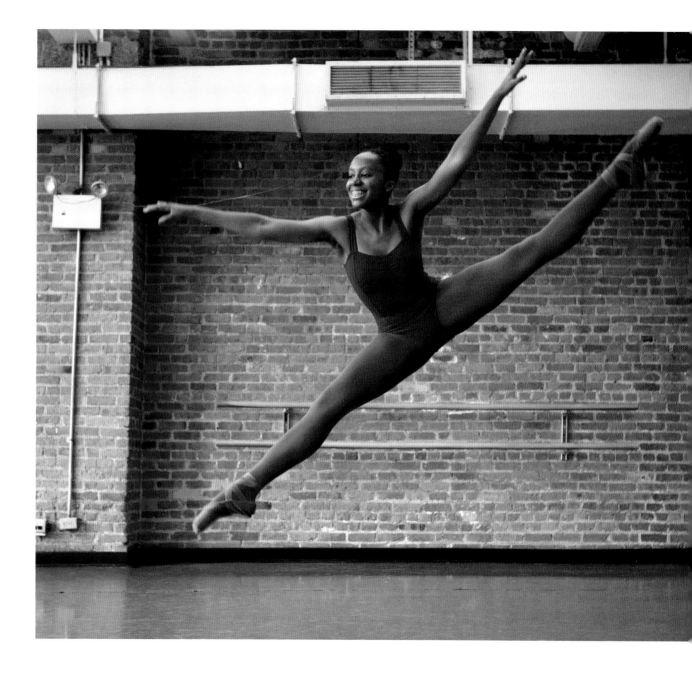

I dance because I want to make people
feel the way I felt the first time I experienced
the art of dance . . . total happiness.
Quaba Ernest
Dance Theater of Harlem School

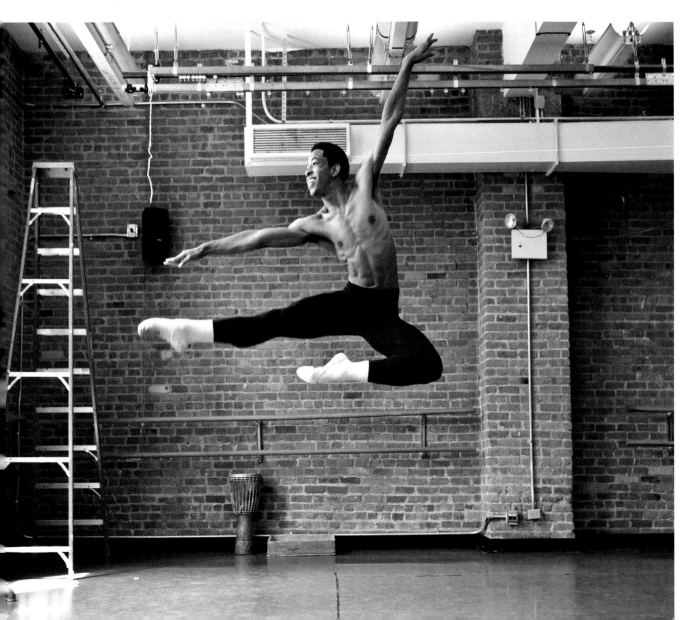

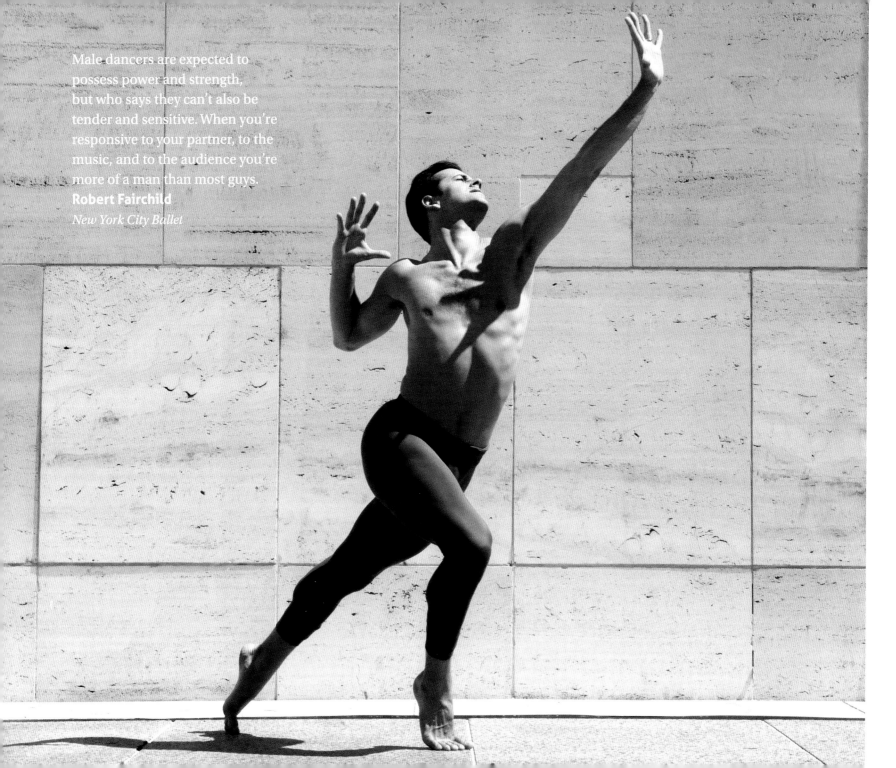

Male dancers are expected to possess power and strength, but who says they can't also be tender and sensitive. When you're responsive to your partner, to the music, and to the audience you're more of a man than most guys.
Robert Fairchild
New York City Ballet

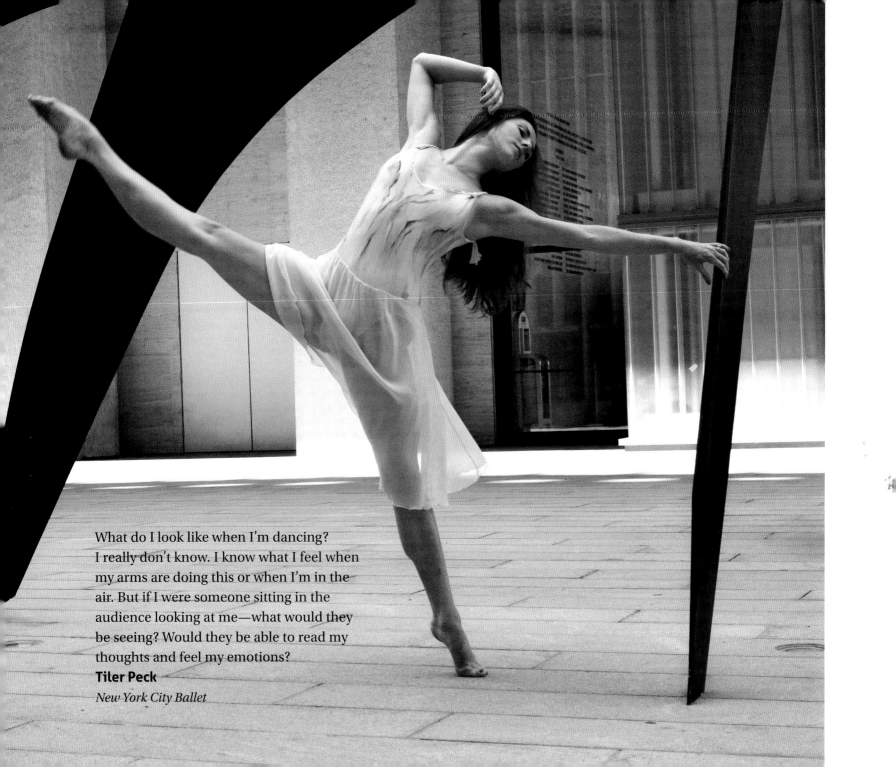

What do I look like when I'm dancing?
I really don't know. I know what I feel when
my arms are doing this or when I'm in the
air. But if I were someone sitting in the
audience looking at me—what would they
be seeing? Would they be able to read my
thoughts and feel my emotions?
Tiler Peck
New York City Ballet

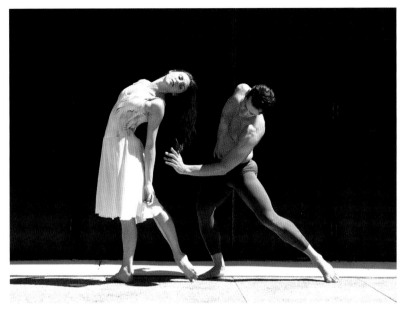
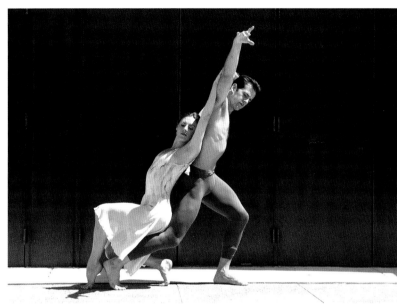
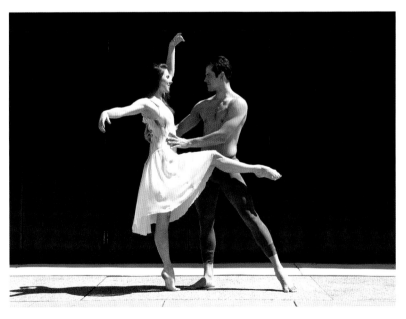
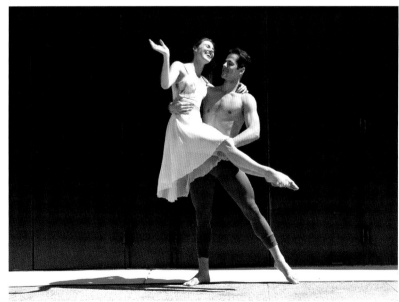

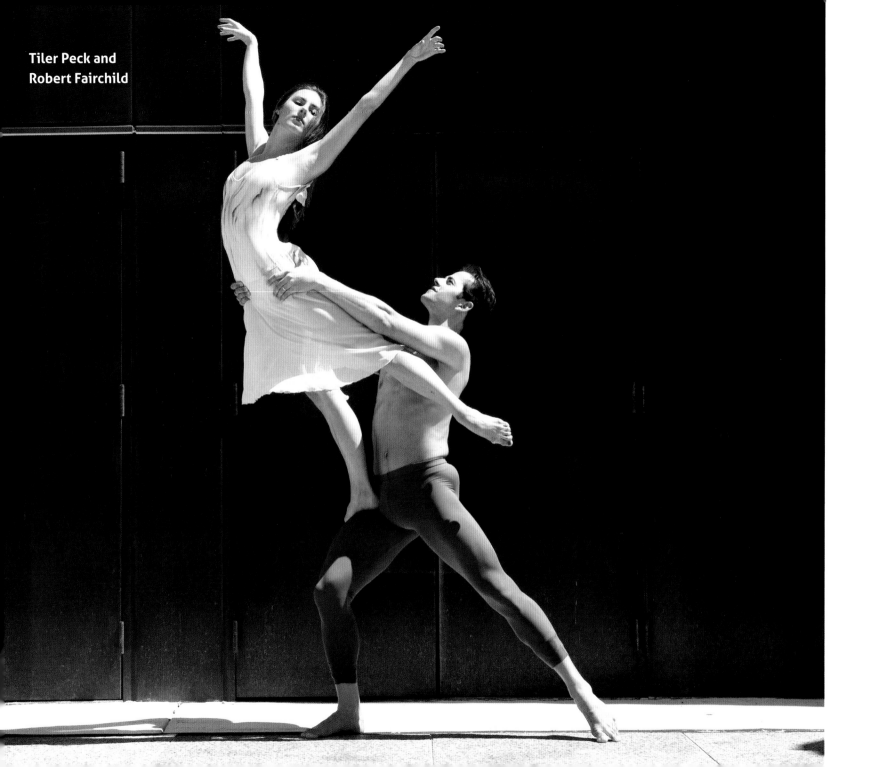

Tiler Peck and
Robert Fairchild

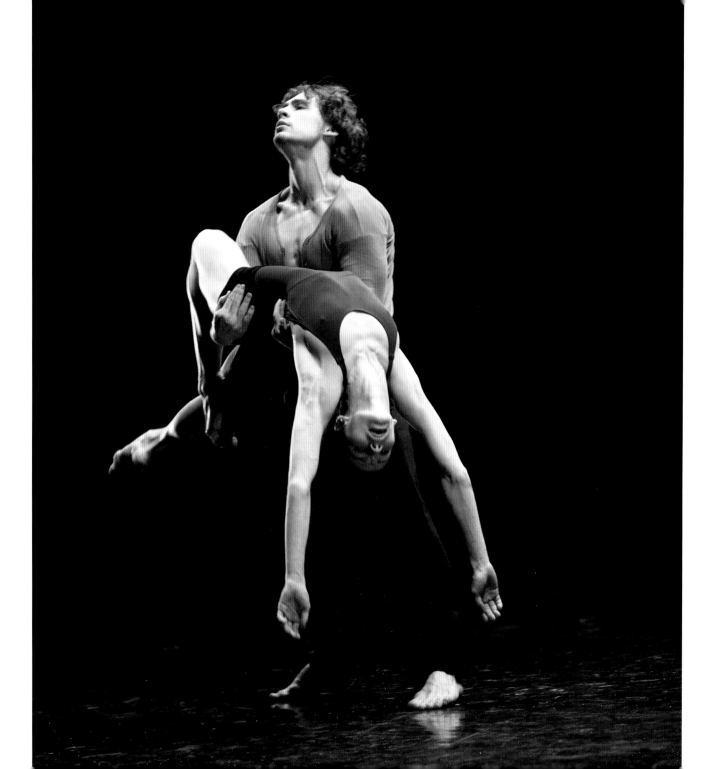

Natalia Osipova
with Ivan Vasiliev

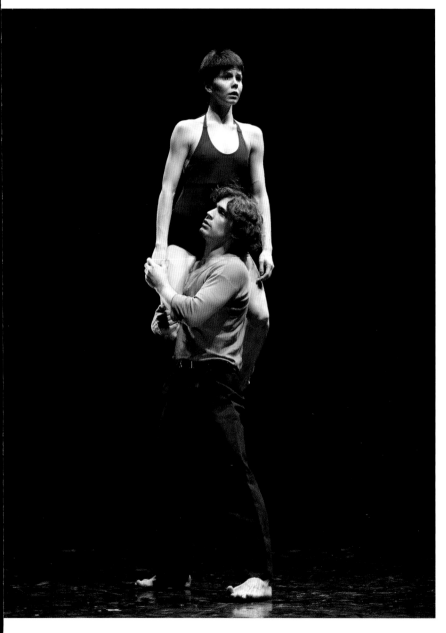

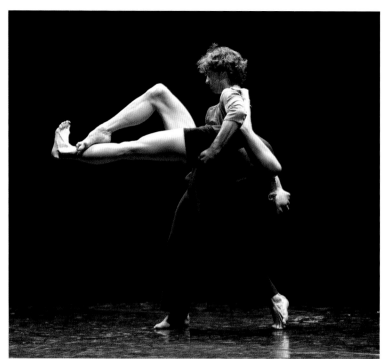

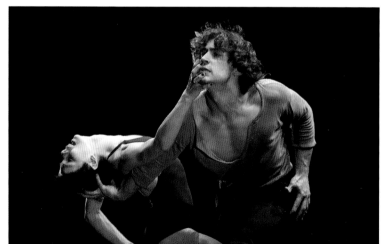

I'm not interested in sporting diamond
tiaras on stage. . . . Ballet has evolved and
the ballerina figure with it.
**Natalia Osipova
with Ivan Vasiliev**

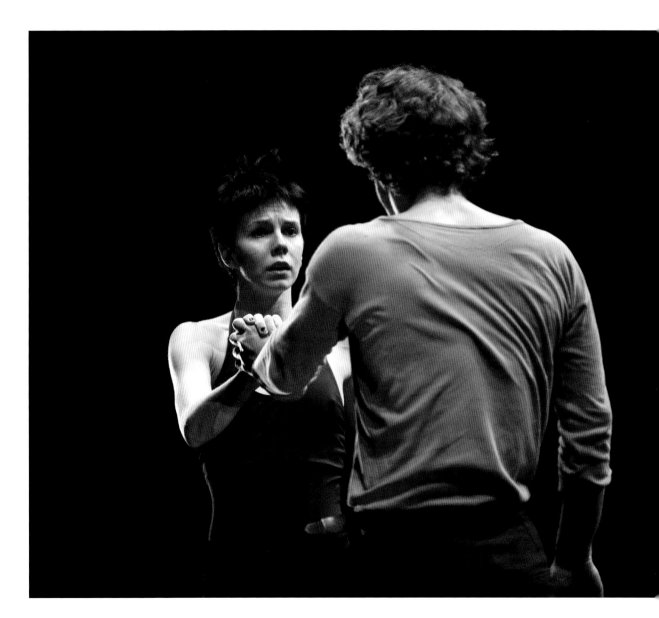

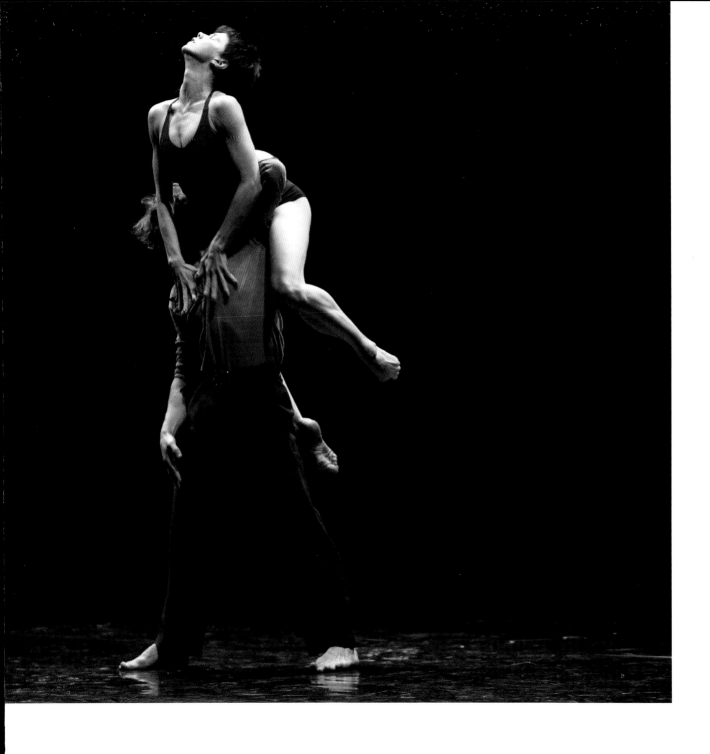

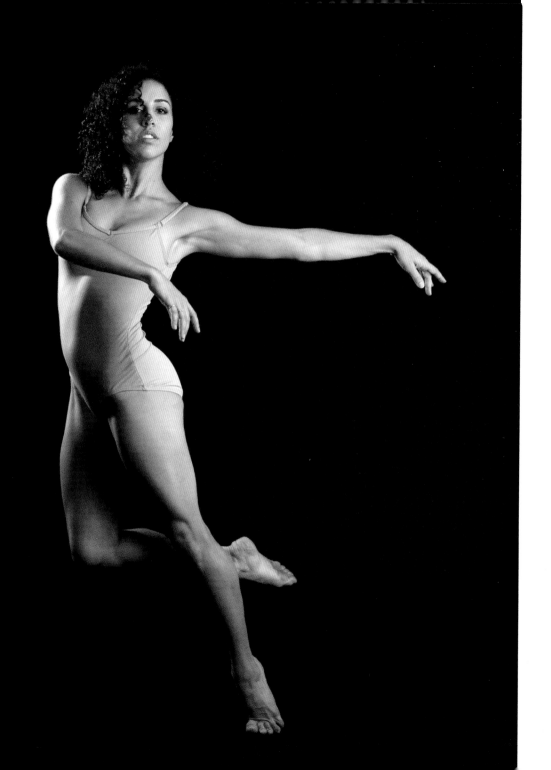

Dancers are always measuring themselves up against each other. We can't help it because we're never satisfied with what we do. It's only when we begin to value ourselves as individuals that we begin to own our art.
Eliana Girard

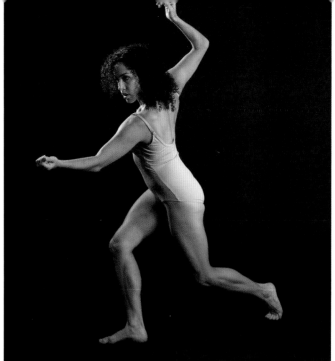

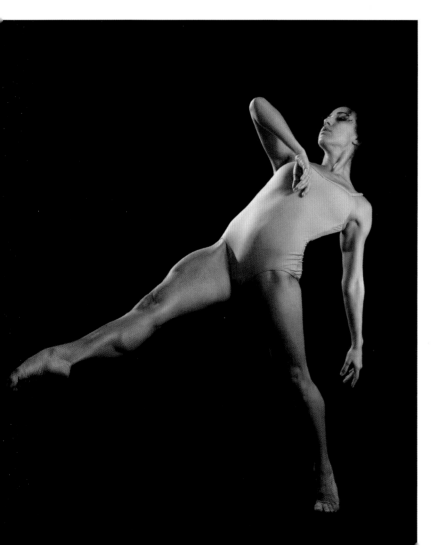

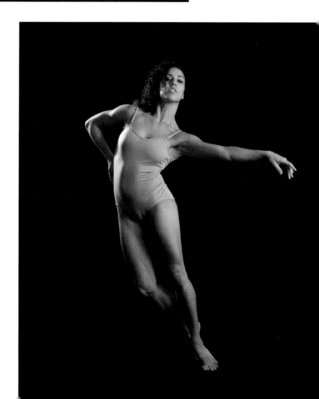

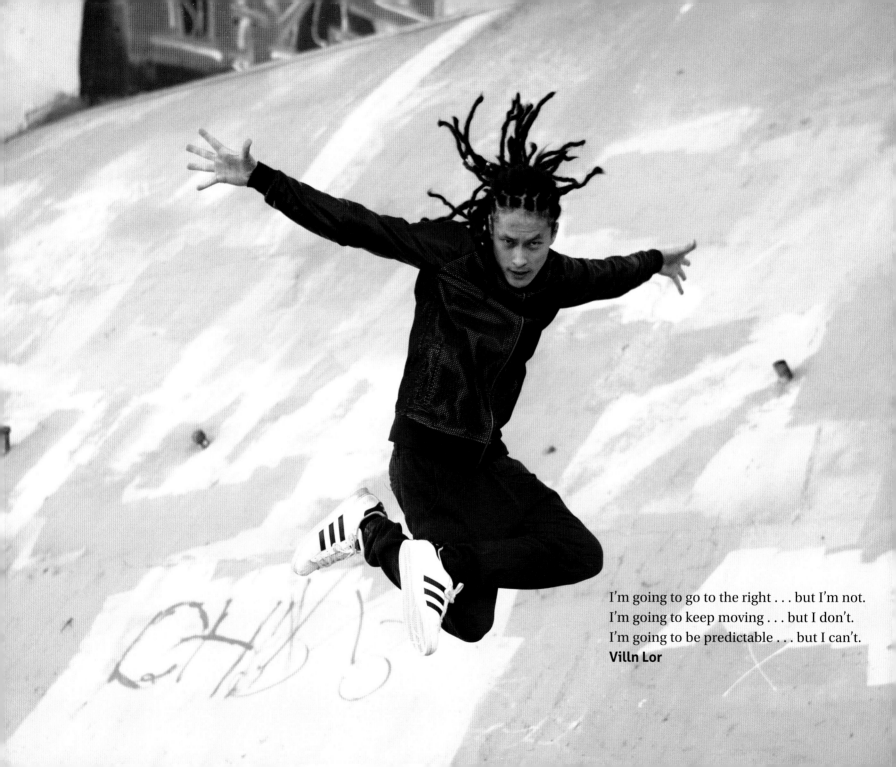

I'm going to go to the right . . . but I'm not.
I'm going to keep moving . . . but I don't.
I'm going to be predictable . . . but I can't.
Villn Lor

When I hit the ground I imagine a ripple effect—like sound waves that vibrate. Only certain people can feel it. If I'm really dancing from my soul I know I'm reaching them. **Ryanimay (Ryan Conferido)**

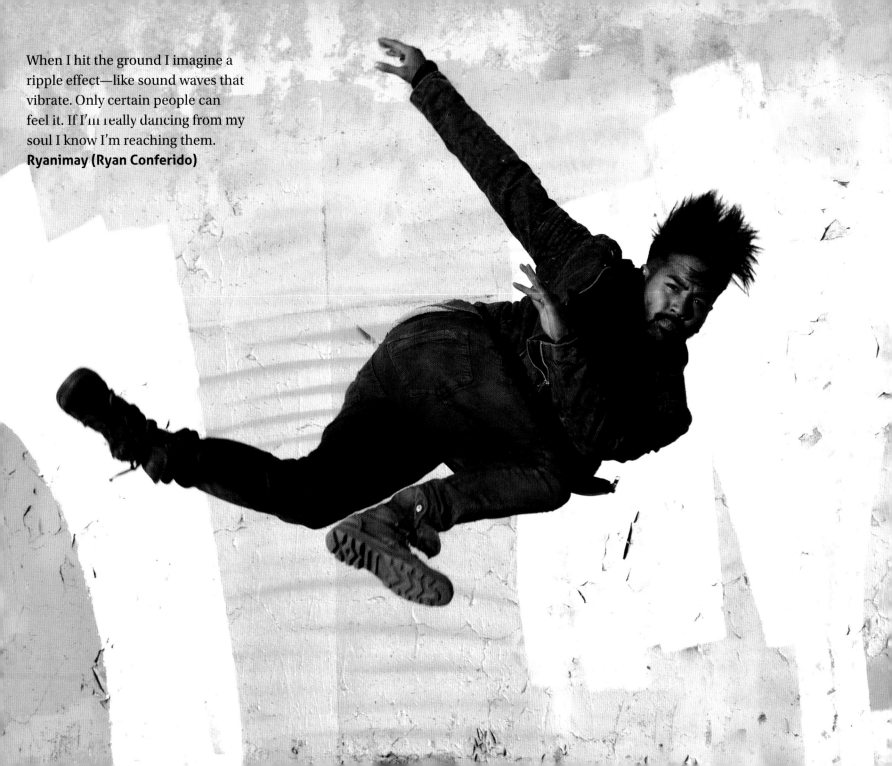

I worship the space in which I dance.
It's holy ground.
Alyssa Allen
USC Glorya Kaufman School of Dance

Dance creates atmospheric shifts
and with God, releases freedom.
Jordan Johnson
USC Glorya Kaufman School of Dance

The most frightening aspect of
the dancer's life is trying to make
a ripple and realizing that you
might never be the stone picked
up to skip the surface of the water.
Aidan Carberry

USC Glorya Kaufman School of Dance

My body is not perfect, but it's
working and that's enough.
Stephanie Dai

USC Glorya Kaufman School of Dance

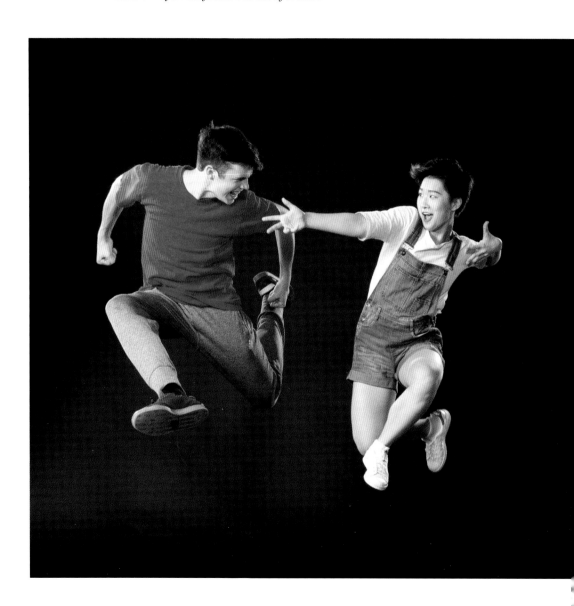

Improvisational dance is all about uncertainty and spontaneity—the life of the dancer parallels dance itself.

Jessica Muszynski

USC Glorya Kaufman School of Dance

The most challenging and frightening aspect of the dancer's life is self-reflection.

Austyn Rich

USC Glorya Kaufman School of Dance

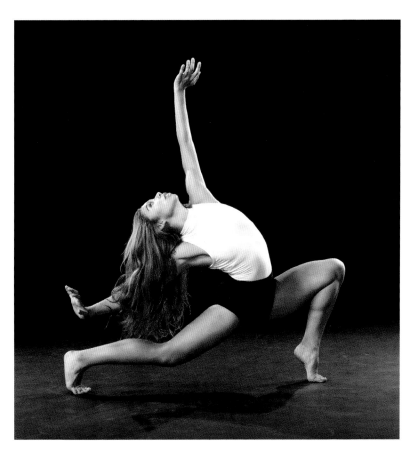

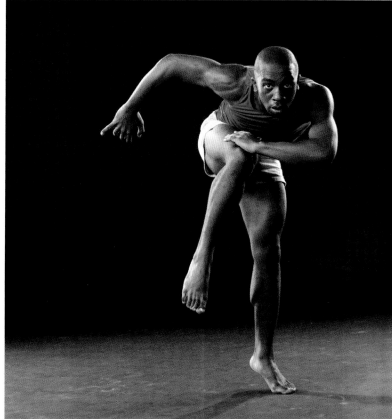

I've been told "no" thousands of times because of my height, weight and ethnicity . . . I want to show the world that if I can make it, anyone can.

Paulo Hernandez-Farella

USC Glorya Kaufman School of Dance

I plan to change the face of ballet. Why shouldn't it reflect this country's ethnic and racial diversity?

Lenai Wilkerson

USC Glorya Kaufman School of Dance

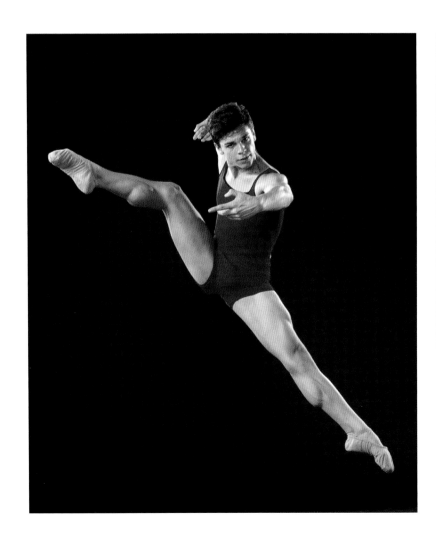

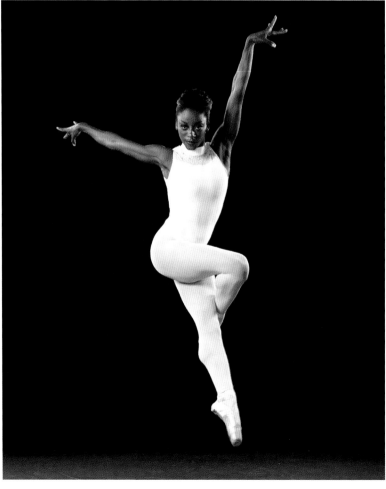

Acknowledgments

Hundreds of dancers and choreographers willingly or unknowingly served as the subjects of my ongoing exploration into the art of dance including the members of dance companies whose names I never knew. To all of them I am deeply grateful.

My appreciation extends to the magazine editors, art directors, dance companies, schools, arts institutions, universities, and festivals whose commissions and projects made it possible for me to work in a field I love and to help support my family and myself.

My career as a photographer began with the help of Zina Bethune, who in 1985 hired me, a total rookie, to photograph her company, Bethune Theatredanse. She taught me what to look for when shooting, how to edit, crop, retouch, and present work. We continued our collaboration until her untimely death in 2012. Zina you will always be in my heart. Thank you.

In the early 1990s, dancers Joaquin Escamilla, Chelsea Hackett, and Rei Aoo modeled for me in exchange for photos. In my sessions with them I honed my skills in lighting effectively, composing with skill and, most importantly, directing a studio shoot. It was these photos that opened doors to magazine editors, art directors, and dance company managers. My photograph of a leaping Joaquin Escamilla caught the eye of *Dance Magazine*'s managing editor and led to assignments, including magazine covers, that have continued to this day. Thank you Joaquin, Chelsea, and Rei Aoo.

Photographing Natalie Willes dancing along the shore in Malibu in 1998 was my first experience of creating images under the spell of a muse. She captivated me with her talent and beauty and made me aware that the act of creating can be as exciting as the finished work. Thank you Natalie.

My first big break came in 1998, when choreographer Donald Byrd hired me to create photos to market his company. I worried that I lacked the experience. On the morning of the shoot, I calmed my nerves, trusted my skills, and relied heavily on my dancer within to guide me. The results

were stunning. After the Byrd shoot, my career took off. Thank you Donald.

In 2000 I began what would evolve into a fifteen-year working relationship with Rodney Gustafson and State Street Ballet. My task was to come up with evocative images that represented the company's unique brand—heavily costumed storybook ballets featuring international casts. The challenge to be inventive and recognize the unique creative opportunities of every situation helped me grow as a visual artist. Thank you Rodney.

Since the summer of 2002, I have served as guest photographer at Jacob's Pillow Dance Festival, which has given me the opportunity to photograph its world-renowned visiting artists, including Mikhail Baryshnikov and Katherine Dunham. The Pillow has exhibited my photography, promoted my books with its Pillow Talks and bookstore sales, and launched "The Art of Photographing Dance Workshop," a five-day immersion into dance photography, which I direct every summer. Thank you Ella Baff, Connie Chin, J.R. Glover, Norton Owen, Ariana Brawley, Christopher Duggan, Whitney Browne, and Cherylynn Tsushima.

In the fall of 2015, Jodie Gates, director of USC's Glorya Kaufman School of Dance, commissioned me to serve as the school's inaugural photographer. What an honor it has been to be part of this new innovative model for dance in the twenty-first century. Photographing the program's talented young dancers and acclaimed faculty brought back memories of my university days as an aspiring dancer. Thank you Jodie and Dean Robert Cutietta.

As we embark on our fourth book together, I want to acknowledge the contributions of Suzanna Tamminen, editor-in-chief of Wesleyan University Press. Her confidence in my abilities and her continuing support are both humbling and invaluable. Thank you Suzanna.

I would never dream of putting together a book without the guidance of my long-time editor and big brother, Aron Hirt-Manheimer. Aron is a master editor, brilliant and intuitive, and blessed with a gentle nature and good sense. He's taught me that dedication to excellence is paramount in every creative endeavor. Thank you Aron.

Master choreographer Lar Lubovitch, who so graciously wrote the foreword for this book, showed me by example what it means to live the artist's life and create work that is impactful and inspiring. In so doing, he has enriched my own art and life. Thank you Lar.

My loving husband, Betzalel "Bitzy" Eichenbaum, has always encouraged and supported my work—even helping to fund my personal projects—no matter how all-consuming they might be. Thank you Bitzy.

My talented artistic son, Jeremy, has always been at the ready when I needed his discerning opinion. He also introduced me to Jessica Lee, my gifted graphic designer, who helped me sort through thirty years of photographs, make selections, and create the conceptual look for this book. Thank you Jeremy and Jess.

Many others played invaluable roles in the creation of this book or on my photographic journey. They include photo teachers Leigh Weiner and Bobbi Lane, family and close friends who lent a supportive ear when the going got rough, helped me with photo selections, opened their homes to me when on location, and even introduced me to some of the artists I wanted to photograph. Thank you Julie McDonald and JC Gutierrez of McDonald Selznick Associates; Terry Lindholm of Go 2 Talent Agency; Virginia Johnson of Dance Theater of Harlem School; Lori Belilove of the Isadora Duncan Dance Foundation; Christine Dobush of the Glen Tetley Legacy; Andrea Paris-Gutierrez of the Los Angeles Ballet Academy; Gillian Murphy of American Ballet Theatre; my long-time photo assistants, Michael Turner and Michael Butler; Jeff Ikemiya of JLI Imaging; Russell Adams of Schulman's Photo Lab; Richard Beardsley, my physical therapist; my amazing mother, Adela Manheimer; sister-in-law Judy Hirt-Manheimer; friends Donna Sternberg and Marcia Canazio; and my beautiful daughters, Ariella and Talia.

About the Artists and Photos

[xiv] This photo was taken in 1985 at Gene Marinaccio's School of Ballet in Hollywood, California. (The dancer's identity is not known.)

[2–7] JOAQUIN ESCAMILLA, Chelsea Hackett, and Rei Aoo (1963–2014) were popular commercial dancers working in the emerging Los Angeles dance scene of the mid-1990s. They graciously posed for me, in exchange for photographs, so that I could hone my skills and practice photographing action and the physical body. Photos taken at the former Moro-Landis Dance Studio in Studio City, California.

[8] MARK MENDONCA's artistry has distinguished him as one of America's most talented tap dancers. Described by Gregory Hines as "one of the finest dancers of any generation," Mendonca has delighted audiences on Broadway in *Bring in 'da Noise, Bring in 'da Funk* and has performed extensively, including at such venues as Carnegie Hall and the Kennedy Center in Washington, D.C. Photo of Mark Mendonca taken in 1997 in Los Angeles for *L.A. Dance and Fitness Magazine*.

[9] GWEN VERDON (1925–2000) was one of Broadway's most legendary triple threats, starring in *Sweet Charity*, *Chicago*, and *Dancin'*. The four-time Tony Award winner is often remembered as choreographer Bob Fosse's muse. Verdon starred in such films as *Damn Yankees*, *The Cotton Club*, and *Cocoon*. Photo of Gwen Verdon taken in 1997 at the Bob Fosse Awards in Hollywood, California.

[10–13] NATALIE WILLES is a recipient of the Los Angeles Music Center's prestigious Spotlight Award for choreography and performance in contemporary dance. She was only sixteen when she became the youngest Rockette in Radio City Music Hall history. Natalie has appeared on Broadway in *Movin' Out*, *Saturday Night Fever*, and *Leap of Faith* and in the film *Chicago*, which won an Oscar for Best Picture of 2002. Photos of Natalie Willes taken in 1998 on the beach in Malibu, California.

[14–15] JULIE BRETTE ADAMS is one of the most active figures in the dance community of Santa Fe, New Mexico. She is a performing artist, choreographer, and instructor of dance, yoga, and Pilates. Photo of

Julie Adams taken at the Santa Fe Photographic Workshops in 1999, when she served as a model for students (of which I was one).

[16–21] DONALD BYRD is an award-winning choreographer who has created more than one hundred modern and contemporary works. From 1978 to 2002 he directed Donald Byrd's/The Group. He is currently artistic director of Spectrum Dance Theater, based in Seattle, Washington. Photos of Donald Byrd's *Jazz Train* taken in 1998 in Hollywood, California.

[22] DAVID PARSONS is one of the dance world's most respected and innovative choreographers. Founded in 1987, Parsons Dance Company has toured twenty-two countries on five continents. With a repertory of more than seventy-five works, he continues to define and expand the art of dance in line with his mission to enrich life through contemporary dance. Photo of David Parsons taken in Central Park in 1999 for *Masters of Movement: Portraits of America's Great Choreographers.*

[23] DANIEL EZRALOW is a hugely sought-after choreographer who works across a wide range of media—theater, film, opera, television, and live-action shows. His credits include *Across the Universe* (film), and *The Green Bird* and *Spider-Man: Turn Off the Dark* (Broadway). In 2014 he choreographed the opening ceremony for the Sochi Olympic Games. Photo of Daniel Ezralow taken in 1998 at El Matador Beach in Malibu for a cover story in *Dance Teacher Magazine.*

[24] PARISSA is an internationally acclaimed tango and ballroom dancer, instructor and choreographer. She and her dance partner and husband, Sandor, have appeared on *Dancing with the Stars* and choreographed many of the show's Argentinian-style tangos. Photos of Parissa and Desmond James taken in Los Angeles in 2001.

[25] RENNIE HARRIS is a dancer, choreographer, and educator and among the first to bring hip-hop street dance into the mainstream. In 1992 he formed his dance company, Puremovement, which continues to serve as a vehicle for the preservation and dissemination of hip-hop dance and culture. Photo of Rennie Harris taken in front of the Philadelphia Art Museum in 1999 for *Dance Magazine.*

[26–29] AMERICAN REPERTORY DANCE COMPANY, founded in 1994, served as a living museum to honor the great pioneers of modern dance and to preserve their works. ARDC brought these extraordinary vintage works to a new generation of dance lovers. Its performers included Bonnie Oda Homsey, Nancy Colahan, and John Pennington. Photos of Oda Homsey, Colahan, and Pennington taken at Conjunctive Points Dance Studio, Culver City, California, in 2000.

[30–31] JANET EILBER is a former principal dancer with the Martha Graham Dance Company. Having worked intimately with Martha and performed many of her signature roles, she is one of the foremost authorities on the Graham repertory. Since 2005, Eilber has served as the artistic director of the Martha Graham Dance Company. Photos of Janet Eilber taken in Hollywood, California, in 1999 for *Dance Magazine.*

[32–33] GREGORY HINES (1946–2003) is remembered as one of America's most beloved entertainers and for having revived the tap dance tradition after its near extinction. Hines has been credited with giving tap a contemporary look with a more hip, sexy, and athletic attitude. Photos of Gregory Hines taken at Westside Academy Dance Studio in 1999 for *Masters of Movement: Portraits of America's Great Choreographers.*

[34–35] STATE STREET BALLET is a West Coast ballet company known for blending classical and contemporary ballet, dynamic costumes and sets, and an international cast. SSB was founded in 1994 by former American Ballet Theatre dancer, Rodney Gustafson. Photos taken at State Street Ballet School in Santa Barbara, California, between 2000 and 2014.

[46–47] RONALD K. BROWN is known for developing a new movement vocabulary by combining classic modern-dance technique and West African traditional dance styles. In 1986 he founded Evidence,

A Dance Company and continues to serve as its choreographer and artistic director. Photo of Ronald K. Brown taken in New York for *Dance Magazine's* first cover story of the twenty-first century. Photo of Evidence, A Dance Company taken in a Manhattan photo studio in 1999.

[48–51] DANZA FLORICANTO/USA, founded in 1975, is the oldest existing Mexican folk dance troupe in Southern California. As a touring company under the directorship of Gema Sandoval, it serves to create awareness of Mexican heritage and promote cultural identity for the Chicano/Latino community. Photos of Danza Floricanto taken in Hollywood, California, in 2000.

[52] JOSÉ GRECO (1918–2000) popularized Spanish and flamenco dance worldwide. An international star for more than thirty-five years, he performed on the theatrical stage, on television, and in films, as well as in stadiums and nightclubs. He was known for his charismatic persona, precision, musicality, and *machismo*, characteristic of the male Spanish dancer. Photo of José Greco taken at his home in Lancaster, Pennsylvania, in 1999.

[53] CARMELA GRECO is the eldest daughter of the late José Greco and an accomplished flamenco dancer in her own right. She has toured throughout Europe, Africa, the Middle East, and the United States. Photo of Carmela Greco taken at Rose Eichenbaum Photo Studio, Encino, California, in 2006.

[54] MATTHEW RUSHING is one of the most dynamic and technically gifted performers to emerge from the Alvin Ailey American Dance Theater. Rushing joined the company in 1992 and has performed many of Alvin Ailey's masterworks, along with those of the company's world-renowned visiting choreographers. Rushing has also choreographed a number of works for the AAADT and became its rehearsal director in 2010. Photo of Matthew Rushing taken in a Manhattan photo studio in 2000.

[55] ANNA HALPRIN is best known for her innovative exploration of movement in the service of personal healing and community building. Her *Circle the Earth*, a contemporary community dance ritual, and her *Planetary Dances* celebrate the beauty of nature and fellow man regardless of race, culture, or spiritual practice. Photo of Anna Halprin taken at her home in Northern California in 1998 for *Masters of Movement: Portraits of America's Great Choreographers*.

[56] JUDITH JAMISON joined the Alvin Ailey American Dance Theater in 1965 and quickly became one of its brightest stars. Her tour de force performance in *Cry* brought her wide recognition as one of the most powerful dancers of her generation. After Ailey's death in 1989, she served as the company's director for over twenty years. Photo of Judith Jamison taken at the Alvin Ailey American Dance Theater Studio in 2002 for *Masters of Movement: Portraits of America's Great Choreographers*.

[57] MARK MORRIS is one of America's most respected choreographers of theatrical dance and opera, acclaimed for his craftsmanship, humor, and musicality. His company, Mark Morris Dance Group, performs an average of ninety shows each year in thirty-five cities worldwide. Photo of Mark Morris taken at the W Hotel in Los Angeles, California, in 1998 for *Masters of Movement: Portraits of America's Great Choreographers*.

[58] KATHERINE DUNHAM revolutionized dance in the 1930s by drawing attention to the roots of black dance and presenting it as beautiful and compelling. In so doing, she inspired a new generation of African-American dancers and choreographers to use dance as a powerful tool for awareness, artistic expression, and social justice. Photo of Katherine Dunham taken in 2002 at Jacob's Pillow Dance Festival for *Masters of Movement: Portraits of America's Great Choreographers*.

[59] BILL T. JONES, the recipient of numerous awards including the National Medal of Arts, MacArthur Genius Grant, and a Tony Award, is one of America's most respected and sought-after dancer/choreographers. He continues to create new works through his

company, Bill T. Jones/Arnie Zane Dance Company, New York Live Arts, and commissions. Photo of Bill T. Jones taken in Harlem outside the Aaron Davis Hall in 2001 for *Masters of Movement: Portraits of America's Great Choreographers.*

[60] ANN REINKING is the recipient of numerous awards including a Tony, Outer Critics Circle Award, Astaire Award, and Drama Desk Award for acting, dancing, and choreography. She has appeared in numerous Broadway shows, among them *A Chorus Line, Chicago, Dancin',* and *Sweet Charity.* Reinking is considered the foremost interpreter of the Bob Fosse style, having been his protégée during the 1970s and 1980s. Photo of Ann Reinking taken in New York in 1999 for *Masters of Movement: Portraits of America's Great Choreographers.*

[61] TOMMY TUNE is the only person in history to win Tony Awards as a dancer, singer, choreographer, and director; he also received the 2015 Lifetime Achievement Award, for a total of ten Tony Awards in all. Known as a tap dancer, he is currently touring the country in his one-man show, *Taps, Tunes, and Tall Tales.* Photo of Tommy Tune taken in his dressing room at the MGM Grand Hotel Theater in Las Vegas in 1999 for *Masters of Movement: Portraits of America's Great Choreographers.*

[62] SHIRLEY MACLAINE began her professional career as a dancer, kicking it up on Broadway in Bob Fosse's *Pajama Game* and later appearing in numerous Hollywood musicals including *Can-Can, What a Way to Go!* and *Sweet Charity.* Photo of Shirley MacLaine taken at the Rose Eichenbaum Photo Studio in 2005 for *The Dancer Within.*

[63] CHITA RIVERA is a two-time Tony Award winner who starred in some of Broadway's most successful shows, among them *Call Me Madam, West Side Story, Bye Bye Birdie, Chicago, Kiss of the Spider Woman,* and *Chita Rivera: The Dancer's Life.* In addition to her stage awards, she is a recipient of the Presidential Medal of Freedom. Photo of Chita Rivera taken in New York in 2005 for *The Dancer Within.*

[64] PAULA KELLY has starred in film, television, and on the Broadway stage alongside Gene Kelly, Sammy Davis Jr., Gregory Hines, Juliet Prouse, and other giants of dance. Paula Kelly also performed opposite Chita Rivera and Shirley MacLaine in the Bob Fosse film, *Sweet Charity.* Photo of Paula Kelly taken at Rose Eichenbaum Photo Studio in 2005 for *The Dancer Within.*

[65] LIZA MINNELLI is an iconic singer, dancer, and actress best known for her role as Sally Bowles in Bob Fosse's 1972 hit film, *Cabaret,* for which she won an Academy Award. Her television special, *Liza with a Z,* aired that same year, winning four Emmy Awards and a Peabody. Photo of Liza Minnelli taken in 2006 at her Manhattan apartment for *The Dancer Within.*

[66–67] ROBERT LA FOSSE was a principal dancer with both American Ballet Theatre and the New York City Ballet during the 1970s and 1980s. He partnered with the greatest ballerinas of the day, among them Gelsey Kirkland, Leslie Brown, Natalia Makarova, and Cynthia Gregory. La Fosse remains a presence in the ballet world as a choreographer and lecturer. Photos of Robert La Fosse taken in Manhattan in 2005 for *The Dancer Within.*

[68] LESLIE CARON became an instant Hollywood star after Gene Kelly chose her as his leading lady in the 1951 musical, *An American in Paris.* With a promising ballet career before her, she chose instead to pursue acting after MGM offered her a movie contract. Leslie Caron is one of the few women to have partnered with Gene Kelly, Fred Astaire, Mikhail Baryshnikov, and Rudolf Nureyev. Photo of Leslie Caron taken in Paris in 2005 for *The Dancer Within.*

[69] FERNANDO BUJONES (1955–2005) is considered one of the finest male dancers of the twentieth century. At nineteen he became a principal with American Ballet Theatre, the youngest in the company's history. During his thirty-year performance career, he guest-starred in more than sixty companies and partnered with many of the world's greatest ballerinas. Photo of Fernando Bujones taken on the plaza at Lincoln Center in 2005 for *The Dancer Within.*

[70–73] CLEO PARKER ROBINSON's Denver-based Cleo Parker Robinson Dance Company serves as a vehicle for her passion for dance,

community building, and philosophy of "One Spirit, Many Voices." As a master teacher, choreographer, and performer, she is one of the most respected figures in dance and the recipient of numerous prestigious awards. Photos of Cleo Parker Robinson and company taken in Denver, Colorado, for *Dance Teacher Magazine* in 2009.

[74] PILOBOLUS is a world-class dance company founded in 1971 by Moses Pendleton, Jonathan Wolken, Robby Barnett, Michael Tracy, Martha Clarke, and Alison Chase. More than forty years later, Pilobolus continues to mesmerize and thrill audiences with their unique physicality, movable body sculptures, humor, and imaginative choreography. Photo of Pilobolus's *B'zerk* taken at the Hatlen Theater on the UC Santa Barbara campus for *From the Wings*.

[75] LA LA LA HUMAN STEPS was one of the world's most acclaimed ballet companies, known for its extreme and inventive use of the ballet idiom and movement vocabulary. Founded by Canadian choreographer Édouard Lock in 1980, the company produced a number of highly original works and toured around the world until disbanding in 2015. Photo of La La La Human Steps' *Amelia* taken at Royce Hall on the UCLA campus in 2002 for *Pointe Magazine*.

[76-77] MARTHA GRAHAM DANCE COMPANY has been at the forefront of dance since its inception in 1926 and among the most influential dance companies in the world. Recognized as one of the greatest artists of the twentieth century, Martha Graham (1894–1991) developed a movement language based on the body's ability to be expressive. Her choreographic works, along with newly commissioned works by contemporary choreographers, make up MGDC's extensive repertory. The company continues to tour worldwide in addition to running a school for training in the Graham technique. Photo of MGDC's *Rite of Spring* taken at Jacob's Pillow Dance Festival in 2013.

[76-77] BLAKELEY WHITE-MCGUIRE is a principal dancer with the Martha Graham Dance Company. Since joining the company in 2002, she has performed major roles in the extensive Graham canon, including *Appalachian Spring, Cave of the Heart, Chronicle, Deaths and Entrances, Deep Song, Frontier, Rite of Spring*, and others. Photo of Blakeley White-McGuire as the chosen one in Graham's *Rite of Spring* taken at Jacob's Pillow in 2013.

[78] MICHELE SIMMONS was a former dancer with the Alvin Ailey American Dance Theater and a popular commercial dancer. She also appeared in Michael Jackson's *Thriller*. (She's one of the zombies dancing behind Jackson, wearing white pearls.) In later years Simmons suffered from multiple sclerosis and was confined to a wheelchair. She died in 2012. Photo of Michele Simmons taken in Los Angeles in 2006.

[79] MITZI GAYNOR, a trained ballet dancer who signed with Twentieth Century Fox Studios at the age of seventeen, became one of Hollywood's most popular singer-dancer-actors. She starred in numerous musicals including *There's No Business Like Show Business, Anything Goes, Les Girls*, and *South Pacific*. Later she headlined in Las Vegas and at supper clubs around the country. From 1963 to 1978, Mitzi starred in nine television specials. Photo of Mitzi Gaynor taken at her Beverly Hills home in 2006 for *The Dancer Within*.

[80] PAUL TAYLOR danced in the Martha Graham Dance Company before becoming one of America's most prolific modern dance choreographers. He established the Paul Taylor Dance Company in 1954 and it remains one of America's most celebrated dance companies. Photo of Paul Taylor taken in 2003 at his Montauk home on Long Island for *Masters of Movement: Portraits of America's Great Choreographers*.

[81] MIKHAIL BARYSHNIKOV is considered one of the greatest dancers in history. After defecting from Russia in 1974, he went on to perform internationally. In 1980, he assumed the role of artistic director of American Ballet Theatre. Baryshnikov has worked with a number of major ballet companies, including his own White Oak Dance Project from 1990 to 2002. He continues to have an impact on the art form through his Baryshnikov Arts Center and stage appearances. Photo of Mikhail Baryshnikov was taken in 2002 at Jacob's Pillow Dance Festival with his permission.

[82] RACHAEL MCDONALD trained at the Performing Arts High School in Pittsburgh, Pennsylvania, the Pittsburgh Ballet Theater, and at the Martha Graham School in New York. She has danced in numerous companies, among them the Martha Graham Dance Company, Landrum Dance Company, and Guajana Dance Company. She has also appeared in film and television. Photo of Rachael McDonald was taken in the Encino Hills in California in 2001.

[83] YURIKO became a member of the Martha Graham Dance Company in 1944. She is best remembered for her extraordinary command of the Graham technique and her performances of masterworks: *Clytemnestra*, *Appalachian Spring*, *Cave of the Heart*, and *Dark Meadow*. She continues to coach the new generation of Graham dancers. Photo of Yuriko taken in 2005 at her Manhattan apartment for *The Dancer Within*.

[84] CYNTHIA GREGORY is one of America's most accomplished prima ballerinas. During her thirty-year career, she performed with the world's leading ballet companies and partnered with the greatest male dancers of our time, including Rudolf Nureyev, Mikhail Baryshnikov, Fernando Bujones, Erik Bruhn, and Bruce Marks. She retired from performing in 1992 but continues to coach and teach master classes as well as choreograph. Photo of Cynthia Gregory taken at her Greenwich, Connecticut, home in 2005 for *The Dancer Within*.

[85] BEN VEREEN is known for his stylish dancing and infectious energy. He has appeared on Broadway in *Hair*, *Jesus Christ Superstar*, *Pippin*, *Fosse* and *Jelly's Last Jam*. An accomplished singer and actor, he played a starring role in the hit television mini-series series, *Roots*. He also appeared in the film *All That Jazz*. He continues to perform his one-man show in the United States and abroad. Photo of Ben Vereen taken in 2005 in Morristown, New Jersey, for *The Dancer Within*.

[86] FRANCESCA HARPER is the daughter of Denise Jefferson, former director of the Alvin Ailey American Dance Theater School. Francesca has danced in the companies of Dance Theater of Harlem and William Forsythe's Ballet Frankfurt and in numerous Broadway shows, including *Fosse*, *The Producers*, and *The Color Purple*. Her Francesca Harper Project was launched in 2005. Photo of Francesca taken in 2005 in New York.

[87] MARY HINKSON (1925–2014) is remembered as one of Martha Graham's most dramatic dancers and one of the first African-American dancers to perform with her company during its golden era from the 1950s to the 1970s. Hinkson danced Graham's most famous works: *Clytemnestra*, *Deaths and Entrances*, *Acrobats of God*, *Phaedra*, *Canticle for Innocent Comedians*, and *Circe*, which was created expressly for her. Photo of Mary Hinkson taken in Manhattan in 2005 for *The Dancer Within*.

[88–89] RASTA THOMAS was only sixteen when he won a gold medal at the International Ballet Competition in 1998, the youngest to win in the senior division. His talent and stature led to guest appearances in some of the most respected dance companies in the world. In 2007 he formed his own company, the Bad Boys of Dance, which continues to tour nationally and internationally. Photos of Rasta taken in Orlando, Florida, in 2004 and Newport Beach, California, in 2005.

[90] MARINE JAHAN served as dancing body double for actress Jennifer Beals in the 1983 hit film, *Flashdance*. An attempt by the film's producers to fool the public into thinking that Beals had done all her own dancing was exposed shortly after the film's release. Jahan was hailed as the film's real star. Photo of Marine taken in Seattle at the Pacific Northwest Ballet studios in 2006 for *The Dancer Within*.

[91] NATALIA MAKAROVA is regarded as one of the world's greatest classical ballerinas. She caused an international uproar in 1970 when she defected from Russia in search of artistic freedom. She found meaningful roles as a permanent guest artist with the American Ballet Theatre and the Royal Ballet of London. Ms. Makarova continues to teach, coach, and stage ballets. Photo of Natalia Makarova taken at Zellerbach Hall on the UC Berkeley campus in 2006 for *The Dancer Within*.

[92] JEAN BUTLER is an Irish step-dance champion who was catapulted

onto the world stage in 1994 when she collaborated with Michael Flatley to create the original theatrical show, *Riverdance*. The show went on to become an international sensation. Butler continues to perform, teach, and choreograph. Photo of Jean Butler was taken at her Brooklyn apartment in 2006 for *The Dancer Within*.

[93] ETHAN STIEFEL was a principal dancer with American Ballet Theatre from 1997 to 2012. Regarded as one of America's greatest homegrown male ballet dancers, he has guest-starred with several world-class companies, including the Royal Ballet, Australian Ballet, Munich Ballet, Zurich Ballet, Teatro Colón Ballet, and others. In 2000 he assumed a starring role in the popular film *Center Stage*. From 2011 to 2014 he served as artistic director for the Royal New Zealand Ballet. Photo of Ethan Stiefel taken at the Colburn School in Los Angeles in 2007 for *The Dancer Within*.

[94] DUDLEY WILLIAMS (1938–2015) enjoyed a brilliant career as one of Alvin Ailey's American Dance Theater's most beloved artists. A member of the company for more than four decades, he also performed in the companies of Martha Graham, Donald McKayle, and Talley Beatty. Williams is remembered for his eloquence, musicality, and technique. Photo of Dudley taken in 2005 in New York for *The Dancer Within*.

[95] SUSAN JAFFE is a former principal ballerina and ballet mistress with American Ballet Theatre. During her years with the company, she danced a wide-ranging repertoire from classical works like *Swan Lake* to Twyla Tharp's *Push Comes to Shove* and Jiří Kylián's *Stepping Stones*. She is active in the dance world as a teacher and choreographer. Photo of Susan Jaffe taken in New York in 2005.

[96–101] JAZZ TAP ENSEMBLE was founded in 1979 and has been at the forefront of the tap dance renaissance since its inception. Over the years, it has featured tap's most legendary artists and continues to showcase new talent. Lynn Dally, one of the company's founding members, serves as JTE's artistic director. Photos of JTE span a number of years, taken on commission at both the Westside Academy in Santa Monica and Malibu's Pepperdine University Theater.

[96, 98] JASON SAMUELS SMITH was only fifteen when he became understudy to the leading role in Broadway's Tony Award winning cast of *Bring in 'da Noise, Bring in 'da Funk*. Smith has since emerged as a multitalented leader in the art form of tap as a performer, choreographer, and director. In addition to his many stage and screen performances, he is known worldwide as an advocate and spokesman for tap. Photo of Jason Samuels Smith taken in 2008 when he was a guest artist with Jazz Tap Ensemble.

[96, 97, 99] CHLOE ARNOLD is an internationally recognized tap dancer, having performed in nearly thirty countries and throughout the United States. Beginning her professional career at the age of ten, she has shared the stage with many of the greatest tap dancers in the world, among them Gregory Hines, the Nicholas Brothers, Savion Glover, and others. She is the founder of Syncopated Ladies, a critically acclaimed all-women tap dance band. Photo of Chloe Arnold taken in 2008 when she was a guest artist with Jazz Tap Ensemble.

[96, 99, 101] JOSETTE WIGGAN-FREUND is the first tap dancer to win a coveted Spotlight Award from The Music Center in Los Angeles. She has been a member of the national cast of *42nd Street*, *American Tap Masterpieces*, and Cirque du Soleil's *Michael Jackson The Immortal World Tour*, and is a frequent performer with Jazz Tap Ensemble. Photos of Josette Wiggan-Freund taken with Jazz Tap Ensemble in 2008 and 2011.

[101] MICHELLE DORRANCE is one of the most sought-after tap dancers of her generation. The recipient of a 2015 MacArthur Fellowship, she is known for pushing the boundaries of tap through her extraordinary technical range, speed, musicality, and choreographic imagination. She is the founder and artistic director of Dorrance Dance. Photo of Michelle Dorrance taken in 2011 when she was a guest artist with Jazz Tap Ensemble.

[102–103] LORI BELILOVE has dedicated her life's work to promoting the art of Isadora Duncan (1878–1927). Through her Isadora Duncan Dance Foundation, performing troupe, and workshops in the Duncan

technique, Belilove maintains and reinforces Isadora's vision: that dance can nurture the soul and lift the spirit. Photo of Lori Belilove taken in Central Park in 2004 for *The Dancer Within*. Photo of the company taken at New York's City Center in 2006.

[104] RUSS TAMBLYN is an American actor and dancer known for his many Hollywood film roles, among them *Seven Brides for Seven Brothers, Hit the Deck, Tom Thumb*, and *West Side Story*, in which he played Riff, the leader of the Jets. Trained as a gymnast, Tamblyn performed the works of such choreographic greats as Michael Kidd, Hermes Pan, Alex Romero, and Jerome Robbins. Photo of Russ Tamblyn taken at Rose Eichenbaum Photo Studio in 2005 for *The Dancer Within*.

[105] RITA MORENO is one of Hollywood's most beloved and enduring entertainers. Her charismatic performance as Anita in the film, *West Side Story*, not only won her an Academy Award, but celluloid immortality. She is among a rare group of individuals who has received an Oscar, an Emmy, a Grammy, and a Tony Award. Photo of Rita Moreno taken at her Berkeley Hills home in 2005 for *The Dancer Within*.

[106] MIA MICHAELS is an American choreographer, best known as a judge and choreographer on the television show, *So You Think You Can Dance*. She has created choreography for some of the music industry's most popular singers, among them Céline Dion, Madonna, Ricky Martin, Prince, and Gloria Estefan. Photo of Mia Michaels taken in 1999 in Greenwich Village for *Masters of Movement: Portraits of America's Great Choreographers*.

[107] PETER BOAL is a former principal with the New York City Ballet who, during his twenty-two years with the company, performed in more than forty ballets and had original roles created specifically for him by ballet's most esteemed choreographers. Boal is currently the artistic director of Pacific Northwest Ballet. Photo of Peter taken in 2004 at the School of American Ballet for *The Dancer Within*.

[108] CARMEN DE LAVALLADE is considered one of the most beautiful dancers ever to grace the stage. She has danced with the Alvin Ailey American Dance Theater, American Ballet Theatre, Metropolitan Opera, Complexions, and Paradigm. Ms. de Lavallade is also an accomplished actor and has appeared on Broadway in *House of Flowers* and *A Streetcar Named Desire*, as well as in the 1954 film, *Carmen Jones*. Photo of Carmen de Lavallade taken at the Los Angeles Music Center during her guest appearance with Complexions Contemporary Ballet in 2000.

[109] IVAN PUTROV is a Ukrainian-born dancer who became a member of the Royal Ballet of London in 1998. Promoted to principal in 2002, he has performed featured roles in *The Nutcracker, Symphonic Variations, Cinderella, La fille mal gardée*, and *Pierrot Lunaire*. Photo of Ivan taken in 2005 at London's Covent Garden at the premiere of *Pierrot Lunaire* for *Pointe Magazine*.

[110–111] DESMOND RICHARDSON is considered among the most gifted dancers of his generation. He has performed the works of some of the world's most celebrated choreographers and danced in such companies as the Alvin Ailey American Dance Theater, Frankfurt Ballet, American Ballet Theatre, Royal Swedish Opera Ballet, Teatro alla Scala, and his own Complexions Contemporary Ballet, which he co-directs with choreographer Dwight Rhoden. Photos of Desmond Richardson taken in New York City in 2005 for *The Dancer Within*.

[112–115] PINA BAUSCH, born in Germany, was a dancer and choreographer who had a profound influence on modern dance from the early 1970s until her death in 2009. She developed a collaborative approach with her dancers that came to be known as Tanztheater, which blended movement, sound, dialogue, sets, and improvisation. Her company, Tanztheater Wuppertal Pina Bausch, continues to perform her extensive repertory. Photo of Tanztheater Wuppertal Pina Bausch's *Ten Chi* taken at UCLA's Royce Hall in 2007 for *From the Wings*.

[116–119] URBAN BUSH WOMEN is an internationally acclaimed dance company founded by dancer/choreographer Jawole Willa Jo Zollar

in 1984. UBW is dedicated to exploring dance as a vehicle for social change. Zollar has choreographed more than thirty works for UBW and numerous other companies. Photos of Urban Bush Women's *Walking with Pearl* taken at the Luckman Theater in Los Angeles in 2006 for *From The Wings.*

[120–121] DAVID ROUSSÈVE is the artistic director and choreographer for David Roussève/Reality, a dance theater company that has toured throughout the United States, Europe, and South America. He has received numerous honors and is a former Guggenheim Fellow. Roussève is currently interim dean of fine arts at UCLA's World Arts and Cultures/Dance. Photo of David Roussève taken at UCLA in 2006.

[122–127] DON MCLEOD is a world-renowned mime, living statue, butoh artist, and actor. He studied movement with the French mime Marcel Marceau and Japanese butoh artist Kazuo Ohno. He has appeared in numerous feature films, television shows, and commercials, including the award-winning ad for American Tourister Luggage in which he played the role of the suitcase-smashing gorilla. Photos of Don McLeod taken over a period of years at Rose Eichenbaum Photo Studio.

[128–131] EIKO AND KOMA are known for extraordinary theater of movement out of stillness, shape, light, and sound, and thematic material based on the human experience. They studied under butoh founder Kazuo Ohno prior to emigrating to the United States and establishing themselves as world-class performing artists. Photos of *Water* were taken in 2011 at the Skirball Cultural Center in Los Angeles.

[132] DONNA STERNBERG founded her company, Donna Sternberg and Dancers, in 1985 with a mission to build bridges between dance, science, philosophy, and other forms of art. Donna has choreographed more than seventy-five works and has showcased them throughout the United States and Mexico. Photo of *Rage to Know* was shot on commission in 2007 in Los Angeles.

[133] DOUG VARONE is an award-winning choreographer who has worked in theater, film, opera, television, and fashion. Since the founding of Doug Varone and Dancers in 1986, his company has toured extensively in the United States, Europe, South America, Asia and Canada. Varone's work is known for its emotional range, kinetic use of the body, and collaborative approach. Photo of *Neither* was taken on commission in 2001 at the Lower East Side Tenement Museum in New York City.

[134] DEIDRE DAWKINS is a dancer, choreographer, and instructor. A former Bessie Award winner, she performed in Ronald K. Brown's Evidence, A Dance Company for eight years before founding her own company, DishiBem Traditional Contemporary Dance Company.

[134] PRINCESS MHOON is an acclaimed dancer, choreographer, and owner of Princess Mhoon Dance Institute. In 2016 she was invited by Michelle Obama to participate in the Black Women in Dance Celebration and served as a panelist for the White House initiative on Education Excellence for African Americans during Women's History Month.

[135–139] Since founding REGINA KLENJOSKI DANCE COMPANY in 2001, the Macedonian-born choreographer has created numerous works that examine human nature and the search for intimacy in contemporary society. Her interest in the moving body and its ability to communicate ideas and emotions, and make socially and politically relevant statements, is what defines her dance work.

[140–141] LES GRANDS BALLETS CANADIENS DE MONTREAL perform a broad range of contemporary and classic works commissioned by notable international choreographers, among them Jiří Kylián, Christopher Wheeldon, and Mats Ek. Photo of *Minus One*, choreographed by Ohad Naharin, was taken in 2007 at the Irvine Barclay Theatre in Irvine, California, for *From the Wings.*

[140–141] OHAD NAHARIN is considered one of the world's preeminent choreographers. Since becoming artistic director of Israel's Batsheva Dance Company in 1990, he has gained international acclaim. Naharin's works have been commissioned and performed by numerous dance companies, including Opèra National de Paris, Lyon

Opera Ballet, Rambert Dance Company, and Hubbard Street Dance Chicago.

[142–143] PACIFIC NORTHWEST BALLET is one of America's most elite ballet companies. Based in Seattle, Washington, it is directed by former New York City Ballet principal dancer Peter Boal. PNB performs extensively throughout the year, showcasing the works of many noted choreographers. Photo of PNB's *Rite of Spring* choreographed by Glen Tetley taken at McCaw Hall in Seattle in 2004.

[142–143] GLEN TETLEY (1926–2007) distinguished himself as a master choreographer by pioneering the fusion of modern dance and ballet. Prolific from the 1960s to the 1990s, Tetley amassed a large body of work widely embraced in Europe. His ballets reside mostly in the repertoire of several European-based companies. Photo of Glen Tetley taken in 2004 in Seattle, Washington, after a performance of his *Rite of Spring* with PNB.

[144–147] DIAVOLO/ARCHITECTURE IN MOTION, founded in 1992 by French-born choreographer Jacques Heim, is a unique dance company that explores the relationship between the human body and its architectural environment. Heim's inventive, larger-than-life structures and models serve to reflect and reveal how we are affected emotionally, physically, and socially by the spaces we inhabit. Photo of Diavolo's *Fearful Symmetries* taken in 2010 in Los Angeles.

[148] DEBBIE ALLEN is a highly accomplished American dancer, choreographer, director, and producer. She is best known for her work on the 1982 television series, *Fame*, in which she played dance teacher Lydia Grant and served as the show's choreographer. Allen is the recipient of numerous awards, including three Emmys.

[148] VIVIAN NIXON is the daughter of Debbie Allen and a dancer and actress in her own right. She has appeared on Broadway in *Hot Feet*, in various regional productions, and on television. Photo of Debbie Allen and Vivian Nixon taken in 2001 for a cover and feature story for *Dance Teacher Magazine*.

[149–151] AURELIA THIERRÉE is the granddaughter of Charlie Chaplin and the daughter of circus performer and illusionist Victoria Thierrée. Aurelia's work is based on a theatrical blending of magic, mystery, dream-like imagery, and suspension of disbelief. Photos of *Aurelia's Oratorio* taken in 2007 at Jacob's Pillow Dance Festival for *From the Wings*.

[152] JOLIE MORAY is a multiple award-winner who has received invitations to train at some of the most prestigious schools, festivals, and summer intensives in the world, among them American Ballet Theatre, the Bolshoi Ballet, and San Francisco Ballet. Jolie is also a student of renowned ballet coach Alla Khaniashvili, formerly of the Bolshoi Ballet. Photo of Jolie Moray at the age of sixteen taken in 2014 in Los Angeles.

[153] KYLE ABRAHAM is one of America's most innovative dancer-choreographers and the artistic director of Abraham.In.Motion. His work, which focuses on identity and social behavior, has earned him numerous honors, including a Bessie, a Princess Grace Award, and a MacArthur Fellowship. Photo of Kyle Abraham taken at Rose Eichenbaum Photo Studio in 2013 for *Inside The Dancer's Art*.

[154–155] TAMICA WASHINGTON-MILLER is the associate director of Lula Washington Dance Theater and the daughter of its founders, Lula and Erwin Washington. LWDT has served the Los Angeles dance community since 1980 through educational programs and theatrical performances. Tamica has been a soloist, choreographer, and teacher for its school. Photos of Tamica Washington-Miller taken in 2001 at Rose Eichenbaum Photo Studio in Encino, California.

[156] TYNE STECKLEIN is a commercial dancer who has appeared in numerous stage shows and films, including *Burlesque*, *Rock of Ages*, *High School Musical*, *17 Again*, and others. She was hand-picked by Michael Jackson to dance in his final *This Is It* tour. She was among the last to see him alive the night before he died. Photo of Tyne taken in 2012 for a cover and feature story for *Dance Magazine*.

[157] DEBORAH LOHSE is a performer, choreographer, and filmmaker whose work has been presented in theaters, public spaces, and

festivals across the United States. She has performed with New Chamber Ballet, Women in Motion, Doug Elkins Dance Company, and others. Photo of Deborah Lohse taken at Jacob's Pillow Dance Festival for *Dance Magazine* in 2012.

[158–159] WADE ROBSON is an Australian-born choreographer who began performing at the age of five and worked closely with pop icon Michael Jackson. He has created music videos and stage shows for some of the biggest names in popular music, among them Britney Spears and Justin Timberlake. He is also known for choreographing the hit animated film, *Happy Feet*, and the reality show, *So You Think You Can Dance*. Photo of Wade Robson taken in 2008 for a cover and feature story for *Dance Magazine*.

[160] AMANDA BALEN is a commercial dancer who has performed in live shows and concerts for such stars as Céline Dion, Janet Jackson, and Lady Gaga. Amanda has also appeared in numerous music videos and stage shows. Photo of Amanda Balen taken in 2012 for a cover and feature story for *Dance Magazine*.

[161] MARK KANEMURA is a former finalist on the hit reality show, *So You Think You Can Dance*, and has appeared on *America's Got Talent*, *Dancing with the Stars*, and *American Idol*. He has performed with Lady Gaga, Katy Perry, Janet Jackson, Carrie Underwood, and Beyoncé. Photo of Mark Kanemura taken in 2012 for a cover and feature story for *Dance Magazine*.

[162–163] DYLAN GUTIERREZ and Jeraldine Mendoza are principal dancers with the Joffrey Ballet. Both have danced leading roles in the company's extensive repertory, including *Romeo and Juliet*, *La Bayadère*, *Swan Lake*, *Lilac Garden*, *Don Quixote*, *Othello*, and many others. Photo of Dylan and Jeraldine taken on location at the Sepulveda Basin Nature Preserve in Encino, California, in 2014 for *Inside The Dancer's Art*.

[164] JULIO BOCCA is one of the world's most respected and talented dancers. He has guest-starred with many of the world's greatest companies, among them La Scala in Milan, the Paris Opera, the Kirov, the Bolshoi and the Royal Danish Ballet. He was a principal with American Ballet Theatre for twenty years. Bocca is the artistic director of his own company, Ballet Argentino, which combines ballet and tango. Photo of Julio Bocca taken in 2006 during his Ballet Argentino tour at UCLA's Royce Hall for *The Dancer Within*.

[165] WENDY WHELAN enjoyed a brilliant career with New York City Ballet from 1984 until her retirement in 2014. Her repertoire included the works of George Balanchine, Jerome Robbins, Peter Martins, Twyla Tharp, Christopher Wheeldon, William Forsythe, and many others. She continues to perform and develop her own independent projects. Photo of Wendy Whelan taken during her performance of *Restless Creature* at Jacob's Pillow Dance Festival in 2013.

[166–167] N'TEGRITY (Alicia Quinones) and Trinity (Nicole Whitaker) are both nationally ranked break-dancers and members of United Outkast along with Sweet Lu (Luis Espinosa), who is considered one of the ten best B-boys in the nation according to bboyworld.com. All three were featured in the hit film, *Step Up 3D*, and are on the faculty of The Enchanted Garden Studios in Ridgefield, Connecticut. Photos taken in 2015 in Bridgeport, Connecticut.

[168] SONYA TAYEH is a contemporary and jazz choreographer best known for her work on the hit reality show, *So You Think You Can Dance*. Her signature combat jazz style of dance has led to commissions with Madonna, the Los Angeles Ballet, the Martha Graham Dance Company, and others. Photo of Sonya Tayeh taken in 2010 at Edge Performing Arts Center in Hollywood, California, for a cover and feature story for *Dance Teacher Magazine*.

[169] BRITAIN GRADY is a beautiful young dance student at Los Angeles Ballet Academy. Photo of Britain was taken when she was nine years old for a cover story in *Ventura Blvd* magazine in 2011.

[170–171] LAR LUBOVITCH is one of the most prolific choreographers of his generation. As the artistic director of Lar Lubovitch Dance Company, he is renowned for his musicality, intelligence, and rhapsodic style. Many of his original ballets are included in the

repertories of numerous dance companies, including New York City Ballet, Paris Opera Ballet, Alvin Ailey American Dance Theater, Stuttgart Ballet, and Netherlands Dance Theater. Photo of Lar Lubovitch taken at the American Ballet Theatre Studios in New York in 2014.

[172] MARCELO GOMES received his early ballet training in his native Brazil. He joined American Ballet Theatre as a corps member in 1997 and rose quickly to soloist and principal. He has performed virtually every full-length leading role in the company's extensive repertoire, including *Apollo, La Bayadère, Giselle, Othello, Le Corsaire, Romeo and Juliet, Don Quixote*, and many others. In addition to performing with ABT, he has guest-starred with the Kirov Ballet, Bolshoi Ballet, Teatro Colón, and Theatro Municipal do Rio de Janeiro. Photo of Marcelo Gomes taken in New York in 2015 for *Inside the Dancer's Art.*

[173] GILLIAN MURPHY has been called one of the most exciting ballerinas of her generation. A principal with American Ballet Theatre since 2002, she continues to delight audiences and critics alike with her beauty, precision, and charismatic stage presence. Her extensive repertoire includes leading roles in *Swan Lake, Romeo and Juliet, Le Corsaire, Pillar of Fire, The Sleeping Beauty, Fall River Legend, Les Sylphides*, and many others. Photo of Gillian was taken in New York in 2014 for *Inside The Dancer's Art.*

[174] SUNHWA CHUNG, a native of Korea, is a dancer and choreographer, and the artistic director of Sunhwa Chung/Ko-Ryo Dance Theater, a company she founded in 1994. Chung has performed Korean dance extensively in the United States, Asia, and Europe. Photo of Sunhwa Chung taken in 2007 at Jacob's Pillow Dance Festival.

[175–177] LAKSHMI IYENGAR is the daughter of accomplished Bharatanatyam dancer and master teacher, Malathi Iyengar, who along with Narmada and Bragha Bessell mentored her in the art of classical Indian dance. Lakshmi is a gifted performer and a lead dancer in the internationally acclaimed Rangoli Dance Company. Photos of Lakshmi

taken at Rose Eichenbaum's Photo Studio in 2015 for *Inside The Dancer's Art.*

[178] ANDREA PARIS-GUTIERREZ is a native of New Zealand, where she received her early ballet training. A former professional dancer, she founded the Los Angeles Academy of Ballet in 1992. Ms. Gutierrez is a master teacher and has received numerous awards, including *Dance Teacher Magazine*'s Outstanding Teacher of the Year Award. Los Angeles Ballet Academy is one of the premier ballet schools in the United States.

[179–181] ASHLEY EVERETT is best known as Beyoncé's back-up dancer and dance captain. She was one of the featured dancers in the music video *Single Ladies (Put a Ring on It)*, which won Music Video of the Year in 2008 and has since generated more than 400 million views on YouTube. Ashley has also worked alongside Usher, Robin Thicke, Jennifer Lopez, Tina Turner, and Ciara. Photo of Ashley Everett taken at Rose Eichenbaum's Photo Studio in 2015 for *Inside The Dancer's Art.*

[182–183] CASSANDRA TRENARY is a soloist with American Ballet Theatre. A recipient of a 2011 National YoungArts Foundation award and a 2015 Princess Grace honorarium, Trenary is among the company's rising stars. She has performed in many of the company's most popular ballets, including *The Nutcracker, Romeo and Juliet, Sleeping Beauty, Le Spectre de la rose, Othello*, and many others. Photo of Cassandra Trenary taken in New York in 2015 for *Inside the Dancer's Art.*

[184] XAI YING is a soloist with the Martha Graham Dance Company. Since joining the company in 2011, she has performed many of Graham's masterworks, among them *Chronicle, Diversion of Angels, Echo* and *Errand into the Maze*, as well as new contemporary works by guest choreographers. Photo of Xai Ying taken at Jacob's Pillow Dance Festival in 2015 for *Inside the Dancer's Art.*

[185–187] NIA DAVIS, Quaba Ernest, and Siobhan Harvey, all still in their teens, are among the Dance Theater of Harlem School's most

dedicated and hard-working students. Each of them is committed to pursuing a professional dance career. Photos taken at the Dance Theater of Harlem School in 2015 for *Inside the Dancer's Art*.

[188] ROBERT FAIRCHILD has been a principal dancer with New York City Ballet since 2009. He has performed George Balanchine's choreography extensively, as well as the works of Jerome Robbins, Peter Martins, William Forsythe, Christopher Wheeldon, and others. In 2014 he landed the featured role in Broadway's *An American in Paris*, for which he was nominated for a Tony Award. Photo of Robert Fairchild was taken on the plaza at Lincoln Center in 2015 for *Inside the Dancer's Art*.

[189–191] TILER PECK is one of New York City Ballet's shining stars. Promoted to principal dancer in 2009, she has become an audience favorite with her versatility, technical skill, and beauty. She has an extensive repertory of featured roles from the works of George Balanchine, Jerome Robbins, Peter Martins, Susan Stroman, Christopher Wheeldon, and others. In 2014, Tiler assumed the lead role in Susan Stroman's 2014 stage show, *The Little Dancer*, based on an Edgar Degas sculpture of the same name. Photo of Tiler Peck taken on the plaza at Lincoln Center in 2015 for *Inside The Dancer's Art*.

[192–195] NATALIA OSIPOVA and Ivan Vasiliev are former principals with the Bolshoi Ballet. Acclaimed for their artistry and meticulous technique, the two are regarded among the world's greatest ballet dancers. Vasiliev is currently a member of the Mikhalovsky Theatre. Osipova is an independent touring dancer who has performed leading roles with the Royal Ballet, American Ballet Theatre, and other companies. Photo of Natalia Osipova and Ivan Vasiliev performing Bigonzetti's *Serenata* at the Segerstrom Center for the Arts in Orange County, California, in 2011 taken for *Pointe Magazine*. Quote from Giannandrea Poesio, "Natalia Osipova Interview," *The Spectator*, July 26, 2014.

[196–197] ELIANA GIRARD was the female winner in season nine of the hit reality show, *So You Think You Can Dance*. Formerly with Cirque du Soleil, Girard was named "America's Favorite Female Dancer" in 2012. Since winning this coveted prize, she has enjoyed dancing on Taylor Swift's Red Tour. Photo of Eliana Girard taken at Rose Eichenbaum Photo Studio in 2015 for *Inside The Dancer's Art*.

[198] VILLN LOR is a member of Underground Flow, which has won numerous highly competitive break-dance battles and competitions. He has also appeared in music videos for some of the biggest names in music, among them Chris Brown, Taylor Swift, Ariana Grande, and The Black Eyed Peas. His commercial dance credits include ad campaigns for Nike, Adidas, Panasonic, Visa, and Apple. Photo of Villn taken in 2015 at the Sepulveda Basin in Encino, California, for *Inside The Dancer's Art*.

[199] RYANIMAY (Ryan Conferido) is one of America's most innovative and talented B-boys. He became a finalist on the first season of *So You Think You Can Dance*. Ryan has performed on such shows as *American Idol, Dancing with The Stars, Glee, The Emmy Awards*, MTV's *America's Best Dance Crew, American Music Awards*, and many others. He has also been part of numerous international music tours to Australia, Asia, and Canada. Photo of Ryanimay taken in 2015 at the Sepulveda Basin in Encino, California, for *Inside the Dancer's Art*.

[200–203] ALYSSA ALLEN, Jordan Johnson, Aidan Carberry, Stephanie Dai, Jessica Muszynski, Austyn Rich, Paulo Hernandez-Farella, and Lenai Wilkerson are among the first graduating class of the newly formed USC Glorya Kaufman School of Dance. Photos taken on commission for USC in 2015.

ROSE EICHENBAUM is an award-winning photographer and author of *Masters of Movement: Portraits of America's Great Dancers*, *The Dancer Within: Intimate Conversations With Great Dancers*, *The Actor Within: Intimate Conversations with Great Actors*, and *The Director Within: Storytellers of Stage and Screen*. Her photography and articles have appeared in *Dance Magazine*, *Dance Teacher Magazine*, *Pointe Magazine*, the *Los Angeles Times*, and numerous other publications. Her photography has been exhibited in museums and galleries throughout the United States, including a three-year national tour hosted by the Smithsonian Institution's Traveling Exhibitions. She lives in Encino, California.